C000075419

ARTIVISM

Daniela Poch & Arcadi Poch

**CARPET
BOMBING
CULTURE**

Alex,

Thank you for being
one of those who
do.

Happy Birthday,

Alex & Guillermo

A catalogue record for this book is available from the British Library.

First Edition 2018
First published in Great Britain in 2018 by Carpet Bombing Culture.
An imprint of Pro-actif Communications
www.carpetbombingculture.co.uk
email: books@carpetbombingculture.co.uk
© Carpet Bombing Culture. Pro-actif Communications

Written by:
Arcadi Poch and Daniela Poch
www.yticlabs.com

Art Direction:
Marc Castan
www.marccastan.com

Translation:
Ian Barnett

ISBN:
978-1-908211-62-0

Backcover:
PEJAC
HEAVY SEA, 2016

CARPET
BOMBING
CULTURE

Europe is lost, America lost, London lost
Still we are clamouring victory
All that is meaningless rules
We have learned nothing from history
The people are dead in their lifetimes
Dazed in the shine of the streets
But look how the traffic's still moving
System's too slick to stop working
Business is good
And there's bands every night in the pubs
And there's two for one drinks in the clubs

Europe is Lost, written by Kate Tempest
Courtesy of Domino Publishing Company Limited

CONTENTS

I'M NOT A REAL ARTIST
Paris, France, 2014
© SpY

PRANKTIVIZM, SONOFABITCHIZM, FUCKTIVIZM, WHATEVERIZM

Someday, they'll understand things.
Maybe, Wes said. But it won't matter then.
Raymond Carver, Chef's House

This book has been a house to us. We've lived in it. At times it's felt a bit like a train-ride in a first-class carriage. In his On the Natural History of Destruction Sebald wrote that it was easy to spot a German on a train after World War II: they were the ones not looking out of the window. It may be just an isolated image, but it really helps to define precisely what we've been trying to do here: never stop looking out of the window. House, window, first-class carriage or whatever, this book is a compilation of thoughts and images that represent what a handful of people do when they aren't at home. The handful are individuals who have found their own way of expressing their protest. Aware as we are of the kicking we may get for playing with labels, we've chosen to call these ways 'artivism' – a fairly contemporary term, but a very ancient one too when we think of the artistic or creative components inherent in any communicative exercise since the dawn of civilisation.

Right, so the book's apparently about artivism, but no matter how far we stick our collective necks out of the window to study it, we still haven't the faintest idea what it is. And we aren't ashamed to admit it: confusion is the best seat on the train. This book is an attempt to approach some kind of a definition. Does it really matter if our knowledge of the subject is still rather blurry? In the early stages it felt like we were on pretty shaky ground, we have to admit. But since completing the journey, we've learnt that sometimes seeing something out of focus is the best way to grasp things that weren't clear in the first place, and perhaps were never meant to be. Still, we should value our determination to comprehend this vast ocean of creative struggle. That's why you won't find any academicisms or taxonomies here: our selection of artists comes with no guarantees; there are no assurances that everything in this book is artivism per se. We prefer to leave that judgement to the reader, so she or he takes us not as scammers but as mere organizers of material that's up for discussion.

What we can say is that this book is about people who have placed their trust in protest as a form of happening. This is a book about things that happen. Everything you see here is a graphic record of messages delivered in full creative awareness with the aim of catalysing change sometime somewhere. As the Spanish anthropologist Manuel Delgado Ruiz has asked, is there a form of protest that wouldn't like to effect change right here and now?

We showcase examples here that illustrate a form of struggle but also demonstrate many further truths and provide us with lessons to make our window a crossable threshold – an unlocked, open door. No conditions. (When you get to the section on Jeff Stark, you'll see what we're talking about.)

How many of those who've collaborated with us on this project had never asked themselves whether they're artivists or not? It's

like when you used to ring someone up on one of those old phones that didn't identify the caller: when they picked up, you had to say 'It's me.' We couldn't say for certain, but we'd bet that almost all of those who agreed to appear here would pick up that old phone and answer with a simple, honest 'It's me.' And we'd reply 'You, who? The artivist?' And they'd either hang up or say, as SpY did, 'I'm not a real artist.' Or, as Artaud might have done: 'Damn anyone who says what I do is art.' But none of the artists here did hang up. They answered the call because they liked the idea.

To draw a few conclusions, we've identified a series of common denominators or recurring traits in the different actions or individuals listed here as 'artivist' or 'potentially artivist'. They light the blue touch-paper for a possible science of artivism. One of these is the artists' relationship with the street, or with that will-o'-the-wisp 'public space'. The struggle is being fought on the streets, so most artivist actions are too. The street is the backdrop against which artivists or those committed to the social struggle – an æsthetic and creative one in this case – expose the mechanisms of domination we're subject to. This exposure rips open the system and by ripping open the system it makes the social happening possible.

One of the main criticisms of the common-or-garden activism is the issue of signatures. Signed activism is one of those painful paradoxes for some thinkers. They feel that if you put the author before the protest, their ego appears more important than the authenticity of the social commitment. What interests are disguised by a signature in an action that's supposed to be serving a social, humanitarian, political or environmental cause? This is the central precept of these critics' internal dialogue. We believe that artivism is born precisely with the appearance of an author who creates an artifice which inevitably brings about a separation from run-of-the-mill activism. One of the leading exponents of artivism and the founder of the Enmedio collective, Leónidas Martín, sees it as a very different process from classic militant activism on account of one key element: the time factor. He claims that, the moment we incorporate fiction, the action acquires complexity in both time and interpretation: artistic thought applied to social criticism sets up a new parallel reality that shuttles back and forth between truth and illusion.

Nowadays this kind of activism usually involves sharp-edged actions with a specific focus, whereas the typical activism often ends up fossilized in eternal causes. The effort and perseverance involved are greater, but the results aren't always directly proportional. In the artivist's world a creative response to a conflict must strike a balance between the rules and the basic pillars on which it is built. On the one hand art, on the other activism. The artivist should be aware of the 'special' limitations and possibilities of her or his role, which is precisely to amplify the message and to repose the conflict within a political, social and/or media agenda. But any hope of solving the problem directly has gone down the tubes.

As Oscar Wilde once said, 'Disobedience, in the eyes of any one who has read history, is man's original virtue.' So let's be honest: we're all born into disobedience. The breach arises from competition between different human wills: some devote their lives to training the will just like another muscle; others lose it completely. Being a 'professional' rebel isn't easy in times like these. Many of our artivists confront extremely serious issues,

conflicts of great social and political import that threaten the human condition itself. But what the rest of us onlookers have to do is to tap into the energy, creativity, enthusiasm and spirit behind these proposals for creative struggle. The great clown Leo Bassi once said that the biggest act of disobedience that exists in these turbulent times is enthusiasm.

Staying with the 'art' element in our frankenword, there's a paradox that envelops the world of the artivist: namely that adding or subordinating the category of art to that of typical activism provides a valuable trump-card when artivists come to defend themselves against the authorities. When you defend that what you're doing is an art form or a cultural contribution to the city, it's accepted without a fuss. When Manuel Delgado Ruiz argued in court that he'd set fire to a container to create an art work, the case was shelved. When art is put into the equation the authorities and political bigwigs no longer feel threatened. The label of 'art' provides clever camouflage for the fierce will to struggle.

Another of those common denominators we mentioned earlier is independent, creative funding. The artivist isn't deterred by his or her lack of financial resources. They create and then see how to get by, because what they're doing primarily is struggling. And you can't put a price on struggle. The law of artivist natural selection states that whoever develops the ingenuity to make the biggest impact at the lowest cost survives. That is pure creativity. But there's another big issue: should the artivist have to act independently of markets? And if artivism isn't independent, does it stop being artivism? The answers to these questions are for each of us to decide.

The evidence may offend, but there's no artivism without protest, dissent, pain or indignation. All the artivists featured here have chosen emotional struggle as a way of life. They're all sensitive souls. In our opinion there's nothing more dangerous or necessary today than an artivist, or whatever we decide to call them. They're people who throw parties in unemployment offices, or dress up as reverends and wander the streets with a choir preaching to the world's consumers. They steal contaminated metal from Chernobyl, send fake weapons to the United States in containers or set up percussion bands outside the G20. They impersonate businessmen to put out false media messages, or paint giant penises on drawbridges opposite KGB headquarters (you can picture the scene every time the bridge is raised to let a boat through). Or they don wrestler-cum-superhero suits and go knocking on the door of the US president's office. So ultimately this is a book about nutters who come up with wonderful ideas.

This isn't a book of tributes, but we do want it to stand as a recognition of all artivists everywhere, starting with those who agreed to appear, but including all those we haven't been able to feature but who are also putting out great work.

And you the readers, we invite you to look out of this first-class carriage window and get out of the door as soon as you've turned the last page. It's a real rush.

Long live the creative revolution!

HUMANIZING THE CITY: THE POETICS OF CRITICAL THINKING

JORGE RODRÍGUEZ-GERADA

www.gerada-studio.com

We couldn't discuss artivism without considering the work of Jorge Rodríguez-Gerada. While he defines himself as a plain artist, he doesn't obviously fit the bill when it comes to the vast bulk of artistic-activist development. To understand his work in all its simplicity and complexity, we need to journey back to his origins, to his birth in the Cuban city of Santa Clara in 1967, and even further back to his Lebanese and Galician lineage. He spent only a brief spell in Cuba before moving to the US state of New Jersey, where he grew up, and later to the metropolis of New York City, where he trained as a professional artist. A Cuban-New Yorker of European-Arabic descent who works as a street artist can never escape the search for truth in the central theme of his work: identity. His sense of identity has brought him mentions in books of the calibre of Naomi Klein's No Logo. Even in his earliest meanderings he established an artistic-æsthetic approach based on a critique of large corporations, altering their outdoor advertising and using their own semiotics to reverse, or rather recipher, the messages lurking behind the products (a bit like the disguised alien overlords manipulating the human race through the mass media in John Carpenter's They Live). He and other urban agitators were partially responsible then for the birth of a new movement in 1980s NYC known as 'culture jamming'. These self-styled 'culture jammers' rebelled against mass consumption using the codes of advertising and promoted a counter-culture that collapsed when brands discovered that such interventions increased their visibility and started hiring culture jammers for their outdoor ad campaigns.

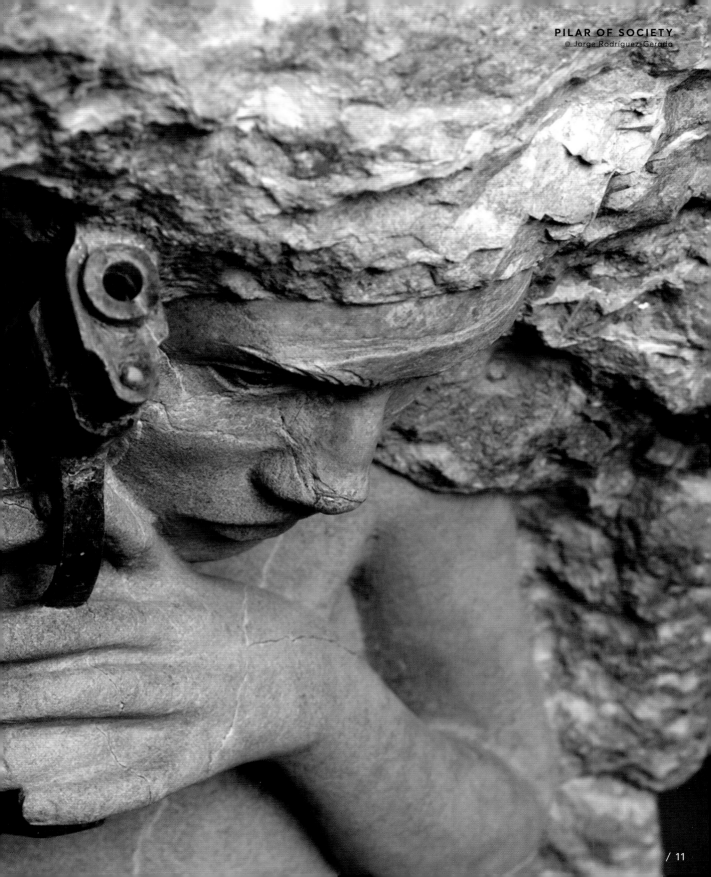

VERY

FC

STYLE GENERAL'S WARNING: E
MAY NOT GUARANTEE YOU AN

CULTURE JAMMING
New York, USA, 1990
© Jorge Rodríguez-Gerada

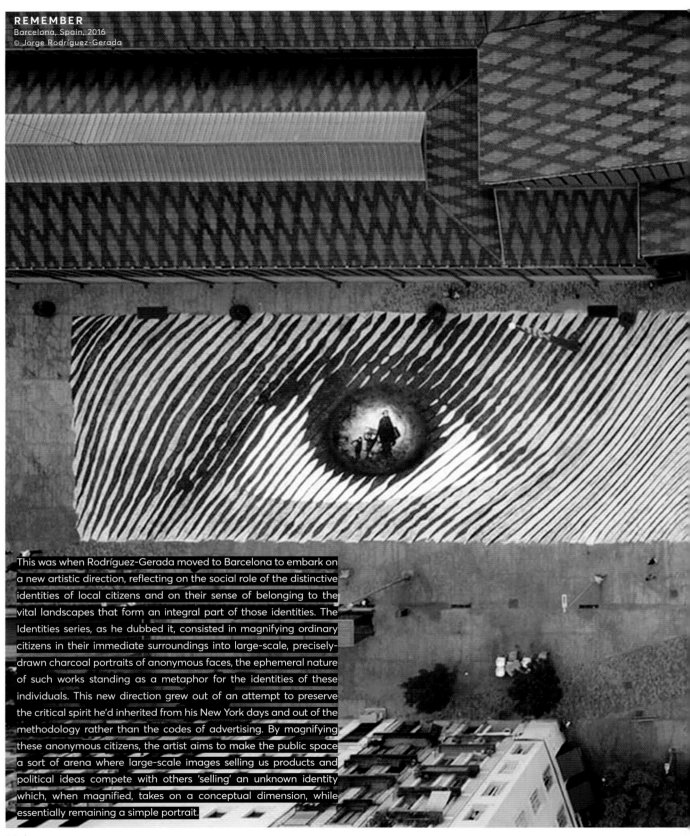

This was when Rodríguez-Gerada moved to Barcelona to embark on a new artistic direction, reflecting on the social role of the distinctive identities of local citizens and on their sense of belonging to the vital landscapes that form an integral part of those identities. The Identities series, as he dubbed it, consisted in magnifying ordinary citizens in their immediate surroundings into large-scale, precisely-drawn charcoal portraits of anonymous faces, the ephemeral nature of such works standing as a metaphor for the identities of these individuals. This new direction grew out of an attempt to preserve the critical spirit he'd inherited from his New York days and out of the methodology rather than the codes of advertising. By magnifying these anonymous citizens, the artist aims to make the public space a sort of arena where large-scale images selling us products and political ideas compete with others 'selling' an unknown identity which, when magnified, takes on a conceptual dimension, while essentially remaining a simple portrait.

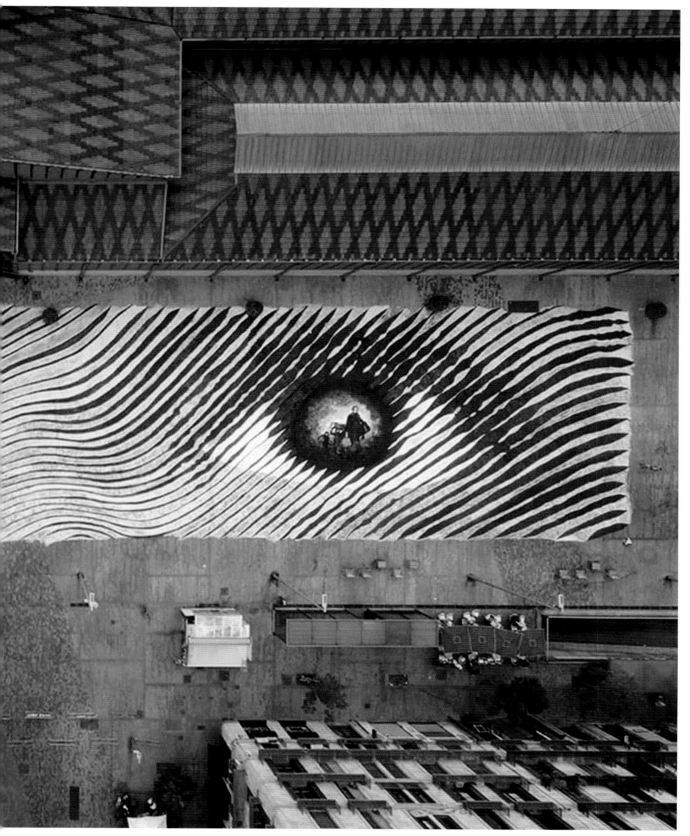

His renowned Identities have appeared in countless cities across the world. Taken together they form a giant catalogue of faces that both parodies and subverts product catalogues. This is where the true essence of his work lies. Regardless of whether or not we can consider him an artivist, his work has a social charge as poetic as it is overpowering. It speaks to us of the realm of advertising and compulsive consumption, and consequently of the classic topic of the prohibition of street art. This is art that produces free-thinkers opposed to the kind of advertising and politics that indoctrinate new consumers and create social automata. We might even call it 'poetic artivism'. Is a mural with no explicit message capable of getting society thinking simply by prompting questions about the appearance of an unknown face?

As a critical artist his work is based on the exploration of the visual impact produced by the society of the spectacle, which is what has led him to use the same codes as the concept of spectacle.

This is the sole reason why his works are always conceived on a spectacular scale, with land art images that can cover anything up to four hectares, and require hundreds of tons of material and large teams, often made up of volunteers. Such thinking is along the classic lines of 'bigger is better': it creates more noise for the social cause that underlies the image; a conscientious, large-scale exercise in raising awareness about issues that need to be tackled due to their negative impact on particular social groups.

His first work on this colossal scale was done in 2008, when Obama first stood for president of the United States. At the time the whole world was in need of a hero, so Rodríguez-Gerada magnified his face in a gigantic one-hectare portrait, using more than 600 tonnes of sand and gravel. With the passing of time this grand iconic statement would be distorted and erased by the wind, just as the artist always knew it would.

DAVID
Buenos Aires, Argentina, 2015
© Ana Álvarez-Errecalde

EXPECTATION
Barcelona, Spain, 2008
© Jorge Rodríguez-Gerada

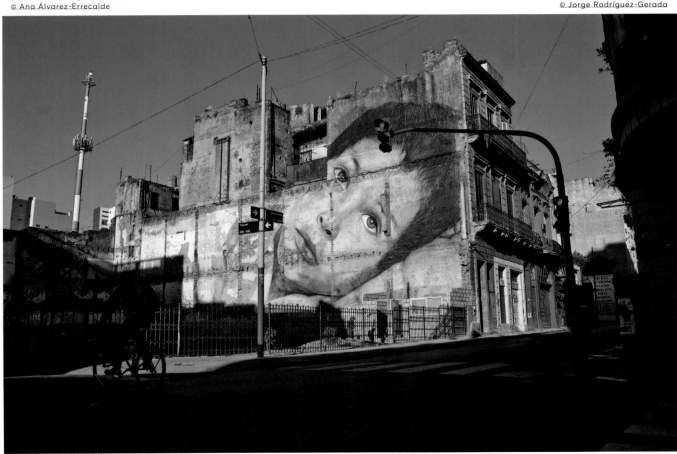

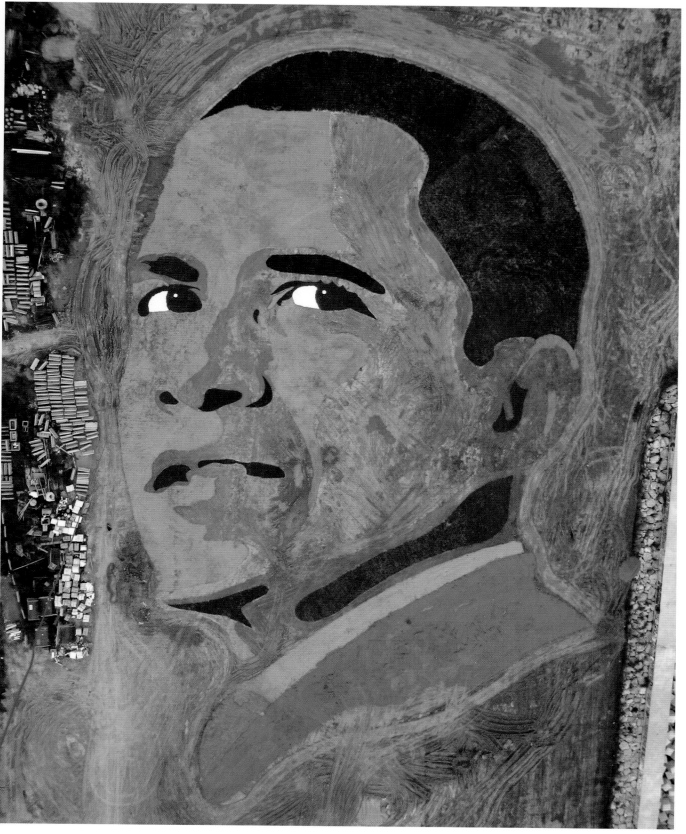

FLOATING UTOPIAS: LUNACY SUBVERTING REALITY ON A GRAND SCALE

SWOON

www.swoonstudio.org

'I look at the word SWOON as a body of work, not as my name. SWOON is not me. I'm not SWOON. SWOON is like a way of thinking. It's a body of work. It's a series of interrelating thoughts,' says Caledonia, the woman behind the tag. When you first start looking into SWOON's work, you begin to glimpse her mental processes: what leads her from one project to the next, what makes her tick, her wildness, her extremism, her concern for the local, how she takes in and takes on the community issues that motivate her…

Swoon's interventions are profoundly artivistic: some in the form of site-specific installations; others of projects designed for a community. Examples of her works can be found in Bethlehem, Ciudad Juárez, São Paulo, Kenya… Sylvia Elena, Swoon's project in Ciudad Juárez, is a clear example of how to use urban art to raise awareness of a horrifying problem: the disappearance of thousands of young girls, later found dead in the desert, in alleged drug-related incidents. Swoon got herself involved in the association Nuestras Hijas Regresan A Casa [Our Daughters Come Home]. Through them she made contact with Ramona, a woman whose young daughter – Sylvia Elena – had been murdered. Swoon staged an installation at the Yerbabuena Gallery in San Francisco. It consisted of a large-scale portrait of Sylvia Elena and a set of headphones over which people could listen to Ramona's account of events.

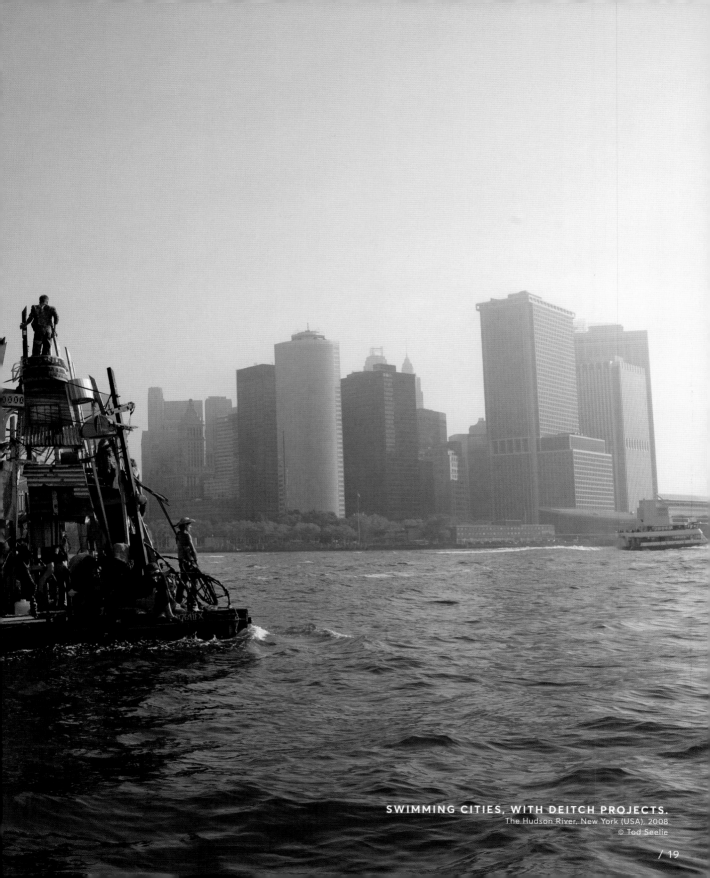

Swoon's most memorable initiative to date is Miss Rockaway Armada. This was an art collective that built a fleet of rafts out of recycled materials to ply the Mississippi River from Minneapolis to New Orleans. Along its way the Armada disembarked in towns to provide non-stop art and workshops where people could meet, share their knowledge and experience and reinvent myths (while performing daily manœuvres and repairing any damage).

They needed so much material to build the fleet that they asked anyone they could find to give them anything they had left over. A lot of people gave them stuff in the hope that this far-out idea would be made reality. Which it was. And this is vital when we describe Miss Rockaway Armada as an act of artivism, because the project somehow became a demonstration of how to fare when faced with the impossible. A real pukka floating utopia. 'You've made me regain my faith in humanity,' read one of the many comments they were paid on their journey. There's a keynote of subversion in all this madness, and it lies precisely in making the madness happen. We like set out to make the wildest dreams we had when we were little come true. And everybody's really getting off on the idea of this new world of possibility. A girl who watched them all day when they were in her town said to them just before they left, 'You're the one perfect thing I've seen in my life and now you have to leave.' Miss Rockaway Armada is a project that changes folk: not just those who've lived it on the inside but those who've lived it on the outside too.

SWIMMING CITIES, WITH DEITCH PROJECTS.
The Hudson River, New York (USA), 2008
© Tod Seelie

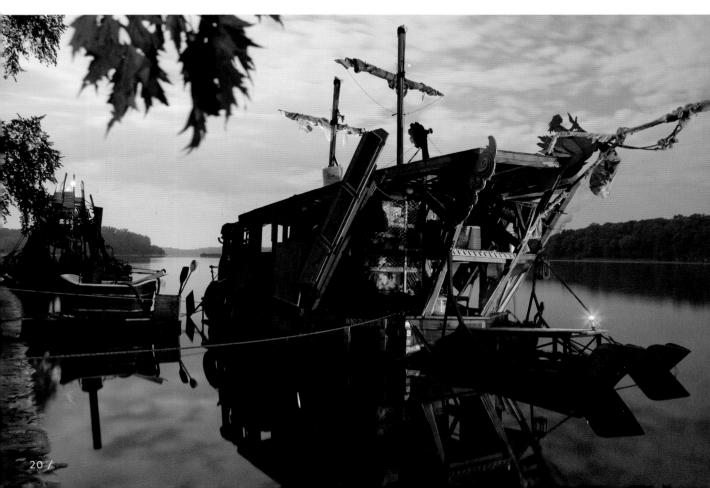

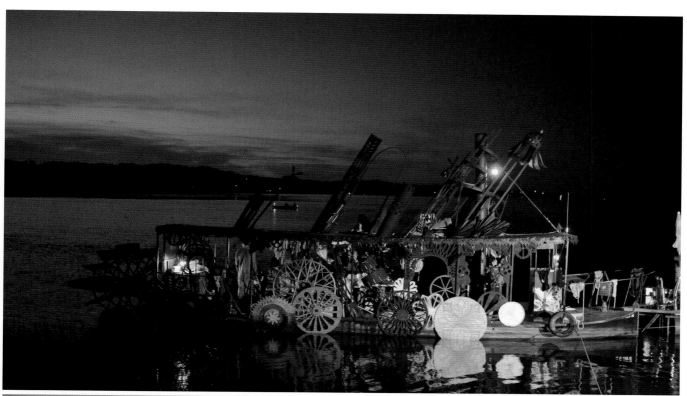

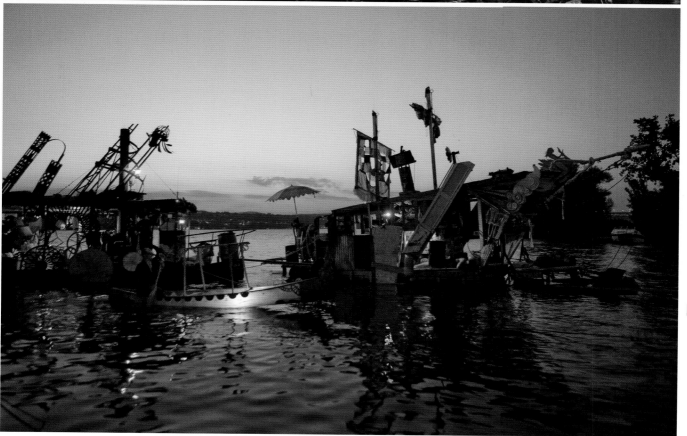

Later came other projects: Swimming Cities of Switchback Sea down the Hudson River in New York State and Swimming Cities of Serenissima on the Adriatic in Venice. This time around there were some salient differences: the people in Mississippi were agog; in New York they called the police. Another difference was that this second floating project had been commissioned by a gallery, so SWOON had an artistic storyline to follow and a collective working to make it happen. There was a budget, a script... The sense of belonging had lessened, although there were still dollops of that unplanned beauty you encounter when you work collectively towards building the real article: a floating utopian community.

As an artist SWOON is deeply involved in the urban space, social conflicts, and the community, and also has such an over-arching sense of what is possible that her works traverse unexpected thresholds. Now she has crossed the fine line from art to artivism.

SYLVIA ELENA
Juarez (Mexico), 2013
© Caledonia Curry

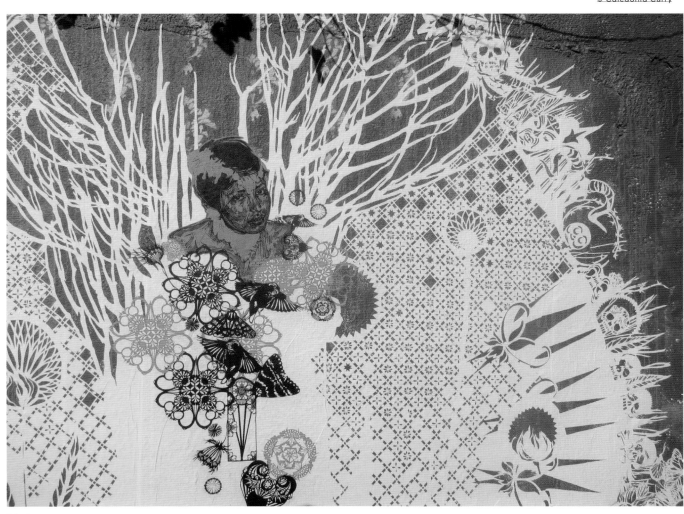

BETHLEHEM BOYS
St. Louis, USA, 2011

TICKLING REALITY'S UNDERBELLY

SpY
www.spy-urbanart.com

Incisive, sharp, caustic, critical, simple, powerful, scathing, relentless… We could go on like this for years without finding the exact word to define the stimulating Madrid-based creator who styles himself SpY. He is a character without a face, who jealously guards his real identity from the media. He started out in the deprived outskirts of the Spanish capital painting graffiti in its purest form. His artwork – be it graffiti or highly conceptual art – is rooted in the most elemental aspects of guerrilla communications: savage exercises in citizen appropriation, either extremely graphic or irreverent interference. He disrupts urban reality and human boredom.

SpY is considered one of the most compelling conceptual urban artists around. His work impacts the spectator like a sharp instrument, leaving deep gashes in the consciousness while still being capable of drawing a smile. SpY has that ability, that gift to turn the critical into the parodic, the formal into the informal, the serious into the comic, the obvious into the uncertain: his work can be seen as one all-encompassing act of artistic sabotage that plays apparently contradictory images, situations and concepts off against each other. His wry and rather amused outlook usually materializes in a perturbing context – a practice in this day and age as fundamental and indispensable as it is healthy.

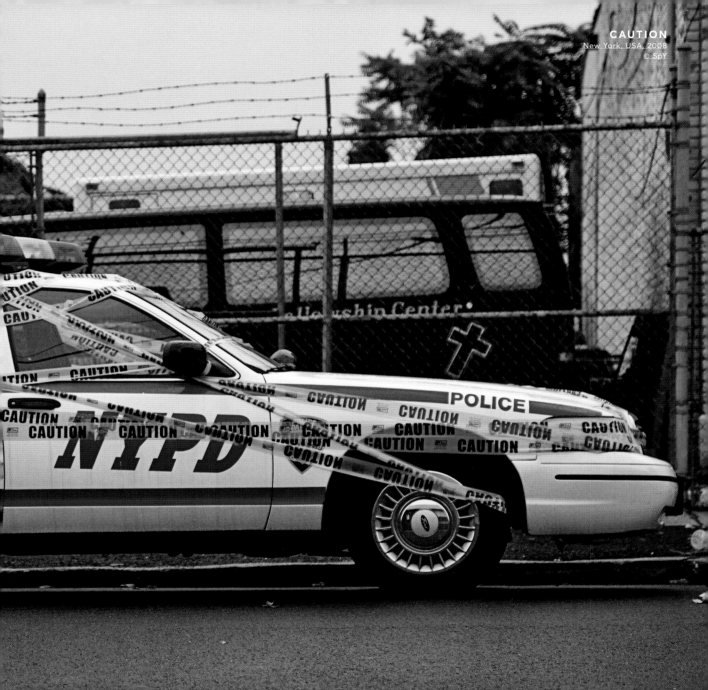

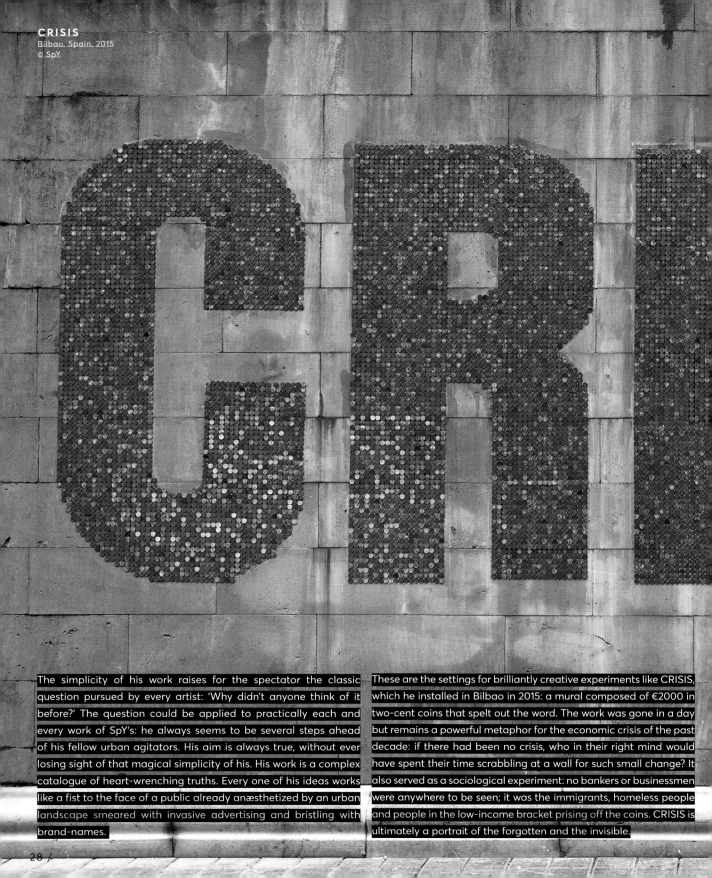

The simplicity of his work raises for the spectator the classic question pursued by every artist: 'Why didn't anyone think of it before?' The question could be applied to practically each and every work of SpY's: he always seems to be several steps ahead of his fellow urban agitators. His aim is always true, without ever losing sight of that magical simplicity of his. His work is a complex catalogue of heart-wrenching truths. Every one of his ideas works like a fist to the face of a public already anæsthetized by an urban landscape smeared with invasive advertising and bristling with brand-names.

These are the settings for brilliantly creative experiments like CRISIS, which he installed in Bilbao in 2015: a mural composed of €2000 in two-cent coins that spelt out the word. The work was gone in a day but remains a powerful metaphor for the economic crisis of the past decade: if there had been no crisis, who in their right mind would have spent their time scrabbling at a wall for such small change? It also served as a sociological experiment: no bankers or businessmen were anywhere to be seen; it was the immigrants, homeless people and people in the low-income bracket prising off the coins. CRISIS is ultimately a portrait of the forgotten and the invisible.

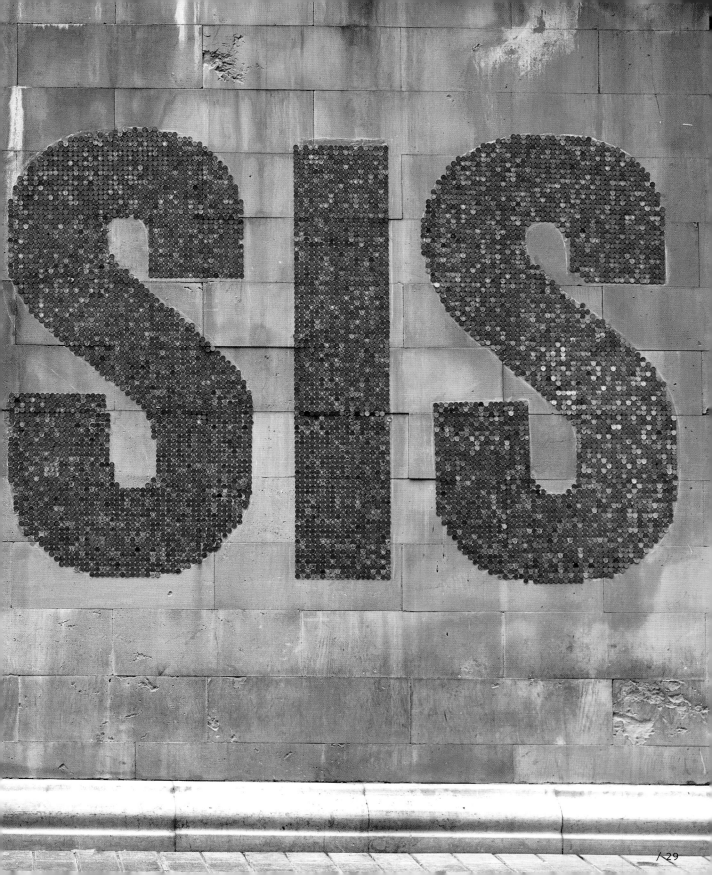

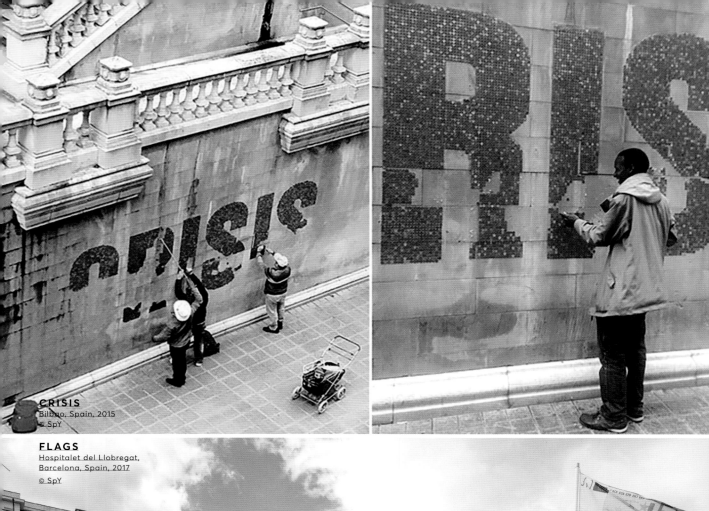

CRISIS
Bilbao, Spain, 2015
© SpY

FLAGS
Hospitalet del Llobregat,
Barcelona, Spain, 2017
© SpY

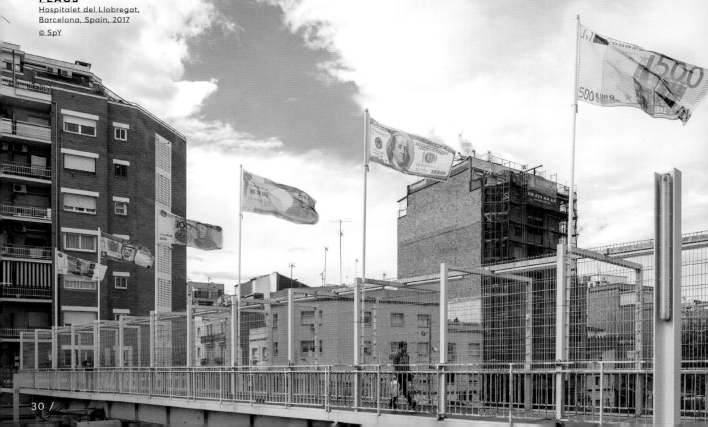

SWASTIKA
Mumbai, India, 2017
© SpY

As art critic and urban art expert, Javier Abarca says: 'SpY's works are not a monologue, but a dialogue between the artist and his environment, between the passer-by and the piece. [...] His work involves the appropriation of urban elements through transformation or replica, a running comment on urban reality and an interference in its communicative codes. The bulk of his production stems from an observation of the city and an appreciation of its components, not as inert elements, but as a palette of materials brimming with possibilities. The unmistakable hallmarks of his actions are his will to play, his careful attention to the setting of every piece and his constructive, non-invasive attitude.'

SpY's steadfast provocation knows no borders or flags. This was true of his work for the annual meeting of the Global Cultural District Network, which took place in Barcelona in 2017 and gathered over 120 cultural and urban leaders from 26 countries. This event collected several events such as workshops, cultural tourism and animation of public spaces and convened featured panel discussions on branding and identity of cultural districts and cultural infrastructure. Under this context and the curatorial of The Polyhedric Festival – one of those events –, SpY placed the flags compulsory at any international rally in the path of those attending; only, in this case, he deployed images of the world's major currencies, a critical look over the institutional neo-liberalism that uses culture as their own flags to empower territories.

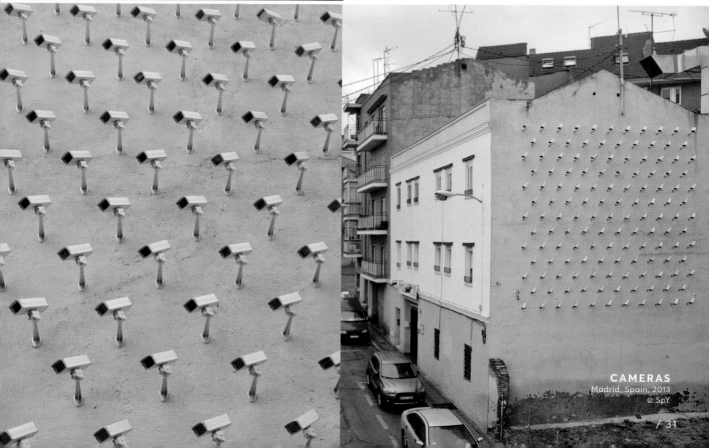

CAMERAS
Madrid, Spain, 2013
© SpY

IN THE MIDST OF NOWHERE AND EVERYWHERE

ENMEDIO COLLECTIVE

www.enmedio.info

'We were born out of a group of dissatisfied professionals who felt we were in the middle of nowhere,' says Leo Martín, one of the founder members of Enmedio [Inthemidst], a Barcelona-based collective. Martin is a professor of æsthetics and art at the Autonomous University, where he teaches a course on art policies, providing a historical overview of the crossover between art and politics. The refusal to accept the world around us has always been one of the greatest spurs to activism and social action. In the particular case of Enmedio this refusal, shared by a group of designers, photographers, filmmakers and artists, has been the key to everything that has followed. They have two very clear goals: to identify and reflect on the power oppressing us today, and to find ways of dealing with it through artistic practice.

Though Enmedio themselves may not quite agree with the term looming over this book, they're probably one of the most graphic examples of new creative activism, or artivism. Their initiatives blend installation, photography, design and the application of fiction techniques, which always have a powerful performatic component to fight the powers oppressing contemporary society. Their work is a clear example of storytelling. The collective is one hundred per cent independent and not subject to market forces, allowing them to maintain maximum levels of freedom. This position means they can keep this space free to do whatever they feel necessary and tackle creatively anything that affects our lives, choosing the focus of action that they feel is appropriate on a case-by-case basis. Enmedio opens a debate on what art really is, what it's for, how it operates, how it positions itself, how it can develop outside conventional or preset circuits, its economic coordinates and so on.

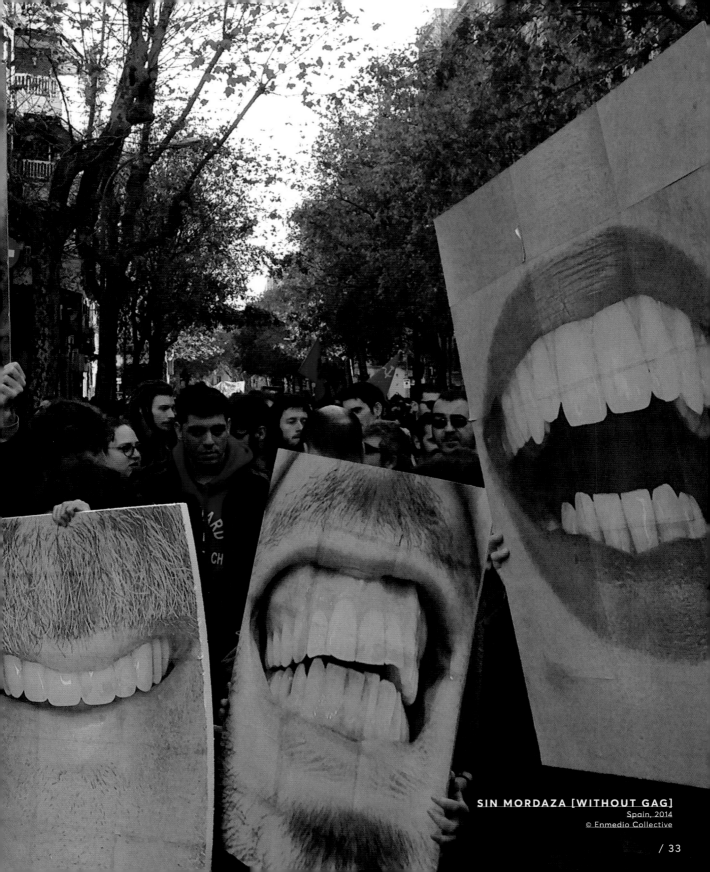

SIN MORDAZA [WITHOUT GAG]
Spain, 2014
© Enmedio Collective

REFLECTANTES CONTRA EL MAL
[REFLECTATION AGAINTS THE EVIL]
Spain, 2012-2015
© Enmedio Collective

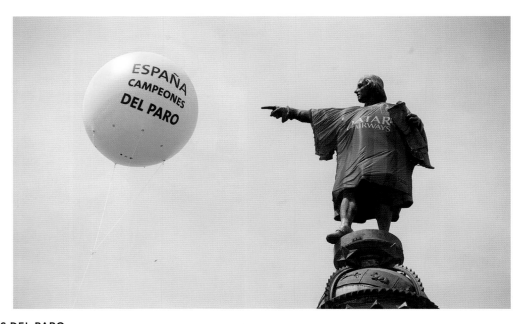

CAMPEONES DEL PARO
[UNEMPLOYMENT CHAMPIONS]
Barcelona, Spain, 2013
© Enmedio Collective

One of Enmedio's recurrent themes is urban speculation, a phenomenon that ever more flagrantly affects Barcelona's citizens, creating high levels of gentrification and discontent. This translates, among other things, into a whole new generation of tourismophobic citizens. It's getting more difficult by the day to find a decent place to live in the city, especially for young people. Clear proof of this is that the collective managed to beat the world record for people shouting in unison: 'No vas a tener casa en tu puta vida' – 'You'll never get a house in your fucking life!' They even recorded the action and sent it in to the Guinness Book of Records. Guinness rejected it, deeming it too weird, 'like there was no weird stuff in that book, truly weird stuff.' Another clear diagnosis of the appalling evil caused by real-estate violence was the runaway success of their putometro, or 'fuckometre', a means of measuring citizens' swearing levels directed at such subjects.

One of the collective's most popular projects with the public, however, was the fiestón ('big party') they threw in a job centre in Barcelona. They saw the outbreak of the 2008 crisis as the perfect moment to bring people joy. So when they came to choose a venue for the party, they decided unemployment office would make the perfect setting. So they took their sound system along and improvised a really big party. The video of the party has since received over a million hits and inspired many similar actions in several different cities.

One of their dream projects to be done is the installation of a giant E.T. finger in public space. It would mimic a typical public art project and the finger would point at the site of a new hotel to be built at the entrance to a neighbourhood already threatened with destruction by gentrification policies. The colossal, deliberately ugly sculpture disrupts the landscape and counters the theme-park æsthetic which Barcelona has been acquiring in recent years. If they eventually manage to get the project off the ground, some specially designed software will let sufferers of real-estate violence upload their experiences, which will then be displayed on a screen attached to the piece and make the finger glow.

Leo very shrewdly points out one of the key differences that distinguishes artivism from more traditional activism. According to his theory, when working with fiction and art, he doesn't see social change as a long road but as a series of fairly immediate actions: something that simply takes place but which can catalyse change years later in another part of the world. In their case Enmedio have managed to shunt the issue of housing from the personal to the social realm. Only artivism could have made this happen.

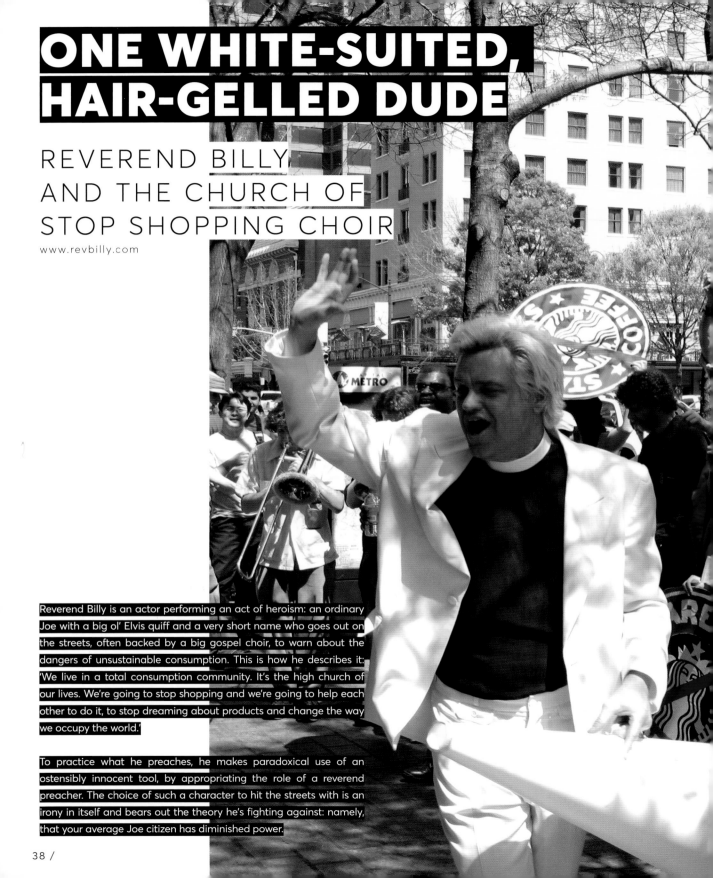

ONE WHITE-SUITED, HAIR-GELLED DUDE

REVEREND BILLY AND THE CHURCH OF STOP SHOPPING CHOIR

www.revbilly.com

Reverend Billy is an actor performing an act of heroism: an ordinary Joe with a big ol' Elvis quiff and a very short name who goes out on the streets, often backed by a big gospel choir, to warn about the dangers of unsustainable consumption. This is how he describes it: 'We live in a total consumption community. It's the high church of our lives. We're going to stop shopping and we're going to help each other to do it, to stop dreaming about products and change the way we occupy the world.'

To practice what he preaches, he makes paradoxical use of an ostensibly innocent tool, by appropriating the role of a reverend preacher. The choice of such a character to hit the streets with is an irony in itself and bears out the theory he's fighting against: namely, that your average Joe citizen has diminished power.

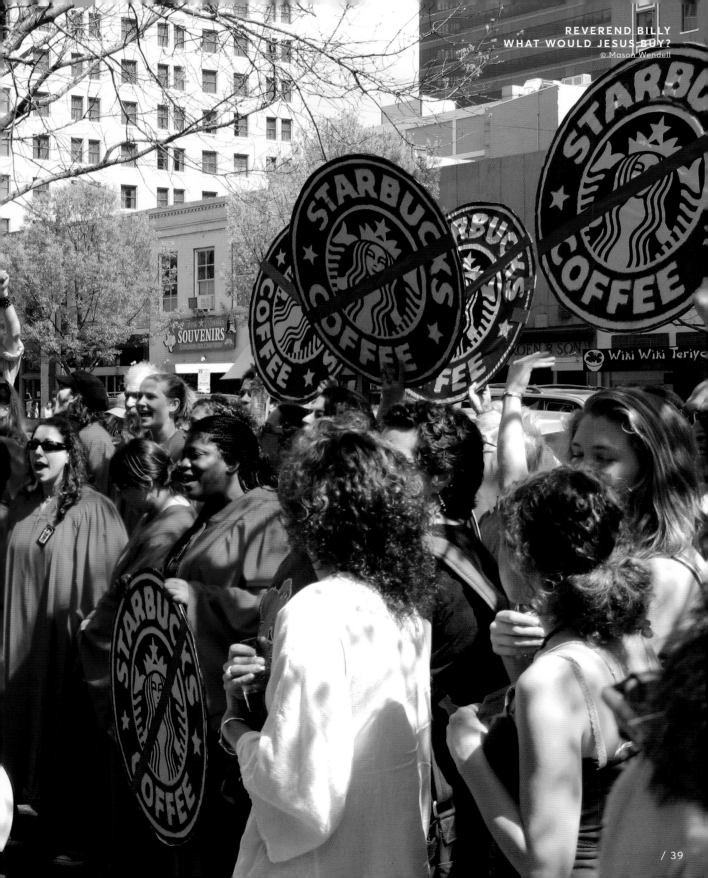

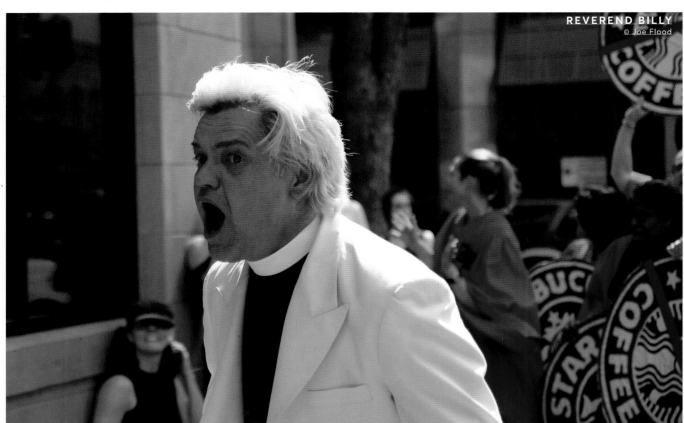

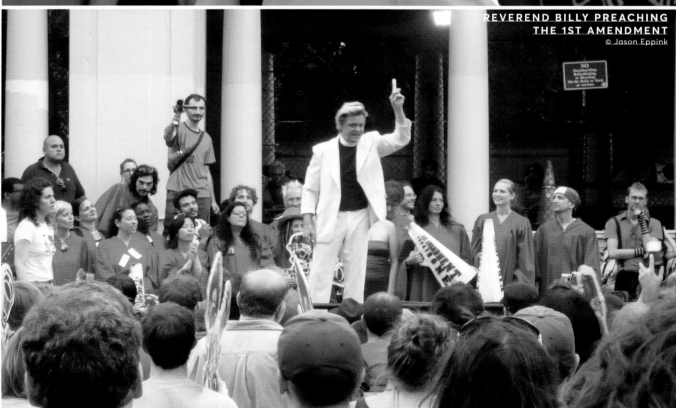

REVEREND BILLY PREACHING
THE 1ST AMENDMENT

The actor's real name is William Talen. So let's try and picture good ol' Bill out on the street, trying to bring consumerism to its knees. Let's rack our brains and imaginations and be honest with ourselves. How effective do you think plain ol' Bill Talen would be? Now let's try and visualize a guy with a golden blond, gel-slicked toupée and a face trained to say 'I can see the Apocalypse within me,' a bright white suit with shades of Presley and a big gospel choir behind him. In short, the spitting image of the apocalyptic, religious, alt-right American male that appears on late-night TV. People with big hair, glitzy clothes and large lung capacities. They shout a lot. They're kinda shouty folk. It's an incredibly smart move to recycle the figure of a preacher, turn it around and make it ironic. He's exposing the farce. Bill Talen doesn't make his own tools for action; he steals them, reuses them, reveals them, unmasks them. He appropriates the power of his character – the clothes, the gestures, the voice – and transforms them into something else. And he does it in a profoundly Christian context. William Talen says: 'You could say all Reverends are fakes, wear disguises, it's always been a ruse, but a socially accepted one; it wasn't obvious before, it wasn't transparent, you couldn't see the construction before your eyes.'

Another paradox to his story is that for many people the Reverend Billy himself, who plays the televangelist pastor to a tee, is a true pastor who shows courage and acumen. In other words, all the loaded irony of his artivist initiative doesn't reduce the seriousness of the matter at hand. He doesn't want himself to be taken as another mere act or fiction. And so he shouldn't. Because in his case fiction serves a greater will, which is to make the spectator aware of the mechanisms of domination we're all subject to.

Reverend Billy is a Great Big Nobody, just another guy with a very ordinary name that has little force or authority. A reverend with the name of Everyman. He's a bit like Odysseus blinding the Cyclops: 'Who's stabbed me?' Polyphemus asks Odysseus, and Odysseus replies, 'Nobody.' When Polyphemus explains to his fellow giants what's happened, he says he's been stabbed by Nobody. Just as the Greek hero makes himself invisible to the eye of the Cyclops, Reverend Billy makes himself invisible to the eyes of the powers-that-be. And through his actions he provokes the Cyclops to wake Poseidon and make the conflict visible.

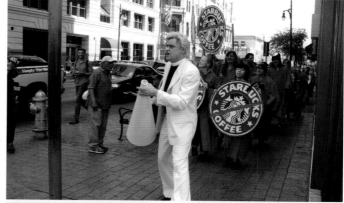

REVEREND BILLY
WHAT WOULD JESUS BUY?
© Mason Wendell

REVEREND BILLY
VALLEJO (CALIFORNIA)
© J.M. Brown, Times-Herald staff writer

REVEREND BILLY
© Brian O'neill

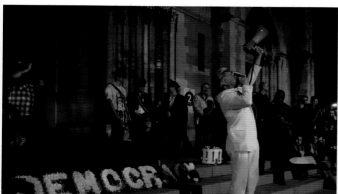

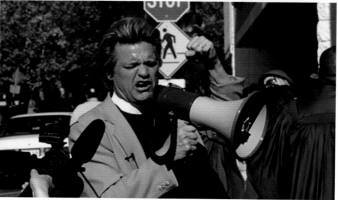

A SONOFABITCH FOR A DAY

THE YES MEN

www.theyesmen.org

The Yes Men are a duo with a long history of activism. Their main artistic tool is imposture. Most of their actions involve impersonating businessmen and distorting their messages at public or media events. By such means they expose such people's wrongdoings and get these new messages across to millions. Public ridicule of these figures is The Yes Men's most effective weapon. At no point do they use Stanislavski's method-acting techniques to portray these individuals yet, while The Yes Men remain plausible, there is always something extreme, something alien, about their 'performance'. They walk a dangerous line. They take risks. They are provocateurs, and as such they provoke change. The cleverest thing about their contribution to improving the world is that those mentioned in their press releases have to respond publically. In other words, feedback is always assured.

They once managed to gate-crash a press briefing at the White House as spokespersons for the Department of Trade. During the briefing they even announced a series of sanctions for polluters, forcing the White House to declare its position.

They also once posed as spokespersons for the multinational oil company Shell. Here's part of what they said: 'And today, I am proud to say that we make a symbolic new start, by saying to the people of the Niger Delta: "We are sorry."'

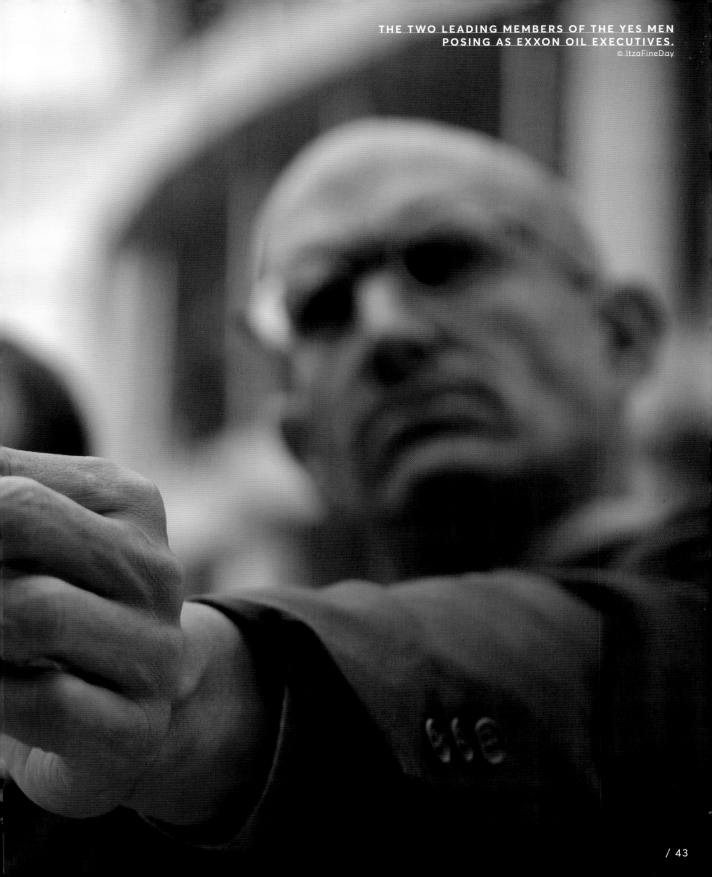

They have also impersonated representatives of the World Trade Organization. Over a three-year period they saw some of the atrocities they proposed being welcomed and proudly adopted by the sheep of the business world. Examples include outlawing the siesta, defending the slave trade as just another sector of free trade or proposing that the poor recycle pre-digested burgers to end hunger.

Another of their most notorious actions is the case of the Dow Chemical Company. Dow owns the pesticide factory that suffered a gas leak in 1984 that killed so many people (the official death-toll varies according to the investments of the interested parties) in Bhopal, India. The Yes Men started up a web-site very similar to Dow's and received an invitation to appear on the BBC news on the anniversary of the disaster. A certain Jude Finisterra (Andy Bichlbaum) turned up for the interview and announced: 'I am very, very happy to announce that, for the first time, Dow is accepting full responsibility for the Bhopal catastrophe. We have a $12 billion plan to finally, at long last, fully compensate the victims, including the 120,000 who may need medical care for their entire lives.' Within days Dow Chemicals had dropped five points on the Frankfurt Stock Exchange and were forced to admit in a public statement they had no intention of compensating anyone.

Either of two things can happen in The Yes Men's adventures: 1) the institution, person or company in question has to acknowledge the artists' statement of the imposture if they are to avoid refuting it, already a bonus point for the duo; 2) the institution, person or company in question has to publically deny the artists' imposture and argue that they weren't the ones making the statement. Further proof of the damage caused by the institution, person or company and the shamelessness of their position. Another bonus point for The Yes Men.

How do they do it? That's one of the big questions surrounding The Yes Men. How do they avoid arrest for identity theft? How do they infiltrate the BBC or the WTO? They share all their techniques on yeslab.org so that anyone can learn how to carry out effective 'laughtivism' actions.

YES MEN MEMBER, JACQUES SERVIN (AKA "SHEPARD WOLFF" AKA "ANDY BICHLBAUM"), FIELDS A BARRAGE OF QUESTIONS FROM MEDIA AFTER THEIR "VIVOLEUM" PRESENTATION WAS BROUGHT TO AN ABRUPT END AT A KEYNOTE LUNCHEON AT THE GO-EXPO 2007 (OIL AND GAS EXPOSITION) IN CALGARY, ALBERTA.
© ItzaFineDay

YES MEN MEMBER, JACQUES SERVIN (AKA "SHEPARD WOLFF" AKA "ANDY BICHLBAUM") IS DETAINED BY STAMPEDE SECURITY OFFICIALS AFTER BEING TOLD TO LEAVE THE STAGE, BUT NOT BEFORE BEING INTERVIEWED BY VARIOUS MEDIA OUTLETS THAT WERE PRESENT.
© ItzaFineDay

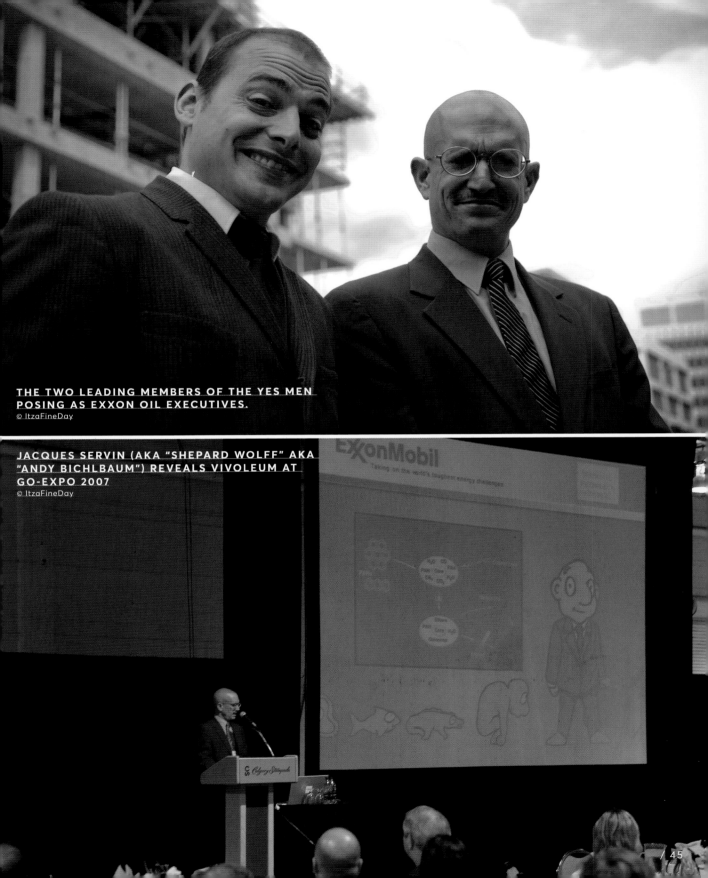

THE TWO LEADING MEMBERS OF THE YES MEN POSING AS EXXON OIL EXECUTIVES.
© ItzaFineDay

JACQUES SERVIN (AKA "SHEPARD WOLFF" AKA "ANDY BICHLBAUM") REVEALS VIVOLEUM AT GO-EXPO 2007
© ItzaFineDay

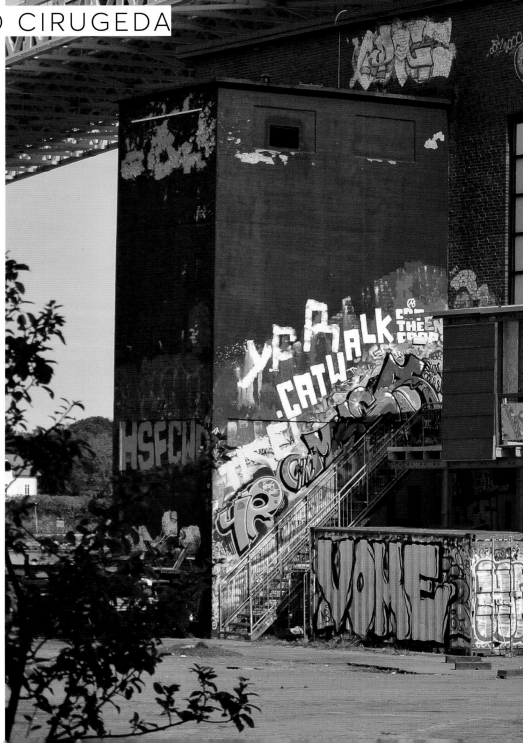

UNWEAVING THE URBAN SPIDERWEB

SANTIAGO CIRUGEDA
www.recetasurbanas.net

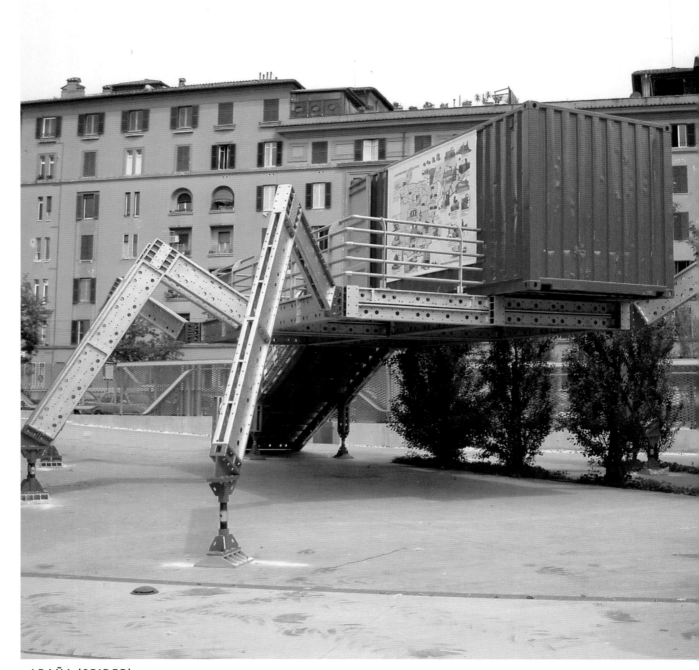

ARAÑA (SPIDER)
MAXXI
Roma, Italy, 2010
© Recetas Urbanas

Santiago Cirugeda and his Urban Recipes have been disturbing the peace of city councils and mayors all over Europe, by utilising a thorough knowledge of the laws of civic construction, accompanied by a guerrilla spirit of protest targeted at administrative bad practice and injustice in the public space. This has brought him worldwide recognition as one of the most notorious architects and activists in contemporary social and participatory architecture. His Urban Recipes studio suggests ways that artivism can also develop out of formal creative disciplines like architecture and urban planning. At a very early age Cirugeda felt deeply aggrieved at how the big issues in his home city Seville were being tackled, so he decided that architecture might be a useful field to fight the good fight, in a struggle he is still waging with unflagging intensity.

In his first year reading Architecture, he tested what would happen if someone anonymous paints a municipal wall. So, first off, with strategically premeditated intent, he graffitied an extremely ugly tag on a wall, then approached the building's administrators to apologize and offered to repair the damage. In this way he received permission to install a scaffold, which – perfectly legally – he made his home for months to come. This is just one in a long string of provocations that make this architect much feared by local governments. On one occasion they even broke into his studio to steal his hard drives.

By his own calculations he's achieved a tangible balance over the course of his career between alegal, illegal and legal projects. Alegality is one of his specialties, as the scaffolding project proves, in which he found a space with a legal loophole that gave him room to manœuvre without being punished or arrested. But where he really puts his integrity on the line is with his 100% illegal projects.

The Fuerteventura project was an outspoken eulogy to illegality and to the autonomous, activist redressing of urban administrative injustice. Fuerteventura is one of the Canary Islands, known for its protected virgin beaches. At one point an illegal road was built, threatening the pristine condition of some beaches and, while the legal system itself ruled for it to be destroyed, the demolition was never carried out. In the meantime visitors had access to these beaches, starting a process of degradation and deviriginization. Faced with this situation, Cirugeda designed a strategy to destroy the road under his own steam. After passing himself off as a municipal architect, he rented a bulldozer, stole the local council's barriers and roadworks signs, and bulldozed the road out of existence to stop the flow of traffic – a veritably theatrical deployment, with all the necessary props for trickery and action.

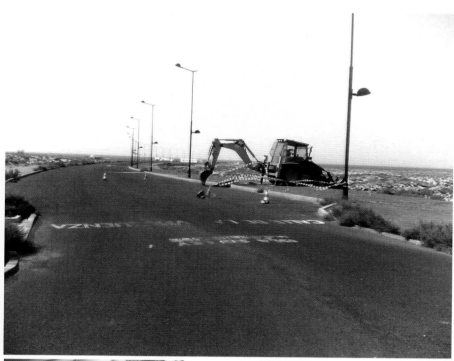

RECOVERY OF TERRITORY IN FUERTEVENTURA
Fuerteventura, Canary Islands, Spain, 2007
© Recetas urbanas

SCAFFOLDING
Sevilla, 1998
© Santiago Cirugeda

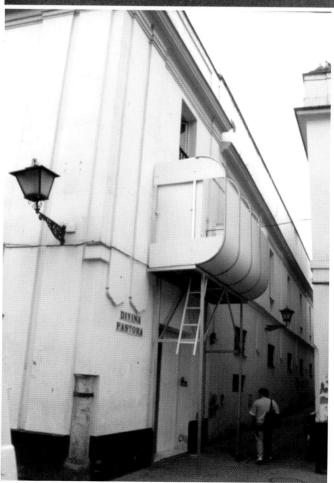

But Urban Recipe's essential groundwork is founded on the concept of citizen reappropriation, building social amenities and centres for the culture and social and educational development of territories self-managed by their own citizens. His citizen self-build projects always utilize construction waste from municipal warehouses, and children, parents and grandparents can be seen climbing all over the works, busily screwing in screws, installing ladders or mixing cement. The result always has a strong artistic, æsthetic component infused with the beauty of the repurposed materials. His visual language and spirit of recycling show a plain intent to harmonize deteriorated spaces. Cirugeda represents a true example of the best in activism, art and architecture.

A SNAILHOUSE WITH A THOUSAND USES

KRZYSZTOF WODICZKO

Homeless Vehicle Project is an update of the classic supermarket shopping trolley associated with the homeless. It was designed by Krzysztof Wodiczko after he came to New York from his native Poland. When he arrived in the city in the 1980s, he became aware of the large number of homeless people living on the streets. Drawing on his background in industrial engineering, he designed a trolley to meet the collective's daily needs: storage, showering, sleeping, sheltering from the weather, getting about. The homeless vehicle has several compartments including a basic bathroom and bedroom. It features a multitude of innovations such as suspension, large wheels for ease of manœuvring over pavements and pot-holes, a braking system for slopes and parking, an emergency exit, alarms, rear-view mirrors and emergency signals to deal with heavy traffic. The vehicle is also combined with a modular assembly system to create collective habitats with other comrades. All this engineering not only improves the quality of these people's lives but helps to make an invisible collective visible.

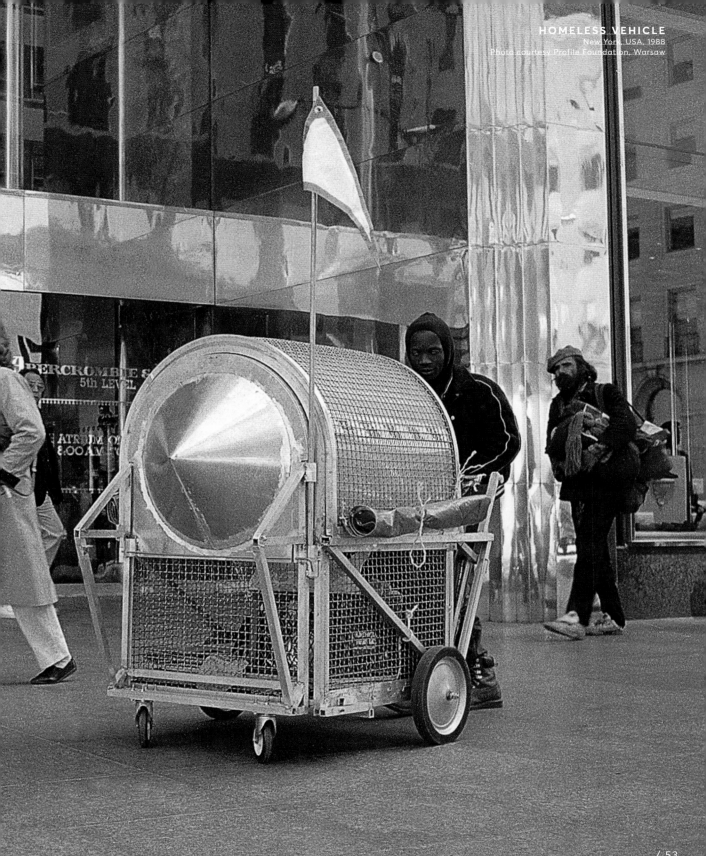

Police moving on the homeless and stripping them of their possessions – as if they weren't real people, as if they didn't have a right to architecture – is all too familiar a sight. Pushing a supermarket trolley around puts them in a category that is socially condemned. But when they move about with a designer trolley, their status is instantly enhanced. This is the real achievement and the great irony of Wodiczko's creation. The designer was perfectly aware of what he was doing. His Homeless Vehicle is no mere experiment in engineering; its social consequences put it straight into the category of Artivism.

Though the project hasn't solved the housing problem, it has helped to establish a critique of homelessness in the city, and to highlight and confront the scale of the problem. And that isn't all: many members of the public have felt the need to touch the vehicles, to explore them, and that has forged personal bonds between street-dwellers and passers-by, giving the homeless an opportunity to explain their situations and their relationships with the object. This is a wake-up call to the most desensitized. A great achievement in itself, right?

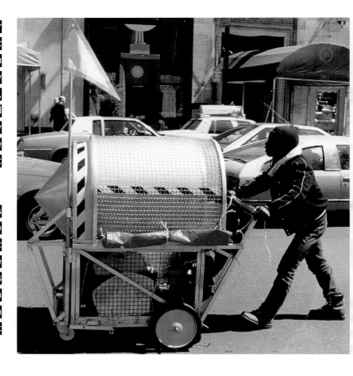

KRZYSZTOF WODICZKO
HOMELESS VEHICLE
1988, photo courtesy Profile Foundation, Warsaw

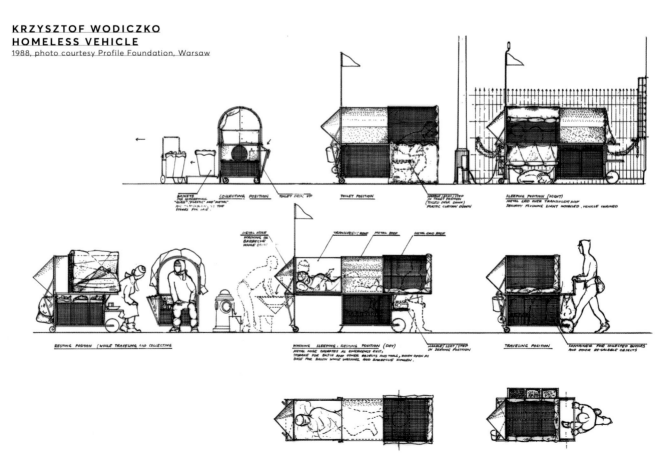

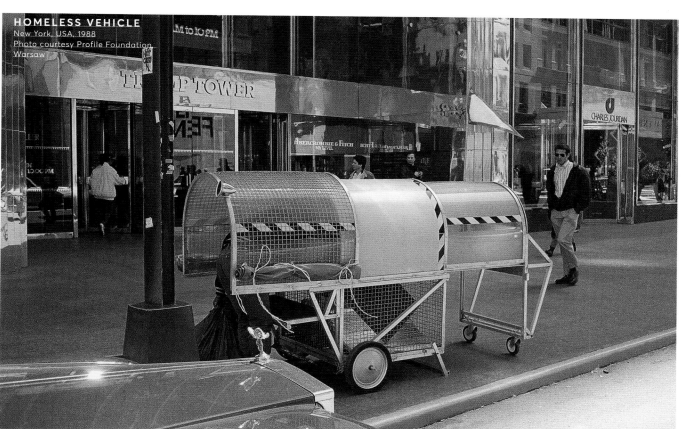

HOMELESS VEHICLE
New York, USA, 1988
Photo courtesy Profile Foundation
Warsaw

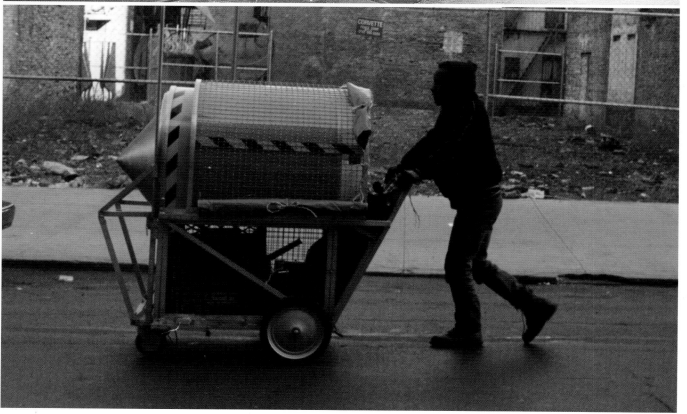

STORIES IN CEMENT

ISAAC CORDAL

www.cementeclipses.com

Isaac Cordal's idea is a very simple one: he dots miniature cement human figures around judiciously chosen locations in an attempt to expand people's compassion whenever they stumble across them. Cordal preaches what he believes: everyone should have the right to participate in decorating the public space. Cement is his material of choice precisely because its uses are one of Man's most flagrant abuses of our planet. In the early days Isaac's figures were all grey to represent the stereotype of urban man languishing in the thrall of capitalism and industry, and enslaved by the system. He later began to add colour. You might say he didn't want the sense of tragedy to overwhelm the comedy.

The passer-by's relationship with these cement figures is pure urban poetry. Encountering them is unfailingly surprising and bizarre. They're easy to relate to. Sometimes the figures disappear, taken from the street. The artist says this happens quite a bit in London, where there's a lot of interest in urban art. One man in Milan stood staring at one tiny scene for ten minutes.

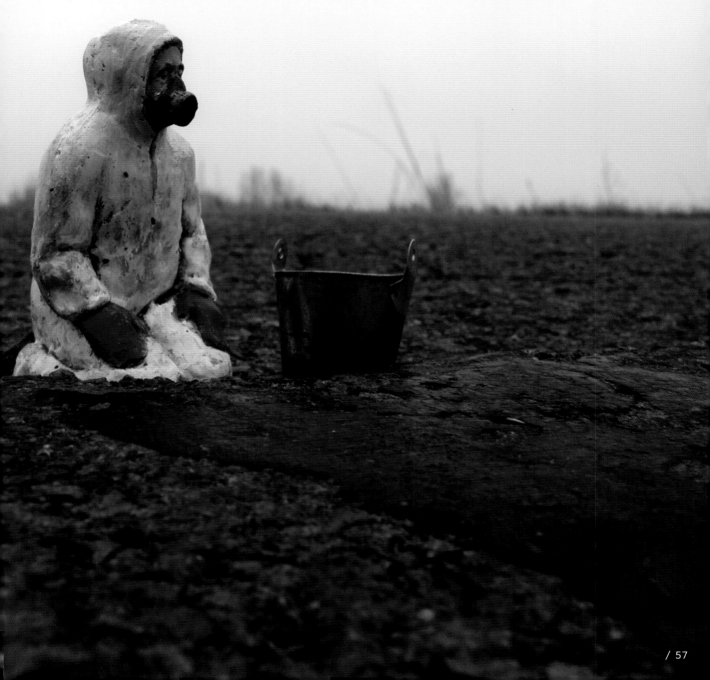

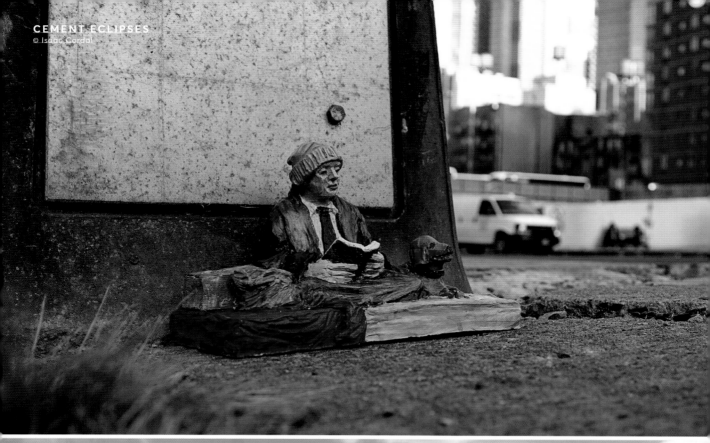

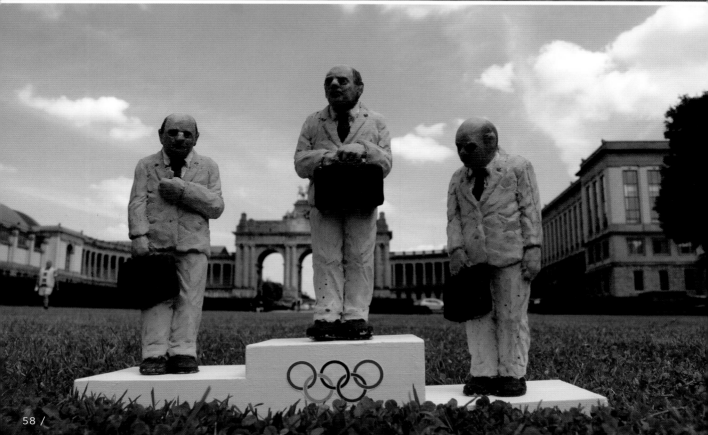

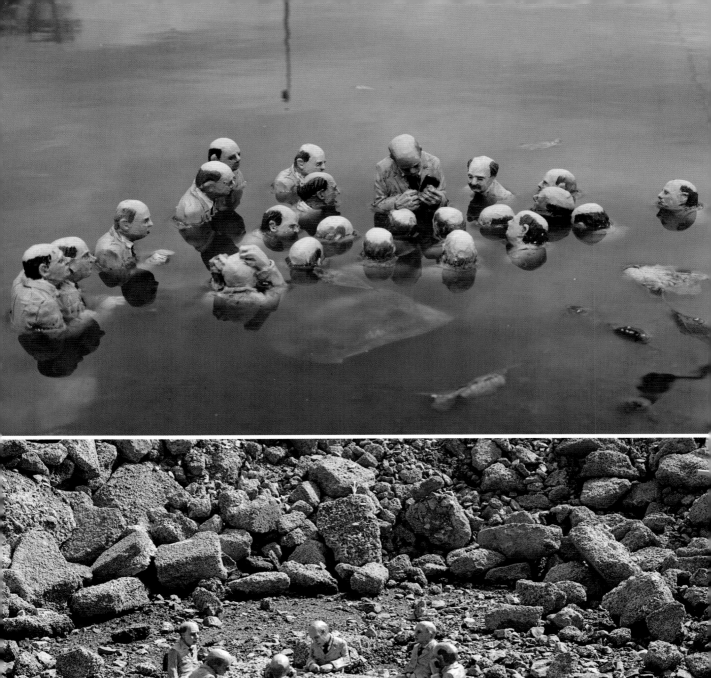

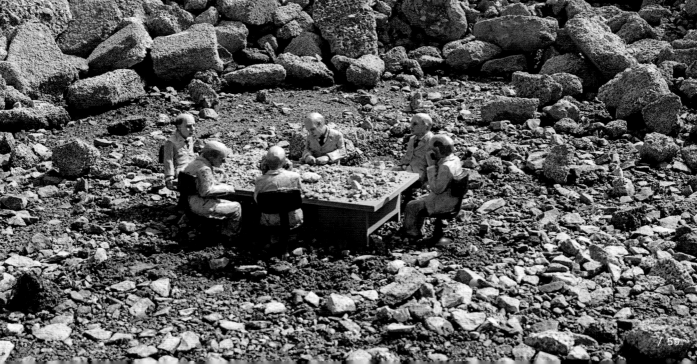

The thing that makes these scenes truly imposing is when you recognize in them the side effects of our stupidity and how they have led us to devalue our relationship with nature. This is what Cordal is telling us. These diminutive humanoids often act out surprisingly faithful representations of our behaviour as a social mass: the immobilized, the polluted, lookers-on, tourists, drifters, suicides, isolated figures on sofas engrossed in television, vagabonds, waifs and strays, people waiting for a bus, losers, winners, people camouflaged as stone, explorers of the abyss. If these figures are looking at anything, it's how everything around them is being demolished and rebuilt.

They are spectators of the world, and we become spectators of the spectators of the world. This is where the monumentality of these ridiculous tiny people resides. When you look at them, you see the pain, the hopelessness and the idleness of all expectation. You see your own passivity. We watch climate change with a bag of popcorn, shrug and say, 'Well at least we can go to the beach in winter or buy an ice-cream all year round.' As an artist Cordal is sensitive to climate change, and projects his protest and grief into the forgotten nooks and recesses of the street. 'I'm not trying to tell jokes. I'm aiming for a more critical kind of art. For me, street art is a way of combat, a way of expressing my ideas. A sort of activism.'

And, we can safely add, yet another avatar of artivism.

THE SCHOOL
Isaac Cordal

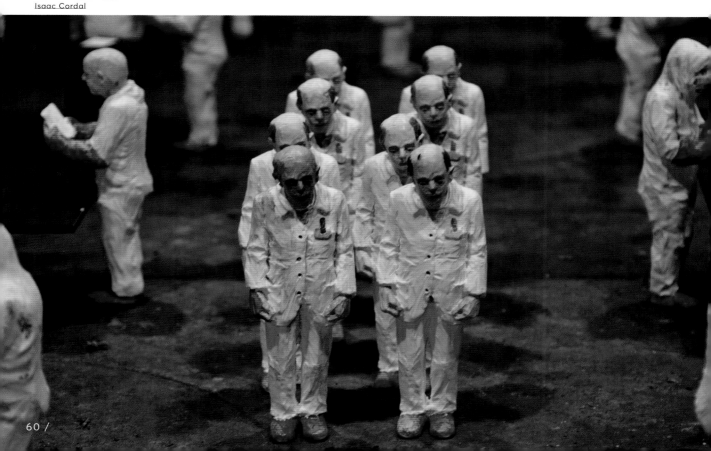

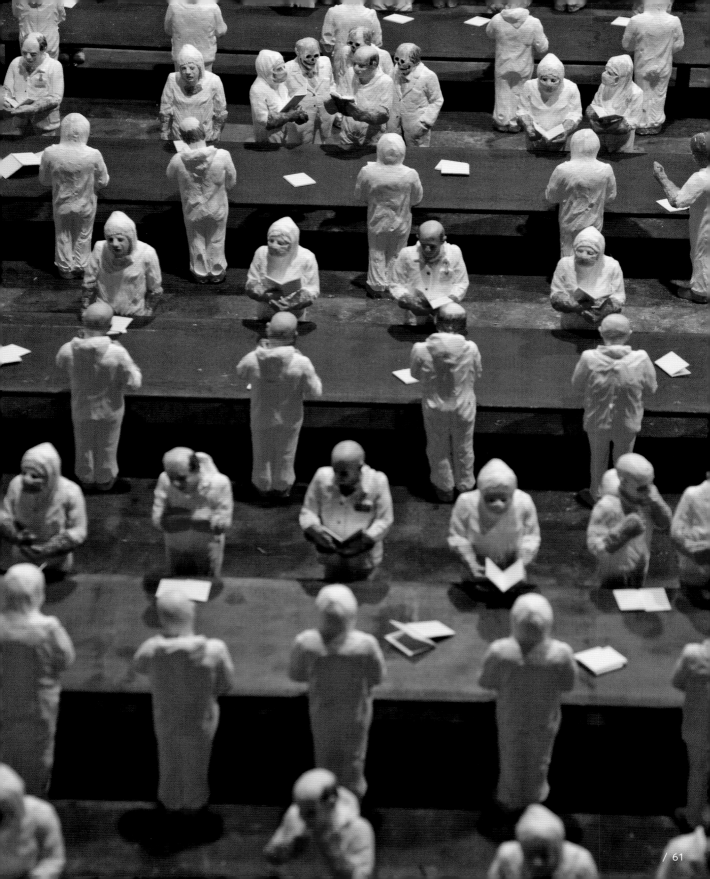

FOOLING AROUND WITH TRASH ART IS TRASH

FRANCISCO DE PÁJARO

www.franciscodepajaro.com

'Trash is my life,' declares Francisco de Pájaro, a colourful urban artist born in 1970 in a small town in the south of Spain who, after unsuccessfully knocking on London and Barcelona gallery doors, plunged into a profound crisis that left him on the streets. This was how the Art is Trash project was born. After being snubbed by galleries year in year out, he decided to laugh it off, get out onto the streets and get everything bothering him off his chest. Or as he himself puts it, 'vomit incendiary messages'. It was a practice that broke the laws of the establishment – the political and cultural/artistic establishment that decides what's art and what isn't – which had pushed him to the brink. This is why his visual language is identified as ugly – very ugly indeed. Breaking with clichés of beauty in the art system on the one hand and, on the other, shaking up the public who come across his pieces on the street are just two reasons why his work strives to be deliberately unpleasant.

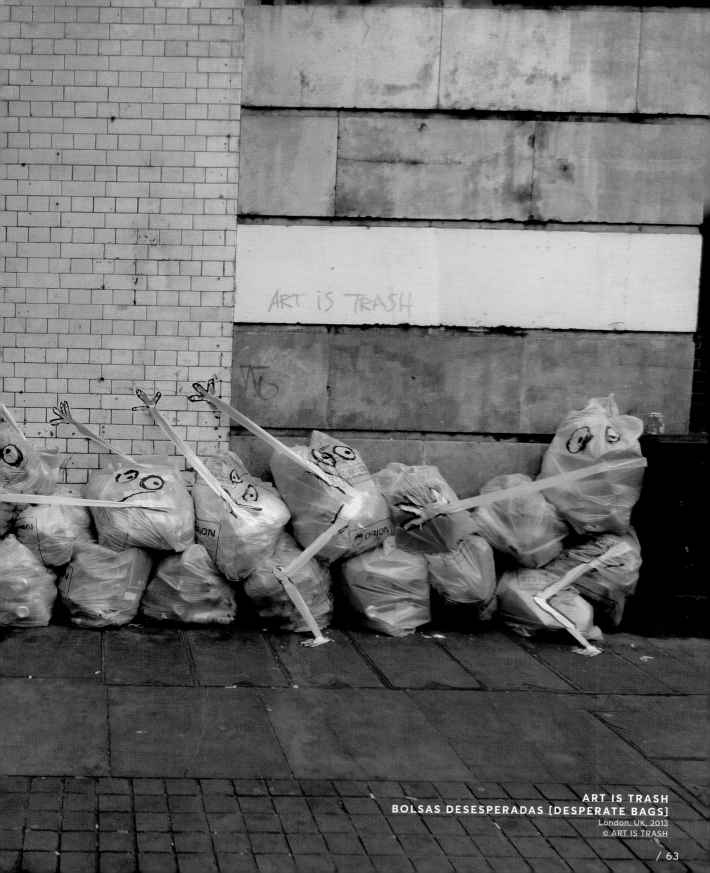

ART IS TRASH
BOLSAS DESESPERADAS [DESPERATE BAGS]
London, UK, 2013
© ART IS TRASH

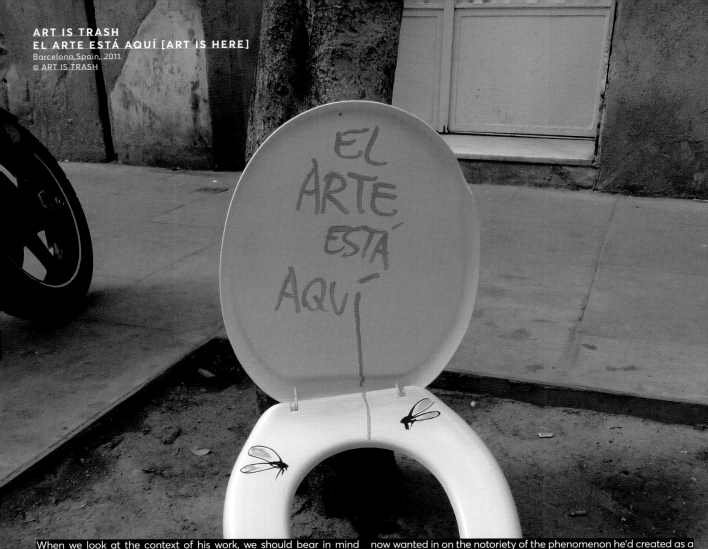

When we look at the context of his work, we should bear in mind that street art in Barcelona had been the object of the most vicious onslaught: the civic laws passed in 2006 changed the city from one of the great capitals of international urban art to one of zero tolerance. All this prompted De Pájaro to create an anti-hero: an Indian, face painted with white plastic paint, who went out onto the street to make anti-art with explicit social or political content that portrayed scenes made with the trash he found in skips. While you might think painting a city's refuse is not a legal issue, apparently it turns out to be prohibited. This is supported by the array of sanctions he has received over the course of his urban adventures: disturbing the peace, unruliness, resisting arrest, occupying the public thoroughfare, etc. The fines he's been given for painting trash have ranged between €100 and €400, yet another graphic example of the creative health of contemporary cities.

After three years' painting in the streets, his works began to gain popularity. Where no one before had paid his talent any heed, galleries now wanted in on the notoriety of the phenomenon he'd created as a result of the frustration they themselves had provoked. Exhibitions in London, Barcelona and a host of other projects in New York suddenly made his career productive and saleable on the international art market. 'I shit for it and it sells my shit […] nearly everything I do is shit but sometimes something interesting comes out…' This is how De Pájaro defines his market mechanics, acknowledging the fact he's selling and that it's contradictory to put out anti-capitalist messages on the one hand yet be part of the system on the other.

That's why, according to the artist, Art is Trash and Francisco de Pájaro are two separate things: Art is Trash is the demon within and Francisco de Pájaro someone who takes advantage of it so as not to have to work serving coffees to tourists on the Ramblas in Barcelona. Art is Trash is a kind of alter-ego born of the purest gut instincts. It recognizes that this purity dies the moment a photo's taken of the intervention. The work has to die in the street because the street is both the judge and the jury of the art.

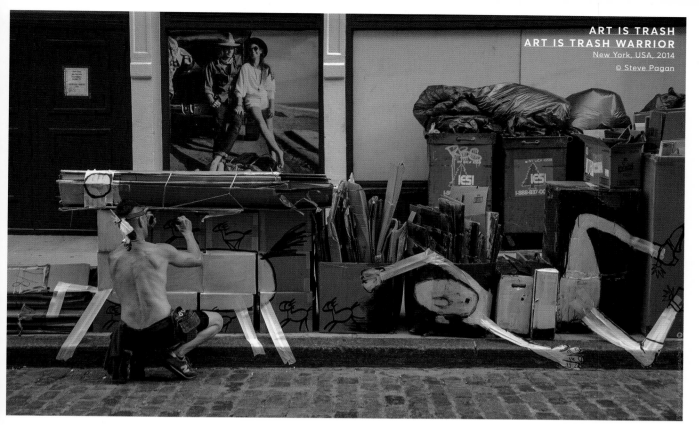

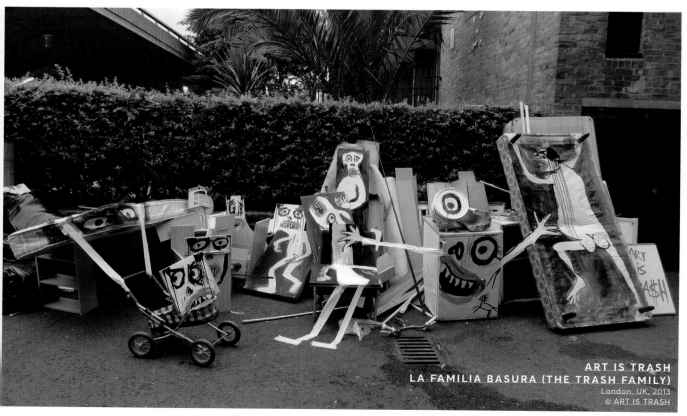

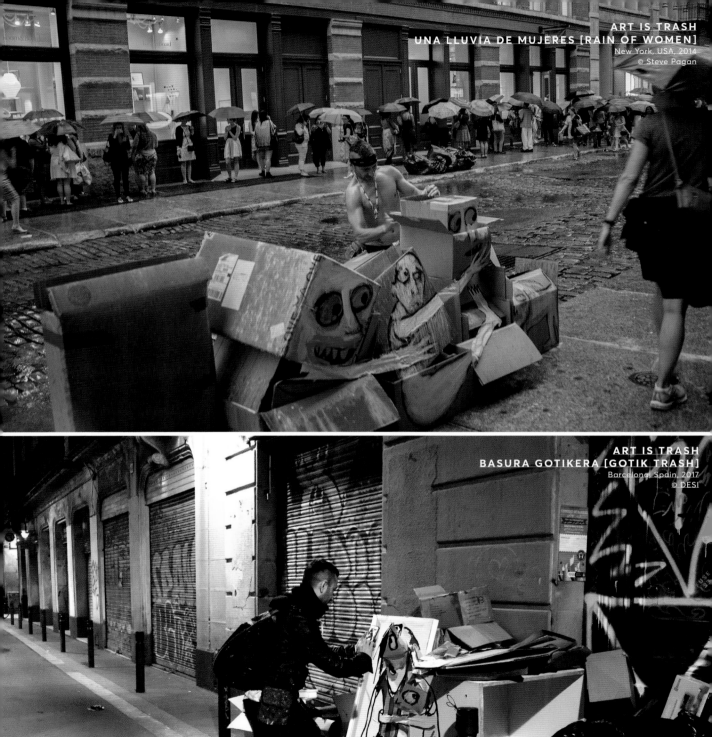

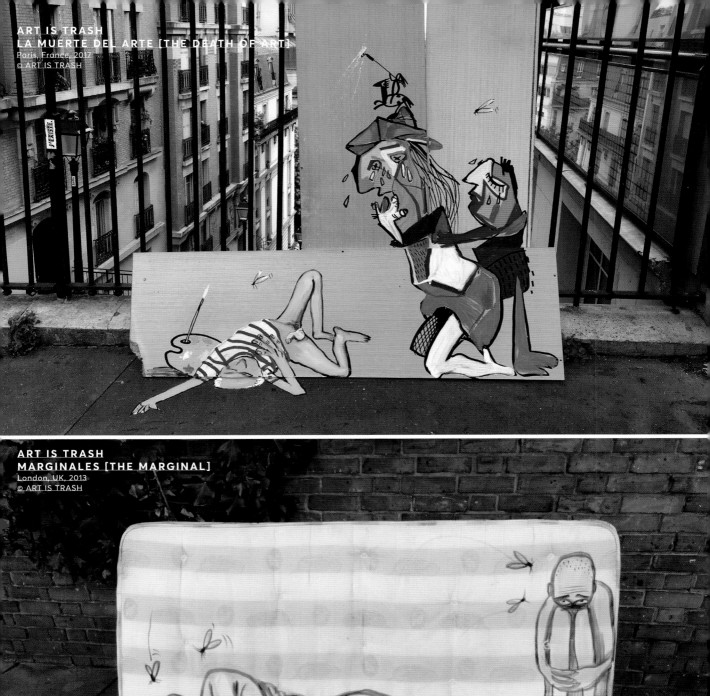

ART IS TRASH
MARGINALES [THE MARGINAL]
London, UK, 2013
© ART IS TRASH

NAVIGATING THE SHIT

BORIS HOPPEK

www.borishoppek.de

Boris Hoppek – son of Horst and Heidi – was born in 1970 into a hippy community in a small German village called Kreutzal, and grew up in the middle of the forest, building things and developing his creativity in the most organic possible way. His intellectual journey began with a book by Charles Bukowski he found on a shelf in his grandparents' house. Although this may seem a fairly irrelevant fact in Boris's life-story, it is anything but: if we take a closer look at his work in context, we can appreciate touches or influences of that irreverent, German-born auteur maudit who settled in L.A. While we may not be able to define Hoppek as a consummate or full-blown artivist, his work always aims to disrupt the quietest environments with interventions that speak to us of other realities, as real and close as they are impossible and alien to the complacent eye.

His work sails the ocean of extreme cynicism through the construction of simple iconographies that belong to the popular imagination. His most familiar, classic icon is a black face with thick red lips and two white ovals for eyes, recalling the exaggerated portrayals of African Americans in mid-twentieth-century US cartoons on TV. We'll never know if such depictions of black people involved mockery or were simply part of the codes of illustration of the day. Likewise we'll never know if Hoppek's Obama Beach Ball project, where hundreds of beach balls with his trade-mark face were released into

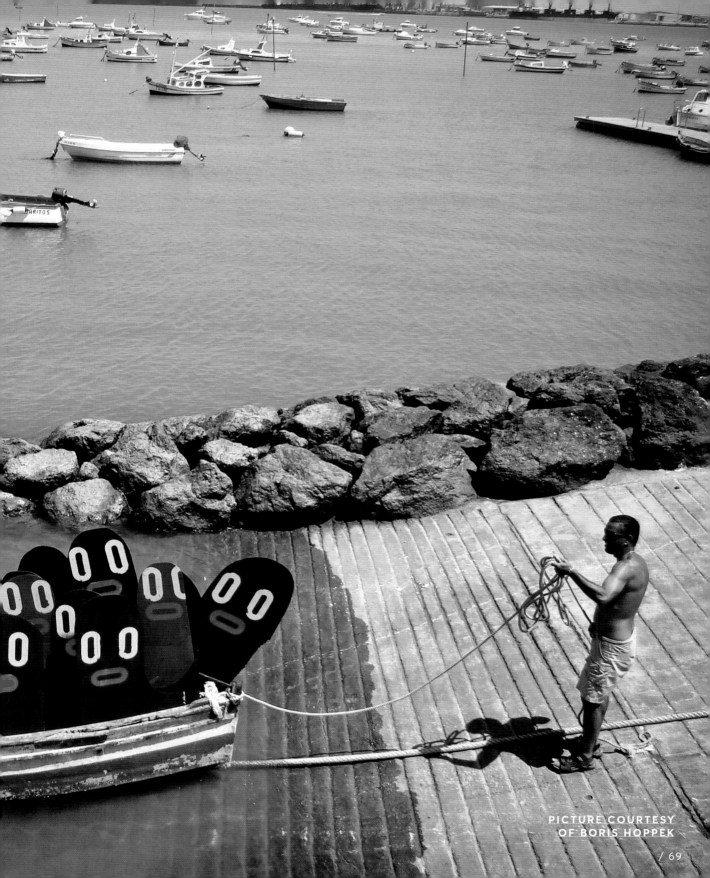

/ 69

Italian streets, is an act of ridicule or not. Whatever the case, it was highly controversial, drawing a shower of criticism from the African American community. But Hoppek's use of his icon stretches to an endless variety of scenes and installations: we see them climbing a wall with a rudimentary ladder or arriving in large numbers by boat reflecting the issue of African immigration in Europe, a humanitarian tragedy repeated day in day out on a massive scale.

Boris, for sure, has more of the artist than the activist about him, and while this sounds like stating the obvious, he's nevertheless sometimes highly effective at shaking up urban reality, which has earned him his place in this miscellany of subversive artists. A case in point was the turds he carefully laid out across one of Barcelona's most neo-liberal consumer streets, creating a comic or tragic scene, depending on the angle you view it from. What happened next was a perfect graphic illustration of the neo-liberal system and its codes of behaviour: the kind of ladies capable of spending over €500 in a single afternoon's shopping spree had to pick their way through a minefield of turds just outside their hallowed halls of consumption. It was virtually impossible to get across without getting their expensive high-heels dirty.

PICTURES COURTESY
OF BORIS HOPPEK

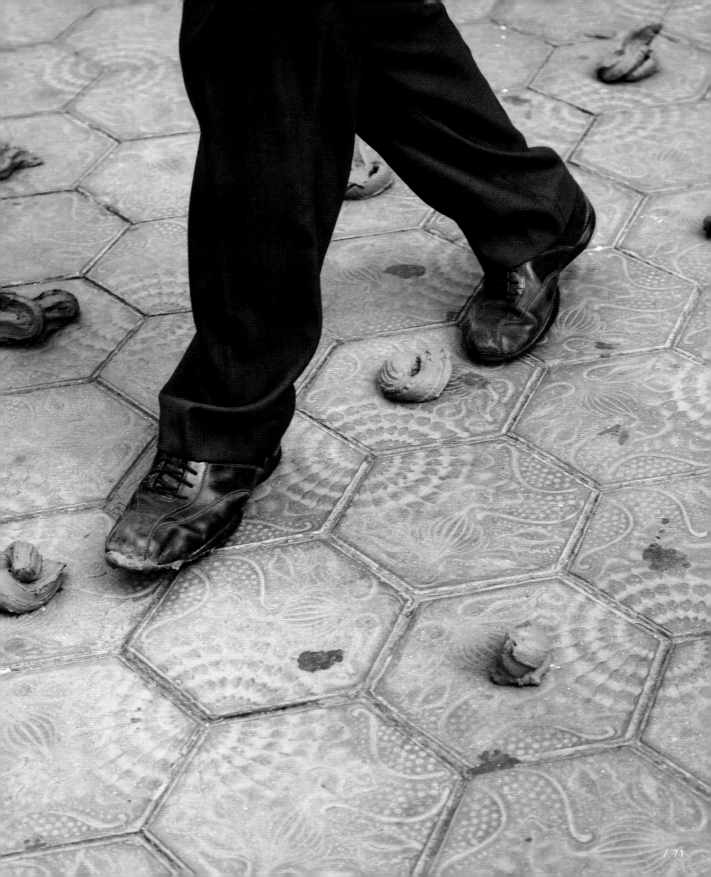

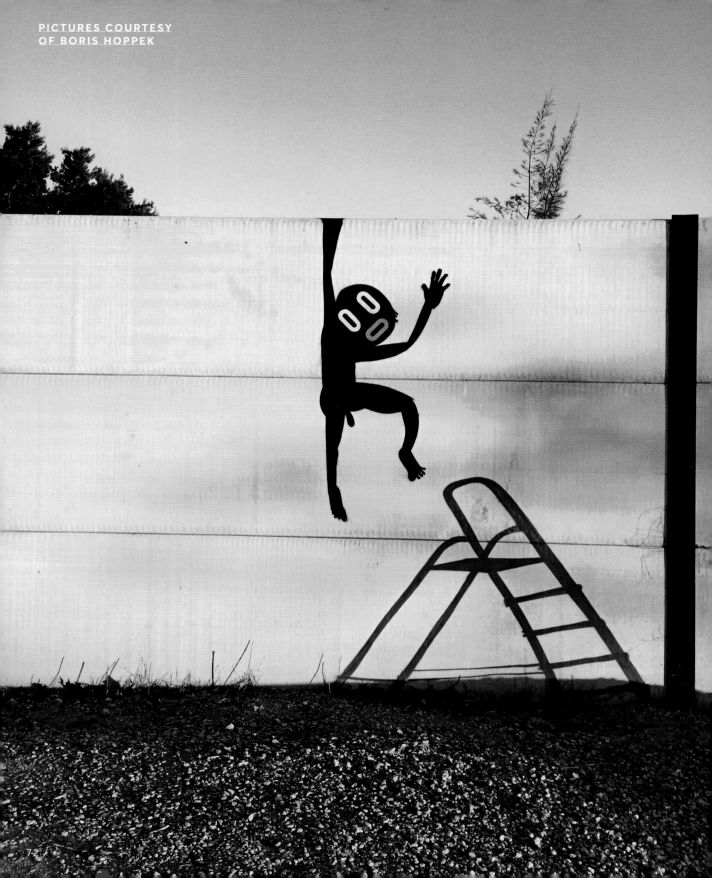

72

THE SELECTIVE CLEAN-UP

ALEXANDRE ORION

www.alexandreorion.com

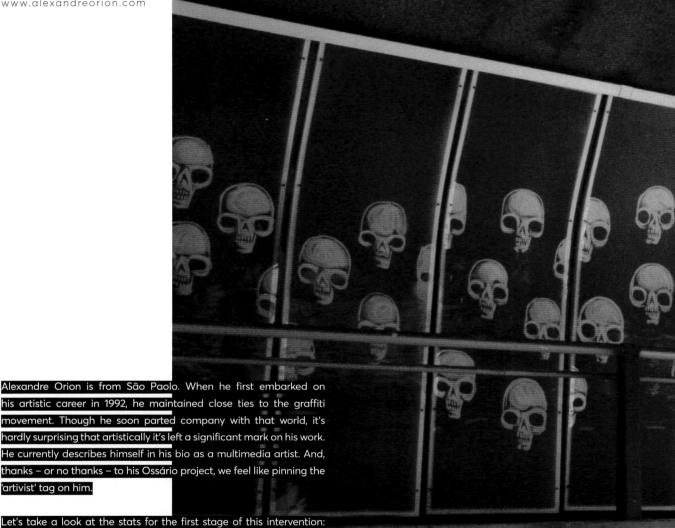

Alexandre Orion is from São Paolo. When he first embarked on his artistic career in 1992, he maintained close ties to the graffiti movement. Though he soon parted company with that world, it's hardly surprising that artistically it's left a significant mark on his work. He currently describes himself in his bio as a multimedia artist. And, thanks – or no thanks – to his Ossário project, we feel like pinning the 'artivist' tag on him.

Let's take a look at the stats for the first stage of this intervention: 13 nights; at least 5 attempted arrests a night; 360 metres of tunnel; 3,500 skulls. Sometimes reading a list of the bare facts can be exciting when it captures the sheer scale of a thing.

Now we can move on to the story behind the facts. When São Paolo's Max Feffer Tunnel was opened, its walls were a bright yellow. But this gleaming mellow yellow was coated in a thick layer of black soot after just three months. If for the tunnel we read our lungs, and it helps to pluck up the courage for an environmental battle, Orion is already committed to the cause.

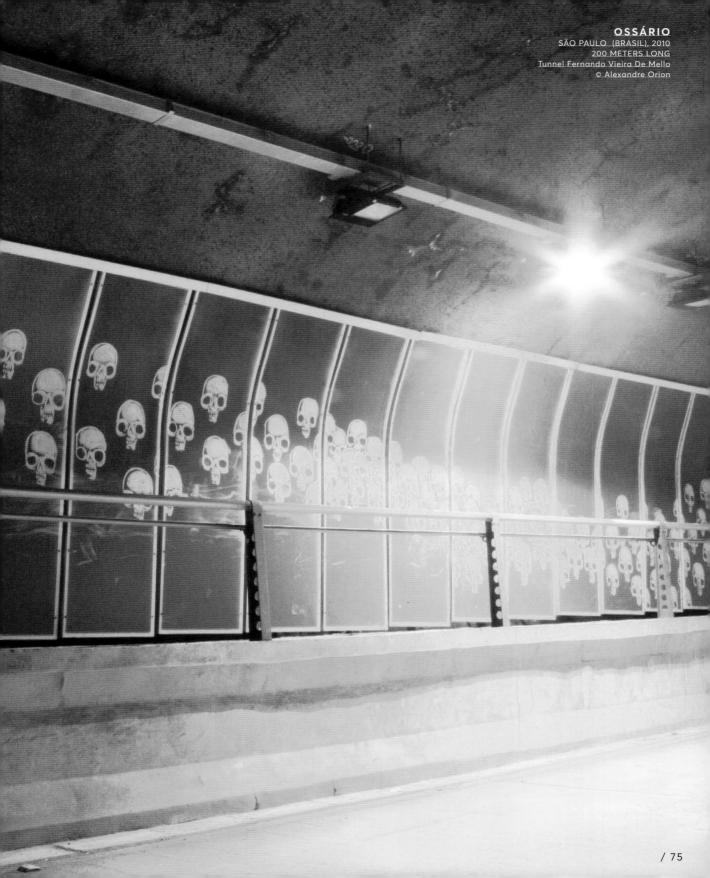

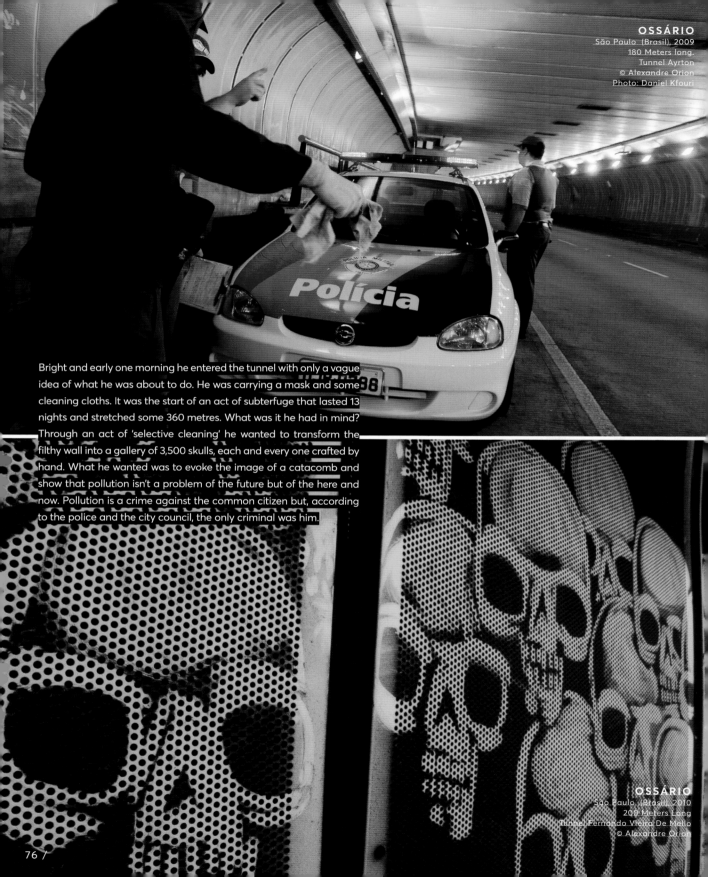

Bright and early one morning he entered the tunnel with only a vague idea of what he was about to do. He was carrying a mask and some cleaning cloths. It was the start of an act of subterfuge that lasted 13 nights and stretched some 360 metres. What was it he had in mind? Through an act of 'selective cleaning' he wanted to transform the filthy wall into a gallery of 3,500 skulls, each and every one crafted by hand. What he wanted was to evoke the image of a catacomb and show that pollution isn't a problem of the future but of the here and now. Pollution is a crime against the common citizen but, according to the police and the city council, the only criminal was him.

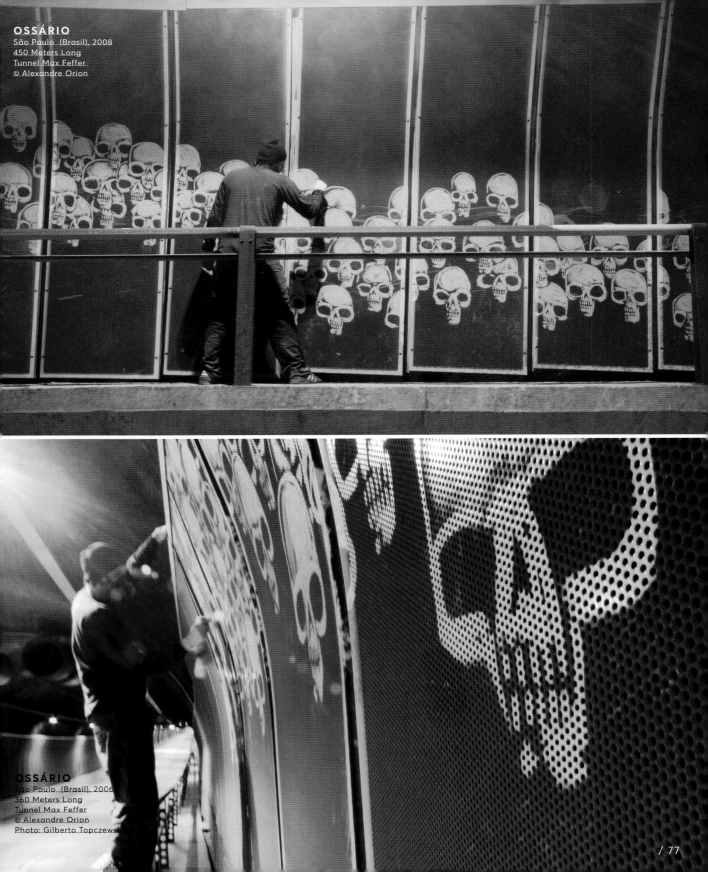

OSSÁRIO
São Paulo (Brasil), 2008
450 Meters Long
Tunnel Max Feffer
© Alexandre Orion

OSSÁRIO
São Paulo (Brasil), 2006
360 Meters Long
Tunnel Max Feffer
© Alexandre Orion
Photo: Gilberto Topczewsk

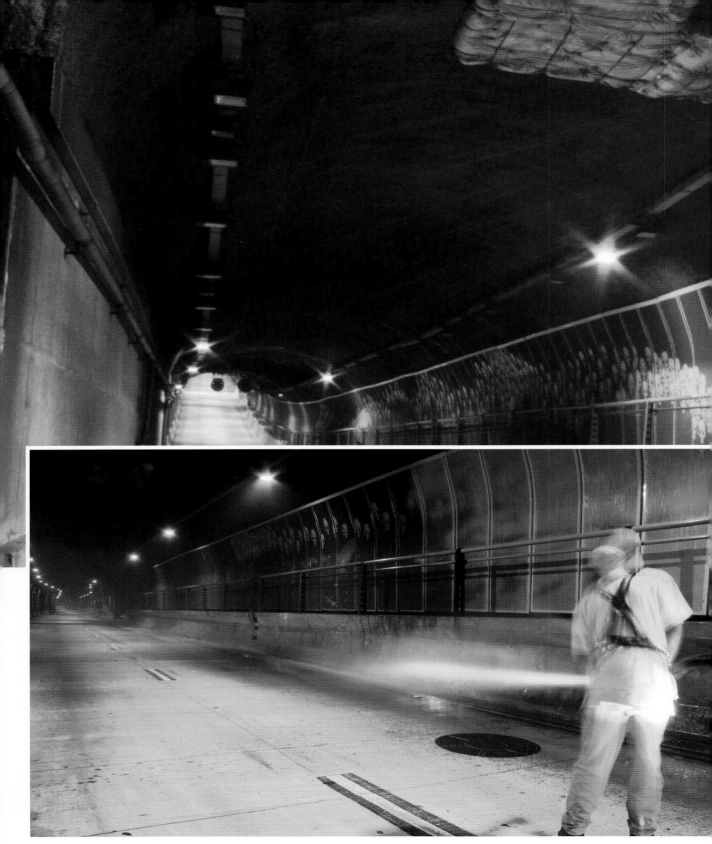

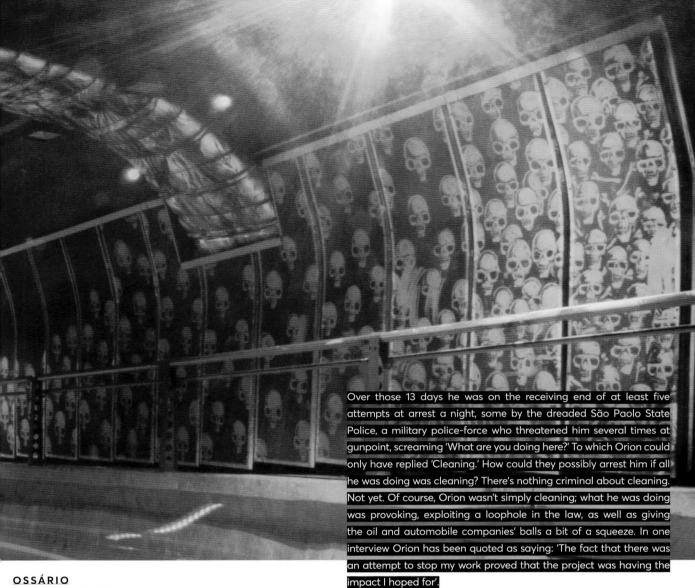

OSSÁRIO
São Paulo (Brasil), 2006
360 Meters Long
Tunnel Max Feffer
© Alexandre Orion

Over those 13 days he was on the receiving end of at least five attempts at arrest a night, some by the dreaded São Paolo State Police, a military police-force who threatened him several times at gunpoint, screaming 'What are you doing here?' To which Orion could only have replied 'Cleaning.' How could they possibly arrest him if all he was doing was cleaning? There's nothing criminal about cleaning. Not yet. Of course, Orion wasn't simply cleaning; what he was doing was provoking, exploiting a loophole in the law, as well as giving the oil and automobile companies' balls a bit of a squeeze. In one interview Orion has been quoted as saying: 'The fact that there was an attempt to stop my work proved that the project was having the impact I hoped for'.

Of course, if he'd been painting flowers nobody would have held a gun to his head. Or who knows? The public space is becoming less and less public by the day. But we'll leave that to other artivists.

The story has a surreal ending: as a result of Orion's actions the city council itself ended up cleaning the walls of the whole tunnel and those of several others in São Paolo. Talk about a serious case of obsessive-compulsive cleaning disorder.

Orion has relentlessly pursued his selective cleaning of the city's tunnels. After the Max Feffer there came others, the Ayrton Senna Tunnel, the Fernando Vieira de Mello and its highly likely that there will be countless others to follow.

A POWERFUL RESPONSE TO AN OILY LANDSCAPE
SPLASH & BURN

ERNEST ZACHAREVIC

www.ernestzacharevic.com

Splash and Burn is a project that's been honing itself in Ernest Zacharevic's head over the last couple of years: it consists of a committed creative platform that connects artists with organizations and NGOs to mount joint actions against climate change. Its primary mission is to bring about a change in awareness about this global problem. Zacharevic spent two years studying the conflict fuelled by palm oil plantations in Sumatra, Indonesia, talking to specialists and scouting locations for creative interventions.

In certain cities and towns on the island these plantations are responsible for an environmental calamity of epic proportions, involving deforestation, animal extinctions and soaring pollution levels (a state of emergency has been declared around breathing problems in six of the territory's provinces). Indonesia is the world's largest producer of palm oil. With all the irreversible problems it causes the best way to effect positive change is to reach out to people and foster a critical awareness of this drama so that change takes place from within society.

Zacharevic and project coordinator Charlotte Pyatt recruited seven leading urban artists: Gabriel Pitcher, StrØk (aka Anders Gjennestad), Isaac Cordal, Pixel Pancho, Bibichun, Axel Void and Mark Jenkins. Then the commando unit prepared to take a plane and carry out interventions at various different sites. At the beginning no press briefings, no communication. Just get in and act. Overnight these locations in Sumatra had murals, sculptures and urban interventions that opened people's eyes to the problem and laid the foundations for a growing future awareness. Then, after the event, they organized a press conference to warn the local community about what was going on and make sure they were aware of the NGOs. As Pyatt says: "One of the objectives was to help NGOs to facilitate relationships with local organizations and people of the community, and Art was a great way to bridge the gap."

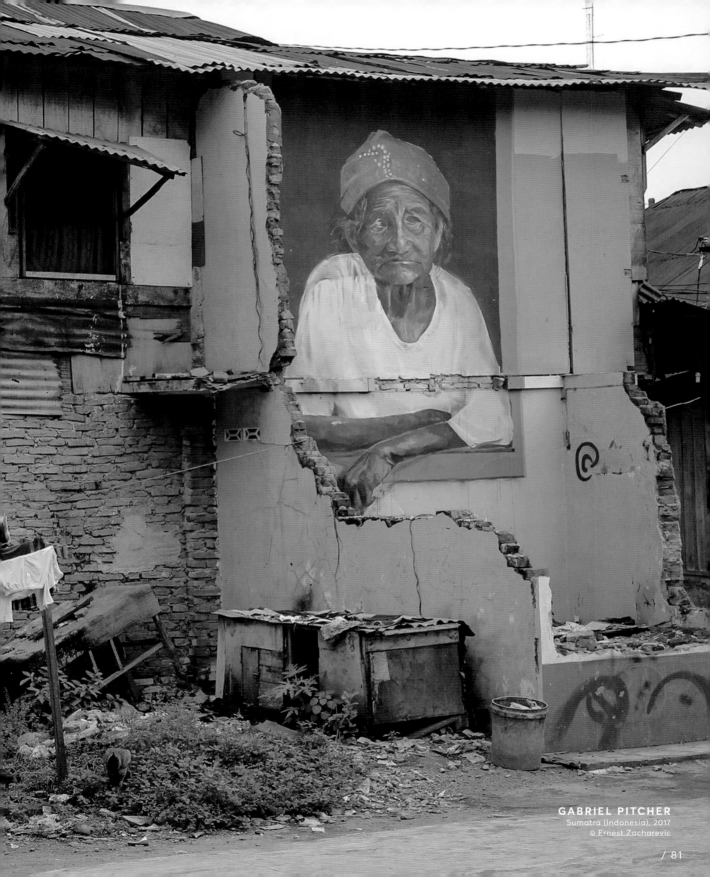

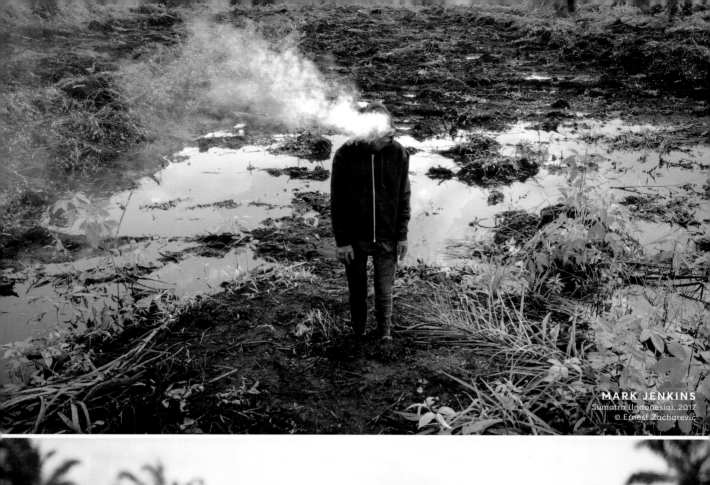

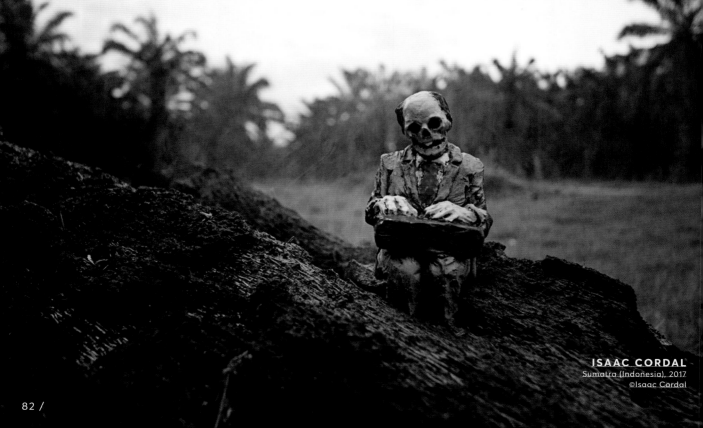

ERNEST ZACHAREVIC
Sumatra (Indonesia), 2017
© Ernest Zacharevic

ERNEST ZACHAREVIC
Sumatra (Indonesia), 2017
© Ernest Zacharevic

ERNEST ZACHAREVIC
Sumatra (Indonesia), 2017
©Hype Media

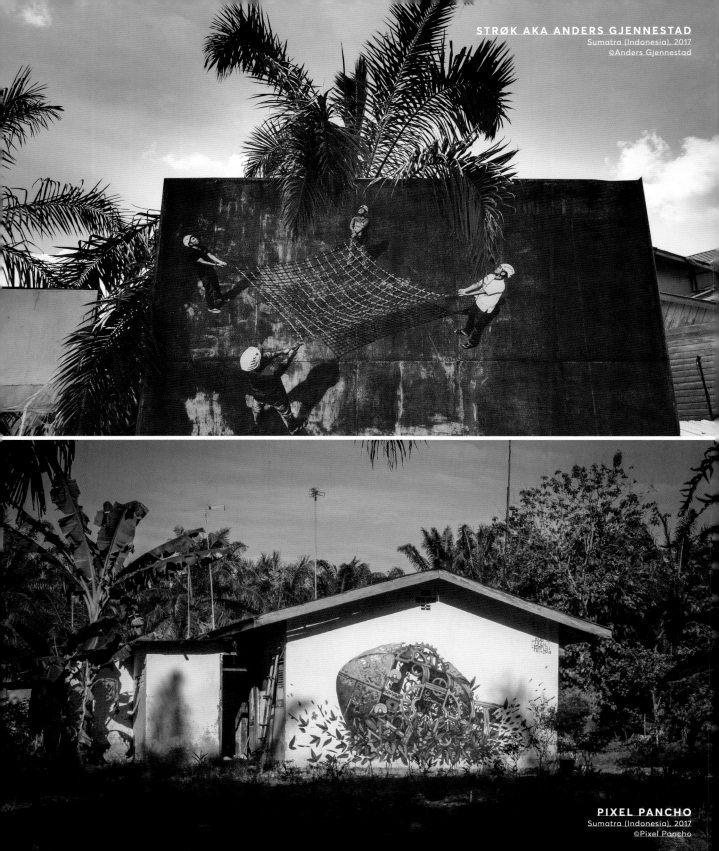

PIXEL PANCHO
Sumatra (Indonesia), 2017
©Pixel Pancho

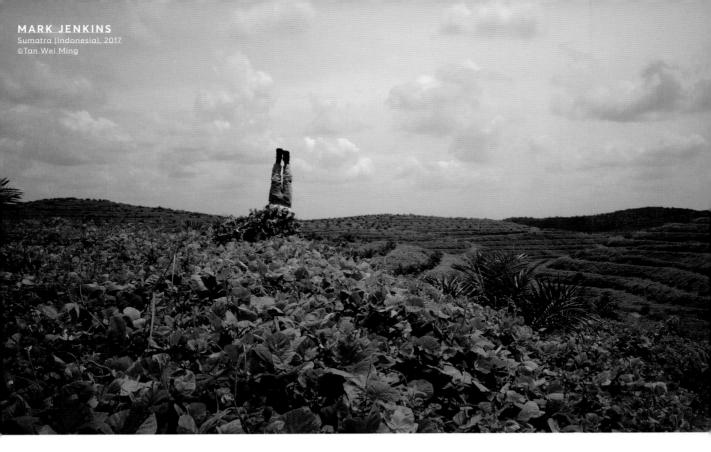

MARK JENKINS
Sumatra (Indonesia), 2017
@Tan Wei Ming

The journalist Kate Lamb of The Guardian joined the mission, and media like the BBC and Juxtapoz magazine were alerted to the idea from the word go. It was important to have good allies to spread the word. The regrettable yet significant thing is that the Indonesian Government is turning a deaf ear to the conflict and a blind eye to the scale of the problem. The Government hasn't targeted the smallest part of its infrastructure or effort at the project. The campaign was supported by many NGOs both regionally and internationally. They worked hand in hand with the London-based NGO SOS (Sumatran Orangutan Society) in conjunction with the Indonesian-based Orangutan Information Centre.

The main source of funding has been the money raised from a limited edition print donated to the cause by Zacharevic. This affords the project total financial independence, and the creative and artistic freedom needed to attack where it's required and carry out fresh interventions in a brave new united artists' future. Splash and Burn is a dynamic, ongoing project determined not to falter. There will be more artists, more trips, more impact. This was just the first wave in a unique series of ongoing creative projects.

Splash and Burn brings to mind a more personal, internal conflict, namely the fact that many artists are starting to lose any sense of the significance, utility, function and impact of their works. Many of them express frustration at how urban art is being exploited to gentrify cities and create elite neighbourhoods. From our point of view, Splash and Burn is a beacon of hope for how the situation can be rechannelled and how talent, commitment and creativity can be independently invested in major causes. Mark Jenkins, who takes part in the campaign, says the project is a way of reimagining street art because it shifts the focus back to its roots.

Now that's what we call Artivism.

POLITICAL SMOKE AND THE TRAGEDY OF DEMOCRACY

FILIPPO MINELLI

www.filippominelli.com

This artist from a small Italian town has spent much of his career investigating the relationships between perceptions of digital versus natural or real landscapes. Though he doesn't see himself as a typical artivist, his search is closely bound up with the impact of urbanism and architecture in constructing our identities as citizens. Indeed, the central theme of his discourse could be regarded as the identification of contemporary identity. This critical discourse is not interested in politics itself but in the ramifications of the misinterpretation of politics.

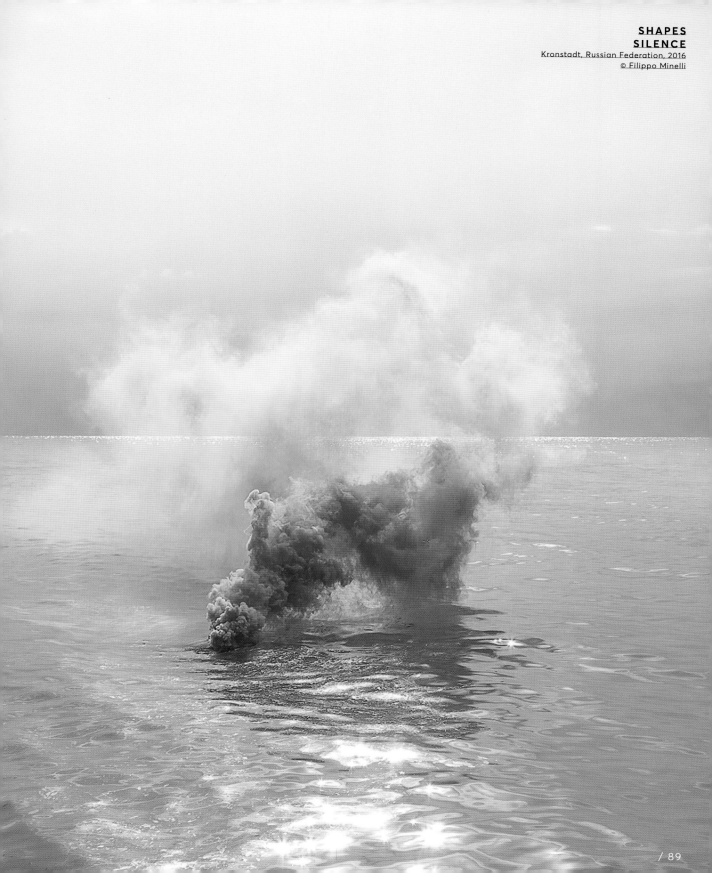

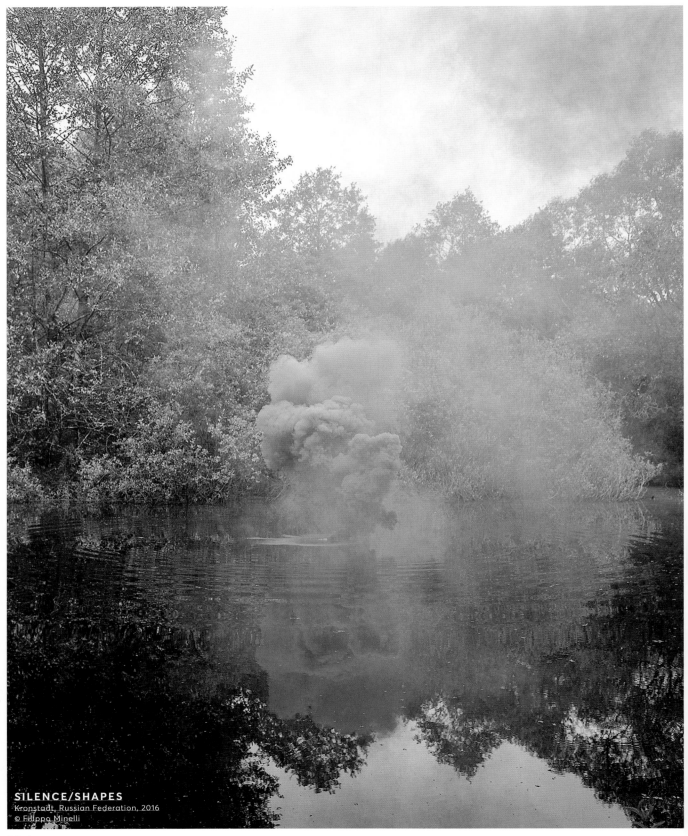

SILENCE/SHAPES
Kronstadt, Russian Federation, 2016
© Filippo Minelli

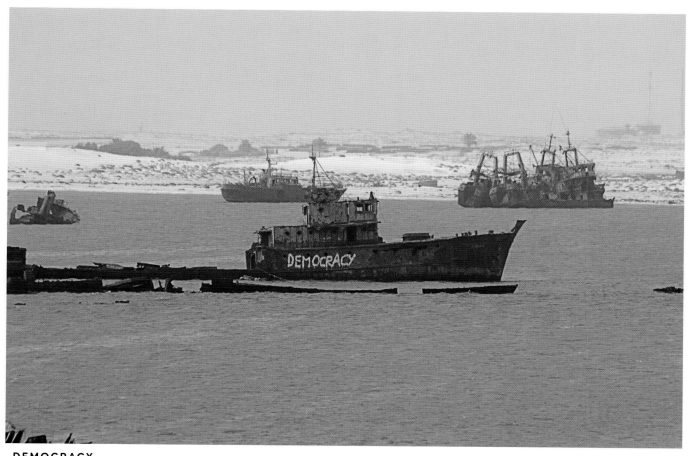

DEMOCRACY
Nouadhibou, Mauritania, 2008
© Filippo Minelli

Perhaps the most graphic example of his intentions is the project Democracy in a remote part of Mauritania: the word 'DEMOCRACY' is painted on one side of an abandoned, rusting husk of a ship listing in a bay. The work is as simple as it is shocking, a bold statement of the idea that the contemporary concept of democracy is utterly stagnant. Explaining the motivation behind his work, Filippo says that, like other twentieth- and twenty-first-century artists, he tries to explain the reality of the world with stories happening here and now, except that he uses public space – reality itself – as his object, drawing attention to the fact that the artist's most essential role has changed little over the years. This leads us to think about the currency of the concept 'artists of their time' – artists committed to their realities and the spectator's sensibilities – and about how this can include the idea that artists of their time always have an essential artivist component in that their work reflects the contemporary world around them.

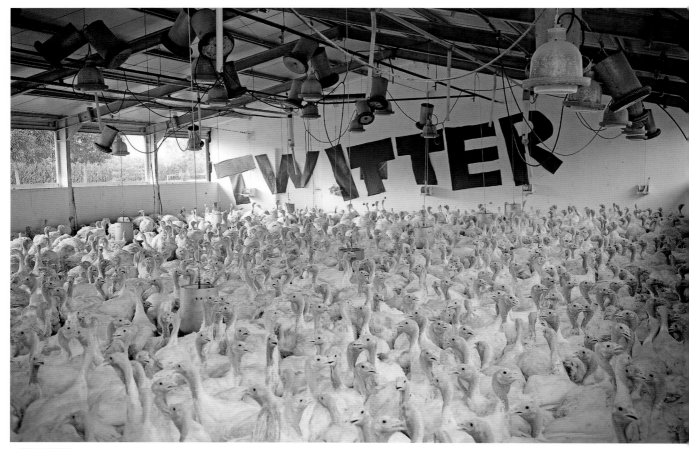

TWITTER
Brescia, Italy, 2010
© Filippo Minelli

In a similar vein is his project Contradictions where, with a visual interplay of reality and fiction, he sets out the problem of building identity through natural and digital living landscapes. 'Technology is part of our lives in our generation, and we aren't looking at the natural landscape around us; 50% of our landscape is digital.' The Contradictions project is about this contradiction, about the perception of what is and isn't real and how we experience the digital landscape as a reality, concrete or otherwise.

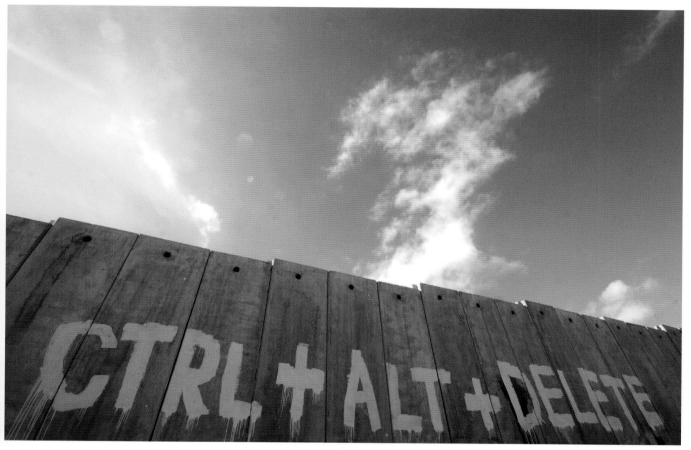

CTRL+ALT+DELETE
Qalandiya Checkpoint, Palestine, 2007
© Filippo Minelli

In recent years he's been incorporating new elements in his discourse, transporting us to more ethereal, less explicit images that carry an essential conceptual charge: notably the coloured smoke-bombs he sets off in natural beauty spots. As he himself explains, it's a political comment. In his eyes these are his most political works because they're about silence. The smoke stands for politics, for how something dangerous, powerful and violent can create something beautiful, the way politics should be.

VANDALISM ÆSTHETICALLY REWORKED

VOINA

There's a whole host of urban legends about the Voina art collective and but a few false memories doing the rounds of the social networks. Still, there are plenty of anecdotes surrounding Voina about police attacks and arrests, and they've received more than a dozen criminal charges against them in total. One of the standout anecdotes about the group centres on the world's most famous artivist, Banksy, spending part of the money he's earned from urban art to stand them bail.

The name 'Voina' is Russian for 'War', a precise description of their relationship with the Russian Government. Two of Voina's leaders, Oleg Vorotnikov and the late Leonid Nikolayev, were arrested for tipping over police-cars under the pretext of searching for their child's ball.

What's certainly true is that many of the artists in the Voina group – Alexey Plutser-Sarno, Oleg Vorotnikov, Leonid Nikolayev and Natalia Sokol – are admired for the depth of their bravery. They don't hide their faces and act without fear of the reprisals the state might throw at them. They keep to a few working principles, like daring, honesty and monumentality. Sokol is on record as saying: 'We have a rule: every next action should be stronger, more impressive, and monumental than the previous one.' Faced with a corrupt government violating human rights, is there any other alternative?

Their first performance policy was Fuck for the heir Puppy Bear! (2008) – a reference to interim president, Dmitry Medvedev, whose last name derives from medved (bear). The night before Medvedev's election as president the group went to the Timiryazev State Museum of Biology and held an orgy, with five couples having sex in public. Another of their most famous actions is Dick Captured by KGB! (2010), which consisted of them painting an image of a penis on the Liteyny Bridge (St Petersburg) in only 23 seconds, just

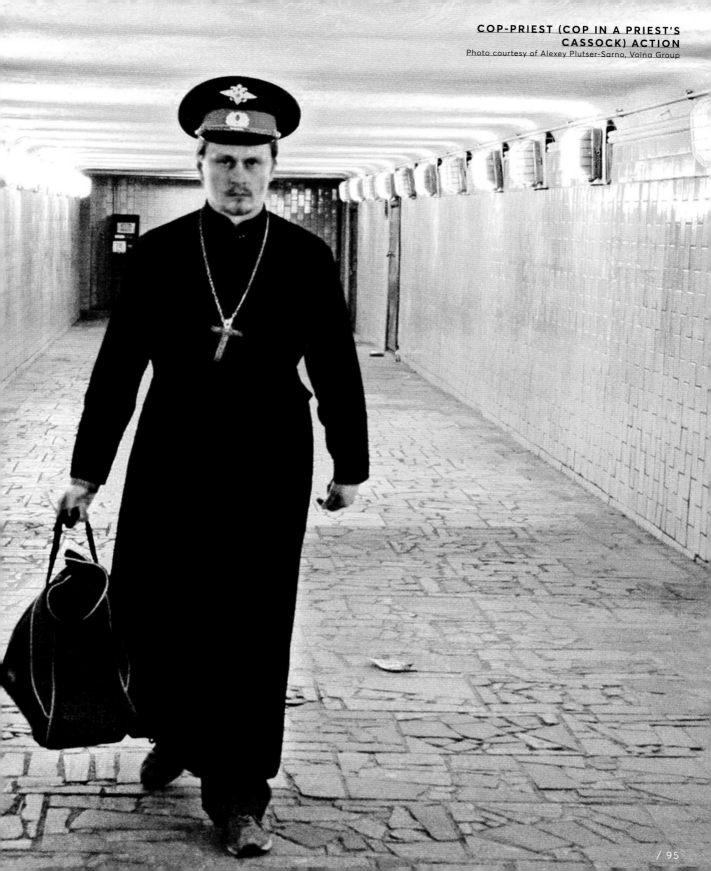

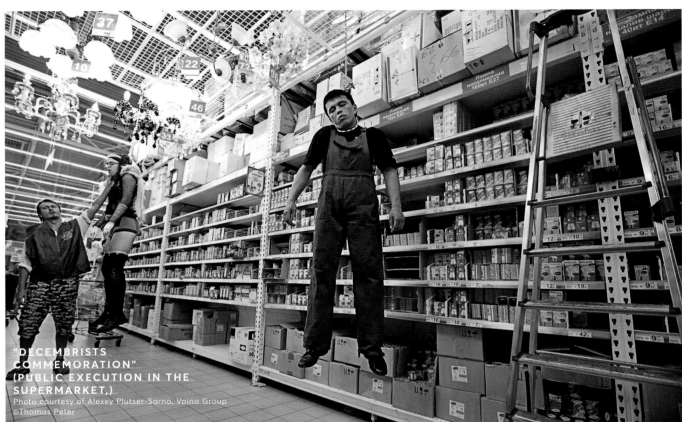

"DECEMBRISTS COMMEMORATION"
(PUBLIC EXECUTION IN THE SUPERMARKET,)
Photo courtesy of Alexey Plutser-Sarno, Voina Group
©Thomas Peter

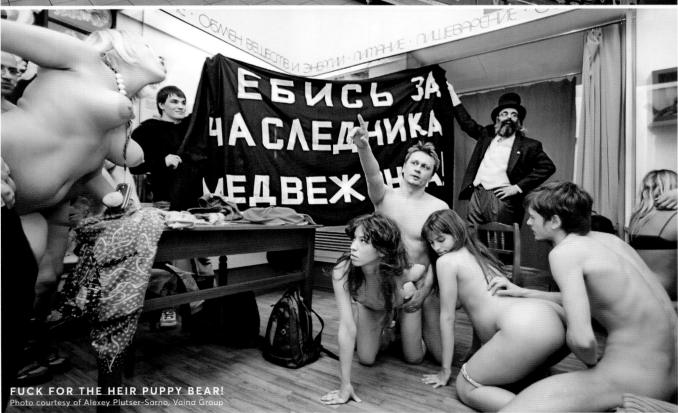

FUCK FOR THE HEIR PUPPY BEAR!
Photo courtesy of Alexey Plutser-Sarno, Voina Group

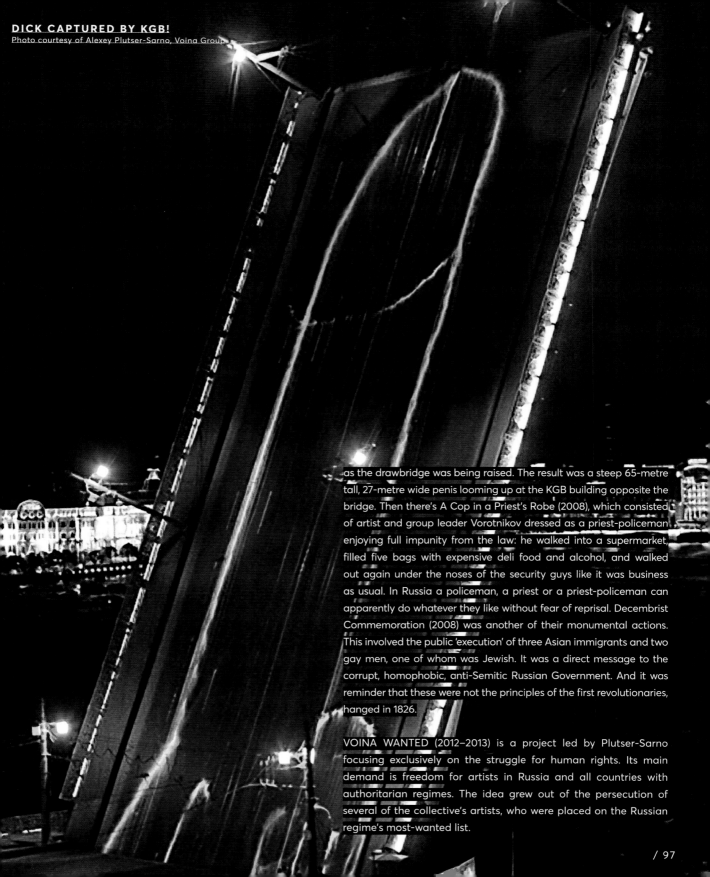

...as the drawbridge was being raised. The result was a steep 65-metre tall, 27-metre wide penis looming up at the KGB building opposite the bridge. Then there's A Cop in a Priest's Robe (2008), which consisted of artist and group leader Vorotnikov dressed as a priest-policeman enjoying full impunity from the law: he walked into a supermarket, filled five bags with expensive deli food and alcohol, and walked out again under the noses of the security guys like it was business as usual. In Russia a policeman, a priest or a priest-policeman can apparently do whatever they like without fear of reprisal. Decembrist Commemoration (2008) was another of their monumental actions. This involved the public 'execution' of three Asian immigrants and two gay men, one of whom was Jewish. It was a direct message to the corrupt, homophobic, anti-Semitic Russian Government. And it was reminder that these were not the principles of the first revolutionaries, hanged in 1826.

VOINA WANTED (2012–2013) is a project led by Plutser-Sarno focusing exclusively on the struggle for human rights. Its main demand is freedom for artists in Russia and all countries with authoritarian regimes. The idea grew out of the persecution of several of the collective's artists, who were placed on the Russian regime's most-wanted list.

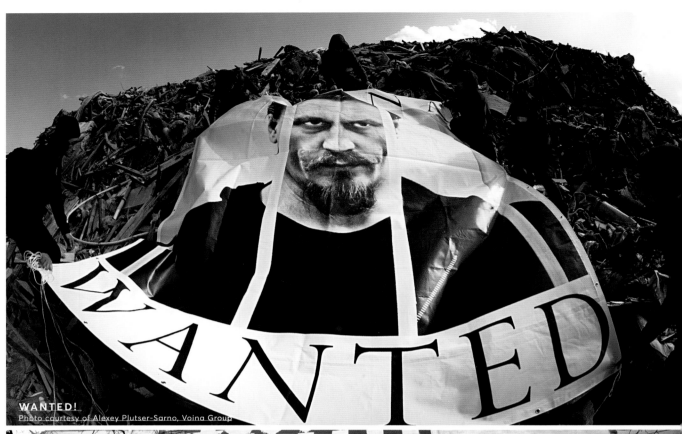

WANTED!
Photo courtesy of Alexey Plutser-Sarno, Voina Group

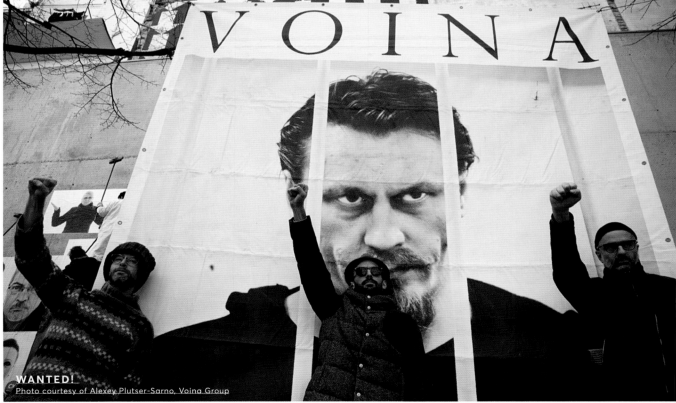

WANTED!
Photo courtesy of Alexey Plutser-Sarno, Voina Group

The Voina collective is one of those activist groups that opens up the ever-present issue of art or vandalism. Some people see them as destroyers, others as one of the most innovative art groups in Russia. They defend what they do as putting into practice leftist social action and protest in the form of urban art, and as an æsthetic reworking of their criminal life. The group never collaborates with public or private institutions and has never received support from Russian gallery owners. What's more, their philosophy of life turns its back on money: when they started out in 2007, the collective had no income, rejected waged labour and the use of money. They followed a self-managing ethic of foraging for food in garbage and supermarkets, and defended it as an art form. They wanted to live in one of the most expensive cities in the world while rejecting everything you're

forced to consider a necessity. Gradually, we renounced everything 'human': a home, wealth, jobs, careers. In Moscow, all of those niceties depended in one way or another on loyalty to the current regime, which can only be characterised as cannibalistic.'
Currently, Alexey Plutser-Sarno – one of Voina's main ideologists – is working on a project of his own, entitled Sacrifice (Minute of Silence). He slashed his wrists before the grave of the founder of modern Zionism, Theodor Herzl, in Jerusalem on the eve of Yom Kippur, the Day of Atonement. His blood was spilled on the Israeli flag and on the grave while Alexey prayed and held a minute's silence. The action was punishable with up to three years in jail. Alexey has stopped giving interviews and few now follow his art actions but, as he himself says, art doesn't cease to exist because others aren't looking at it.

SACRIFICE BY ALEXEY PLUTSER-SARNO
Photo courtesy of Alexey Plutser-Sarno
Voina Group

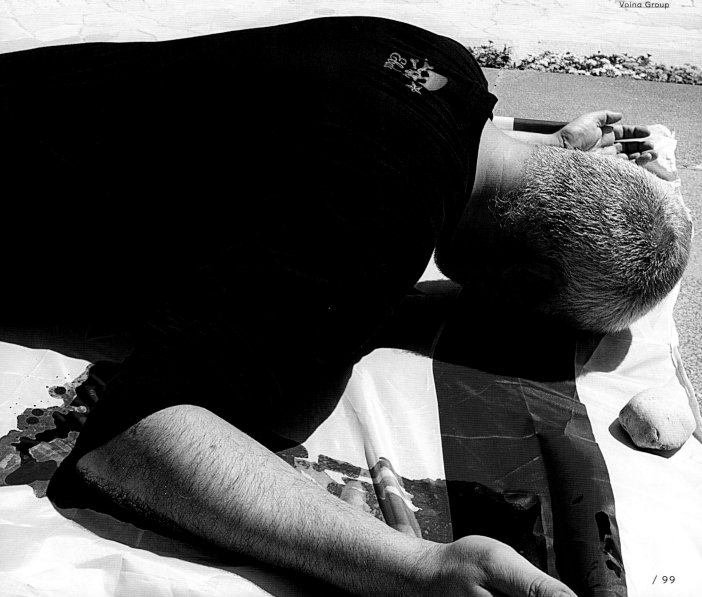

24 HOURS ON LOVE STREET

ADA VILARÓ

www.adavilaro.com

Ada Vilaró sets herself up somewhere with a chair and a pile of slates – no money, no food, no mobile. She then spends 24 hours relying on the kindness, generosity and empathy of passers-by. The slates are there to start some kind of communication, whether it's to express a sensation, an emotion, a need. Vilaró calls the intervention Public Present 24 Hours, 'a performance of collective durability'. In 24 hours the public space can be very giving, and she is present as an observer and receiver of the best human qualities. Everything she experiences over this time period – counted out on a digital clock set up in front of her and facing the passers-by – reflects both the intrinsic goodness of human beings and how difficult it is for the public space to be truly public and collective.

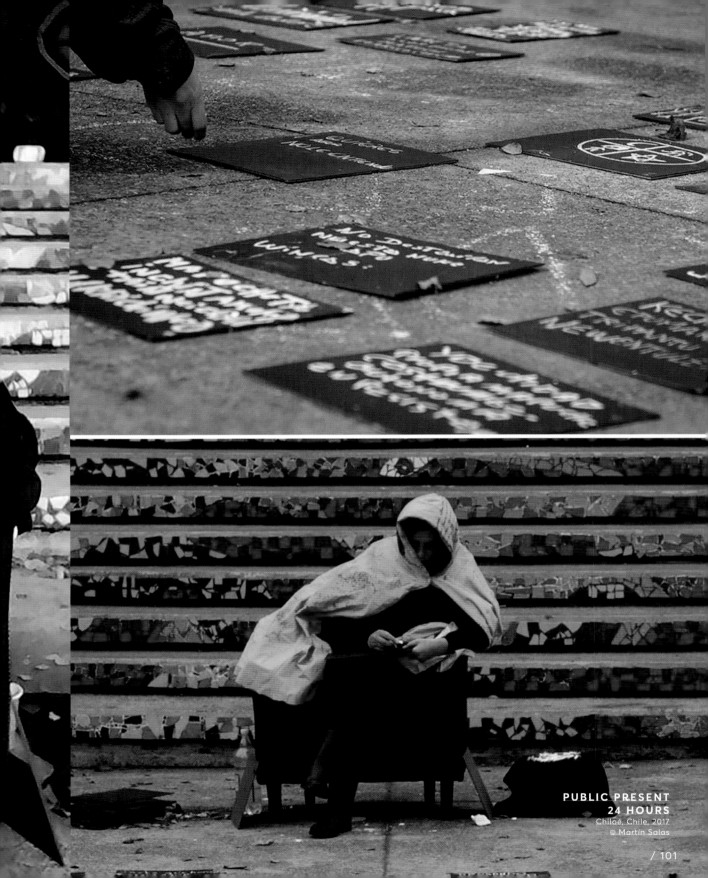

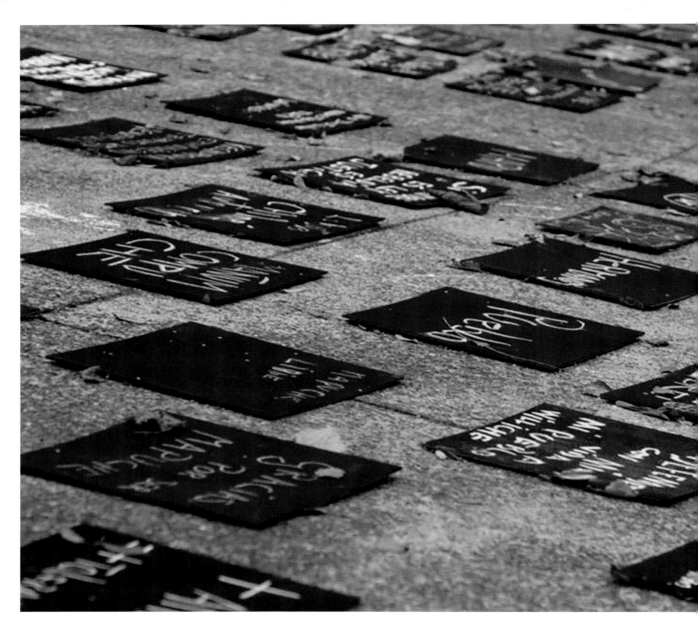

PUBLIC PRESENT
24 HOURS
Chiloé, Chile, 2017
© Martín Salas

For 24 hours Vilaró becomes an active agent who sets out her stall in the street to engage in honest, essential communication with the space and its passers-by. She breaks apart the idea that the street is a space of automatism and thoughtlessness, and opens up the lavish artery of human generosity. Yes, people really do give her a scarf when she asks for it in writing, or stand in for her while she goes to the bathroom, or bring her a drink and raise a glass with her.

It will start raining, and someone from the area will remember she's out there in the street and go and set up a makeshift shelter for her. In doing so people feel good about themselves, something has changed in them. Probably. Hopefully. The public space is torn a little further open: the street belongs as much to us as to those who govern it. The boundary between being a passer-by and inhabiting the public space has dissolved, if only for 24 hours.

Vilaró makes someone sitting in a chair on the street, in silent, peaceful occupation, both transgressive and provocative.

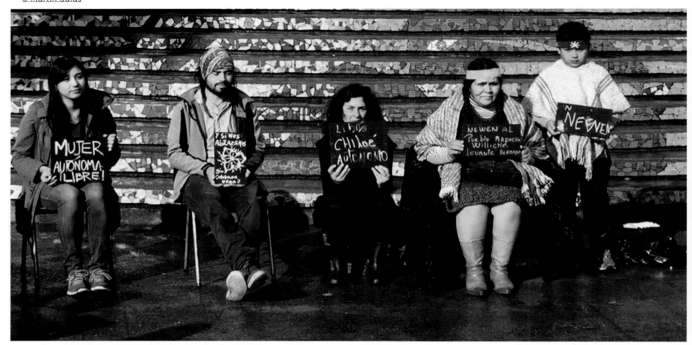

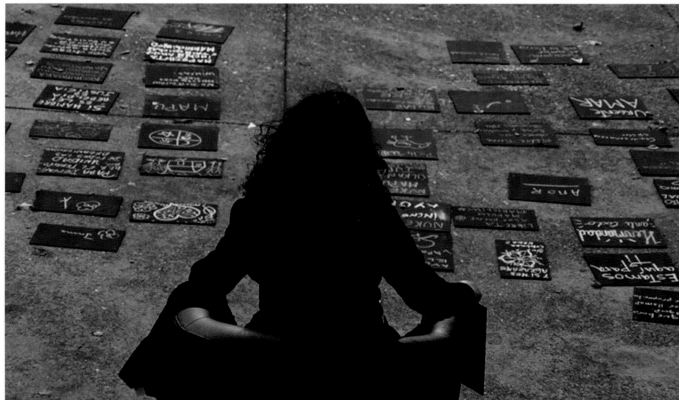

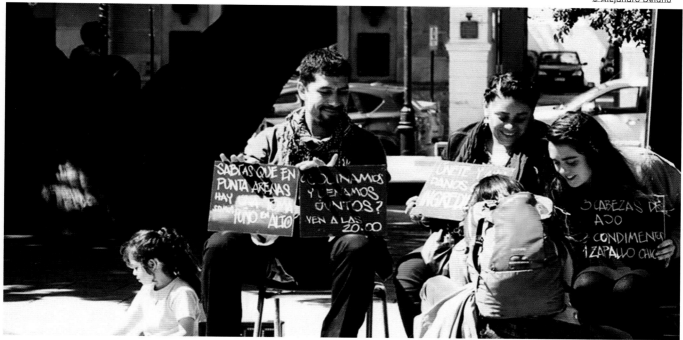

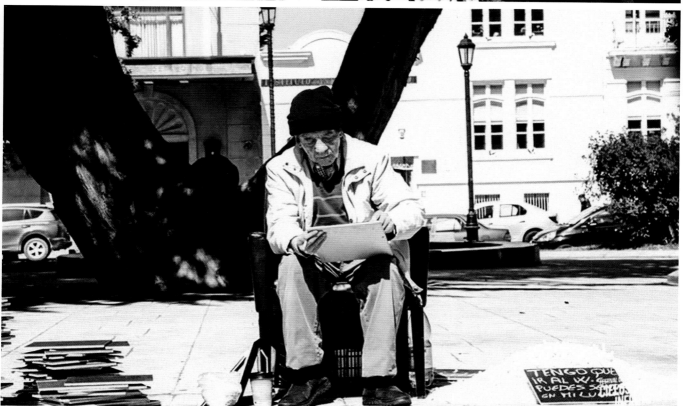

UNCLASSIFIED UNDERCOVER URBAN ADVENTURES

JEFF STARK

www.jeffstark.org

Jeff Stark is one of those guys who started out as a journalist – a writer of cultural events 'of interest' – and ended up as a cultural agitator. His story began in 2000, when he created a weekly e-mail called 'Nonsense NYC', 'a discriminating resource for independent art, weird events, strange happenings, unique parties, and senseless culture in New York City': street events, guerrilla theatre, loser open mics, cirkuses and absurdist pranks, movies in unusual places, bike rallies, puppet shows or any other stuff that has no name.

Stark's documenting habit gradually morphed into a continuous round of urban pranks centring on how we occupy and use public space. If his interventions – involving anything from one or two to dozens of friends and collaborators – have something in common, it's that they're independent, self-financing and participatory, and have no public permission. This all fits our ever-changing, subjective definition of artivism.

SECRET DINNERS
© Jordan Seiler

A TRAGEDY IN THREE STATIONS
© Tod Seelie

His earliest actions always ended with the police wading in and asking 'What the hell are you up to?' They found it so hard to classify his urban activities that in one of them they ended up giving him a parking fine. This left Jeff scratching his head about how to proceed without all these interruptions from the authorities. He decided to undertake smaller-scale, more intimate, undercover projects, like his 'Secret Dinners', where up to 40 people dined out in extraordinary places that were either creepy, illegal or hard to reach. You were handed what came to be called the 'city keys': all-empowering tools that gave you access to places which, according to the authorities, were either impossible or illegal for citizens to visit on foot. Armed with their 'keys', they would find ways into spaces that had been disused for up to 40 years.

Another distinctive feature of Jeff Stark's initiatives is that each evolves naturally from the last. As soon as he feels they're running on empty, he moves on to the next. Relentlessly. A case in point is his 'Secret Dinners'. These morphed into extraordinary theatre plays staged in extraordinary, sometimes illegal and above all out-of-the-way places. Once again, 40 people: a manageable group that, despite the obstacles, always make it to the venues. And from plays in off-world locations they moved on to plays in subway carriages, where, immersed in their own thoughts, the uniform masses are suddenly invaded by a crowd of players hauling bulky wooden furniture, huge screens and false walls through the carriage doors.

Jeff Stark is a child at play, crossing the boundaries of the forbidden with his favourite toy, the city. But how much truth and disobedience are hidden behind a game?

SECRET DINNERS
© Tod Seelie

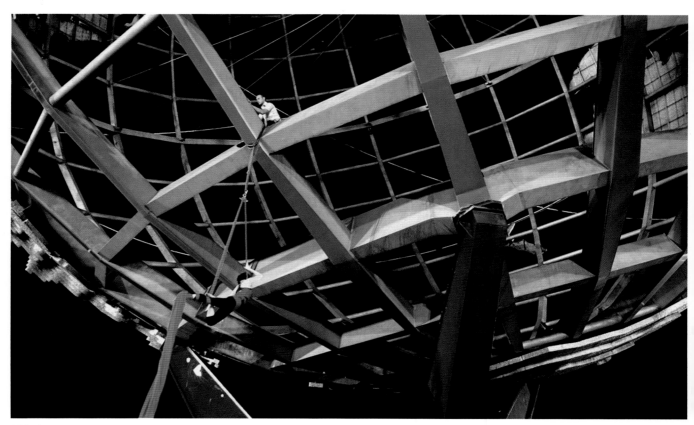

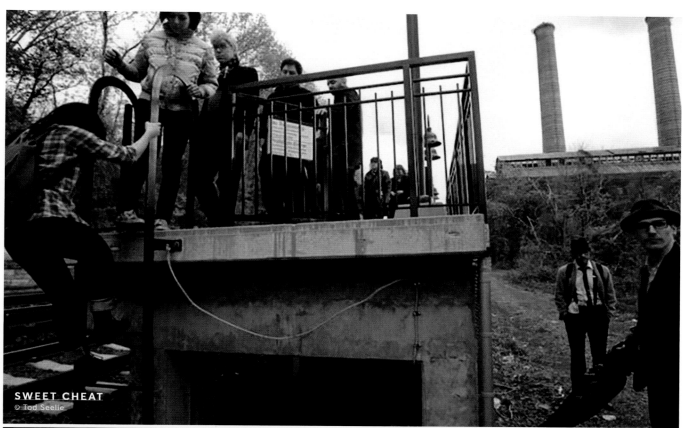

SWEET CHEAT
© Tod Seelie

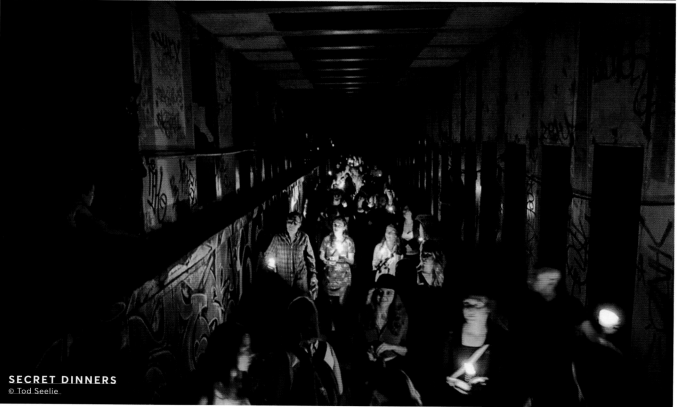

SECRET DINNERS
© Tod Seelie

ROCKING ON THE CORE

CHIM↑POM

The Chim↑Pom art collective has been dubbed 'the enfant terrible of Japanese art'. For ten years now they've been dumbfounding Japanese society with their ruses and radical black humour. Like many artists in this book they spark debate, controversy and doubt about being catalogued as artivists. But what there's no doubting is that Chim↑Pom make a direct impact on Japanese reality. Indeed, it's almost their sole inspiration. Apart from that they're ultra-subversive and annoying, a real pain in the arse for the Japanese system. But isn't that artivism? Raising the surprise party to the category of art, to paraphrase the anthropologist Manuel Delgado, or challenging the dynamics of a global order that should never have been allowed to happen in the first place, without a second thought for the consequences?

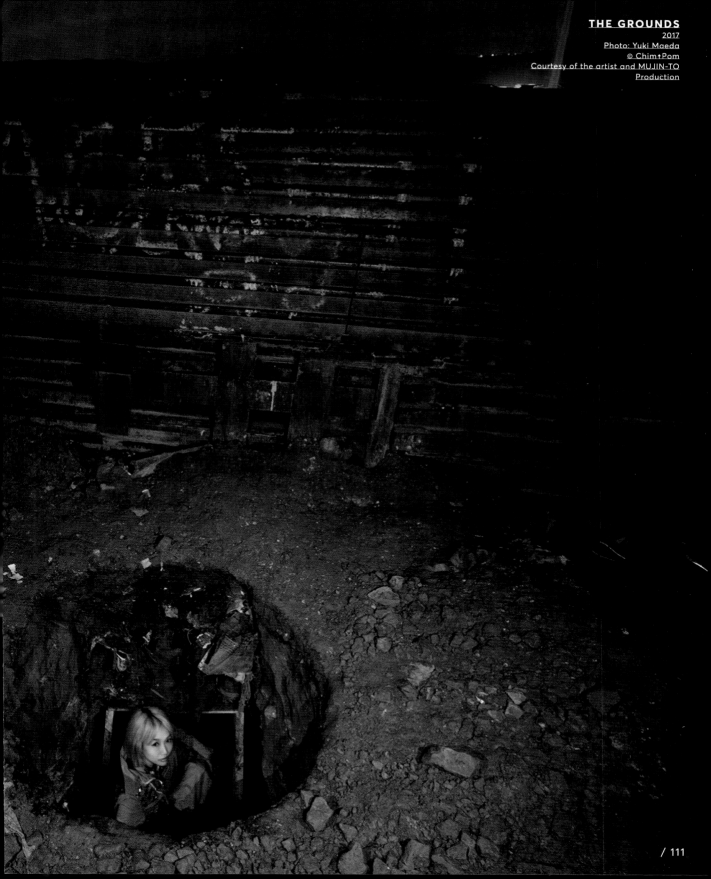

THE GROUNDS
2017
Photo: Yuki Maeda
© Chim↑Pom
Courtesy of the artist and MUJIN-TO
Production

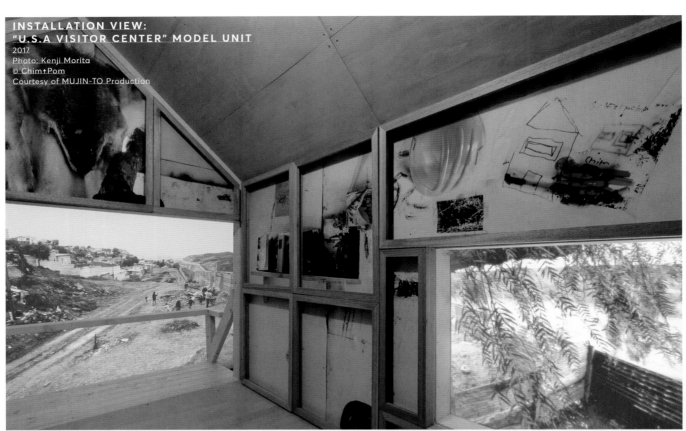

INSTALLATION VIEW:
"U.S.A VISITOR CENTER" MODEL UNIT
2017
Photo: Kenji Morita
© Chim↑Pom
Courtesy of MUJIN-TO Production

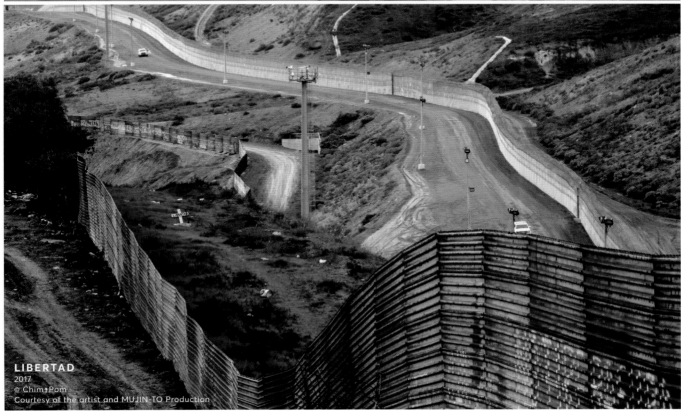

LIBERTAD
2017
© Chim↑Pom
Courtesy of the artist and MUJIN-TO Production

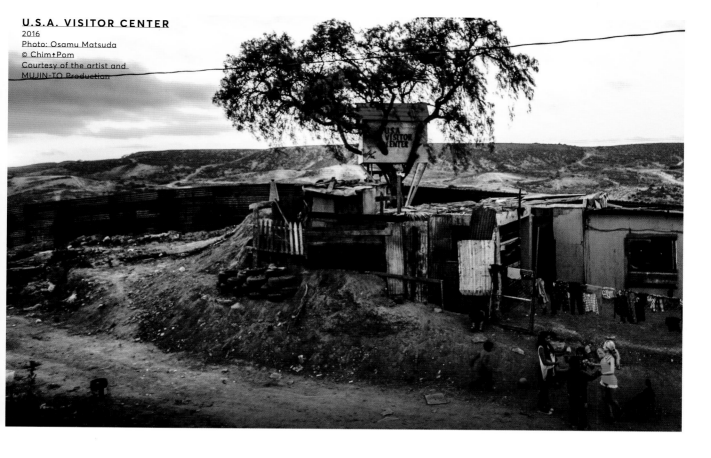

U.S.A. VISITOR CENTER
2016
Photo: Osamu Matsuda
© Chim↑Pom
Courtesy of the artist and
MUJIN-TO Production

Chim↑Pom's first, most emblematic action was Super Rats. Tokyo's Shibuya district is swarming with rats. The locals live right alongside them. The rats have got so tough that they're immune to poison and routinely survive any traps set for them. They actually seem to feed on the poison and show supernatural growth rates. It's a real problem in Tokyo and, with their inimitable black humour, the collective wanted to send people a nudge about this burning issue. So they set about catching, dissecting and stuffing the rats, painted them yellow with red cheeks like Pikachus, arranged them in cute positions and dotted them around different parts of Tokyo.

The artivism of Chim↑Pom (the name in Japanese sounds like 'penis', a fact that always gets them rocking in the aisles in Japan) is closely bound up with border issues: many of their projects have been about literally crossing borders and prohibited places. One of the collective's maxims is to incorporate present-day geographical barriers into their work. Amidst today's global anti-immigration hysteria crossing international borders has become a subversive act in itself. The context itself sanctions the creative act.

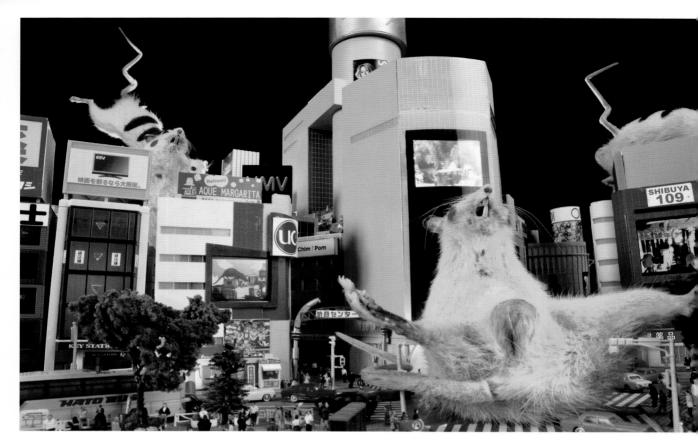

SUPER RAT , 2006–, VIDEO, STUFFED RAT
Photo: Yoshimitsu Umekawa
© Chim↑Pom
Courtesy of the artist and MUJIN-TO Production

**CURATORIAL TEAM ON A SITE VISIT IN THE
FUKUSHIMA EXCLUSION ZONE**
Courtesy of Don't Follow the Wind Committee

A WALK IN FUKUSHIMA, 2016
360 degree video, headsets, cafe furniture from Fukushima,
Australian uranium, maps installation commissioned by the 20th
Biennale of Sydney view at Carriageworks
Courtesy of Don't Follow the Wind Committee

Their first such provocation was when they entered the Fukushima exclusion zone just a few weeks after the nuclear explosion. At the time not even the media dared to get within more than 30 kilometres of the reactor, but in Chim↑Pom went. They interact with reality. They believe art can influence society if it goes where others won't. 'We always go to the core of events.' So they slipped in through the back-door with video cameras and later staged a 3D macro-installation of what they'd seen, punctuated with reports from residents whose houses had been contaminated. Visitors to the installation could watch the video through handcrafted headsets made by the mother, father and grandmother of artist Bontaro Dokuyama, all of them Fukushima residents living near the exclusion zone. The levels of contamination they were living in, albeit low, had changed their lives forever.

Another of their subversive geographical incursions was on the Tijuana side of the border wall separating Mexico and the United States, just before Trump's election in 2016. The collective videoed itself walking up and down the wall. As fate would have it, since 2012 the collective has been blacklisted by the country's Security Department and denied entry to the United States. In that context entering the US becomes a real provocation. This visit became an installation in which everything they had lived through with the local population was on display: the tree-house they built and the hole they dug at the foot of the wall, through which Ellie, a Chim↑Pom member, forced herself so she could say she'd literally set foot on American soil.

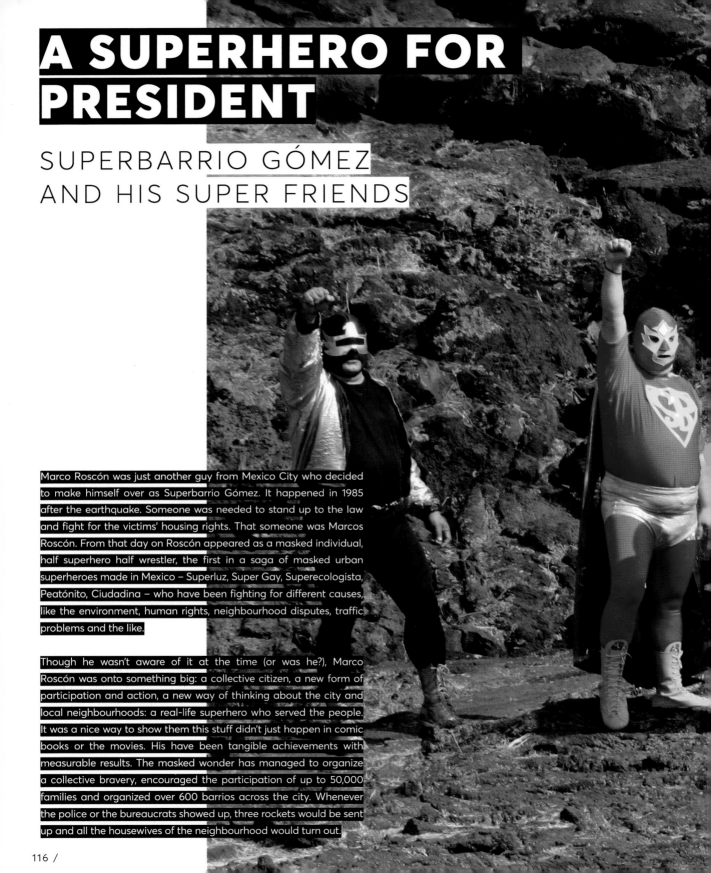

A SUPERHERO FOR PRESIDENT

SUPERBARRIO GÓMEZ AND HIS SUPER FRIENDS

Marco Roscón was just another guy from Mexico City who decided to make himself over as Superbarrio Gómez. It happened in 1985 after the earthquake. Someone was needed to stand up to the law and fight for the victims' housing rights. That someone was Marcos Roscón. From that day on Roscón appeared as a masked individual, half superhero half wrestler, the first in a saga of masked urban superheroes made in Mexico – Superluz, Super Gay, Superecologista, Peatónito, Ciudadina – who have been fighting for different causes, like the environment, human rights, neighbourhood disputes, traffic problems and the like.

Though he wasn't aware of it at the time (or was he?), Marco Roscón was onto something big: a collective citizen, a new form of participation and action, a new way of thinking about the city and local neighbourhoods: a real-life superhero who served the people. It was a nice way to show them this stuff didn't just happen in comic books or the movies. His have been tangible achievements with measurable results. The masked wonder has managed to organize a collective bravery, encouraged the participation of up to 50,000 families and organized over 600 barrios across the city. Whenever the police or the bureaucrats showed up, three rockets would be sent up and all the housewives of the neighbourhood would turn out.

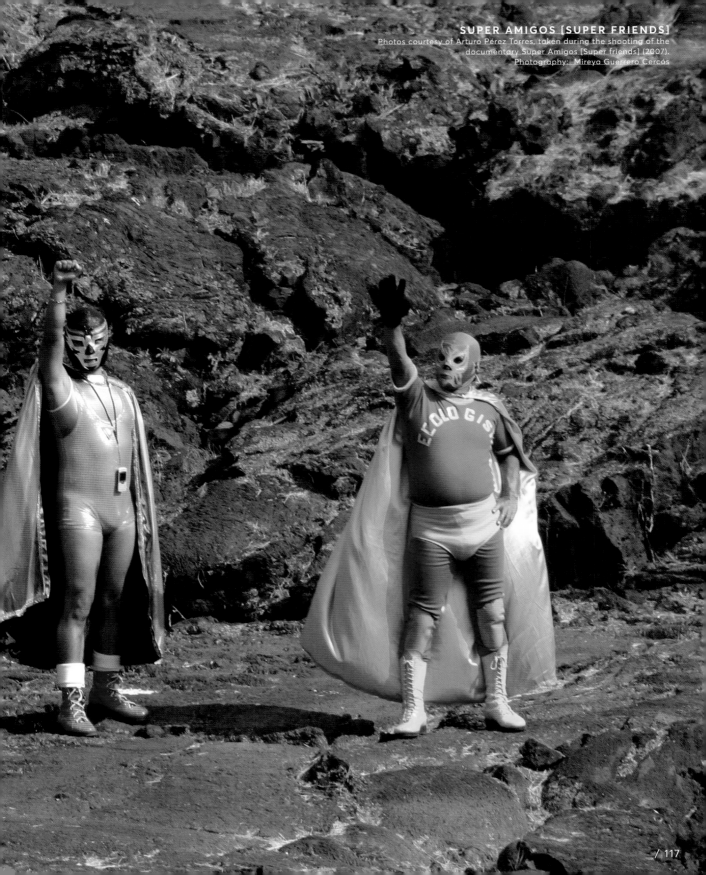

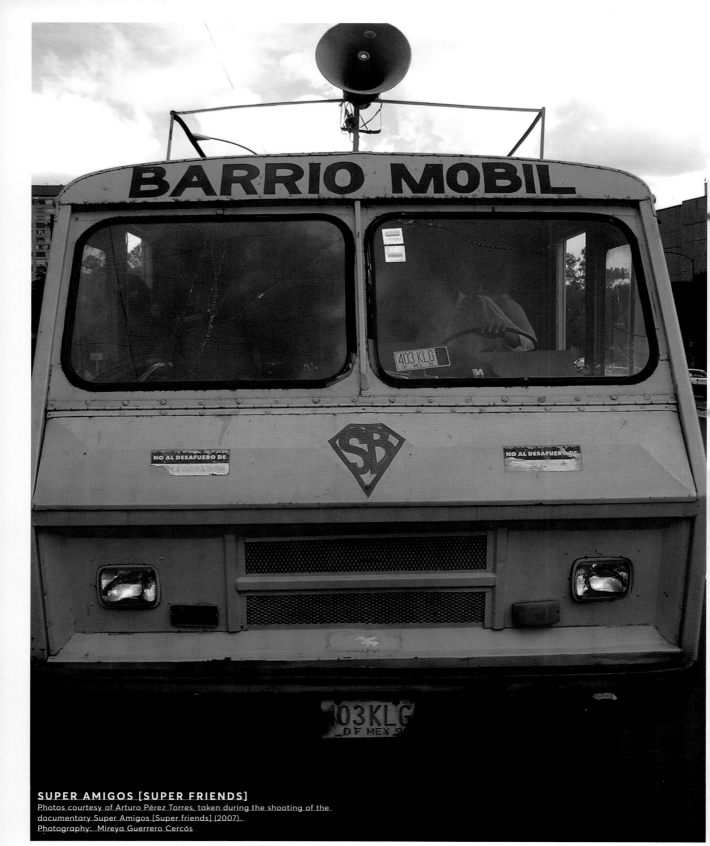

SUPER AMIGOS [SUPER FRIENDS]
Photos courtesy of Arturo Pérez Torres, taken during the shooting of the
documentary Super Amigos [Super friends] (2007).
Photography: Mireya Guerrero Cercós

His great superpower has been his omnipresence: Superbarrio could at any one time be at a demonstration, a housing eviction, supporting a new bill or defending HIV public health policies. His landmark achievements include living through May 68, landing loans for the rebuilding of 48,000 dwellings, standing for the US presidency with the backing of Noam Chomsky, Eduardo Galeano and Carlos Fuentes, founding the Democratic Revolution Party (which still hangs 'BUILDING PROTECTED BY SUPERBARRIO' signs over 20 years later), and opening a restaurant of fresh, well-seasoned food. He has his own biographer and his own museum. In fact, Superbarrio is the only popular movement to have a museum.

The game of his activism involved using humour and parody to ridicule power. 'We turned carnival and parody into tools to question power,' he said on one occasion. They once surrounded the presidential palace and, when the police arrived, simulated a military attack, shouting 'Air force attack!' and throwing paper aeroplanes, then yelling 'Now the tanks!' and pulling out toy tanks. Other times they'd challenge the police to wrestling bouts. It all stemmed from an enthusiasm to organize and from a new way of thinking: a form of struggle 'that had nothing to do with bitterness'. It's been the best part of three decades since the character appeared – though now he's played by different people – and Superbarrio and his Super Amigos can still be seen walking the streets of Mexico.

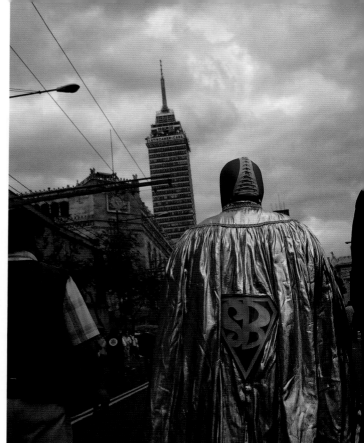

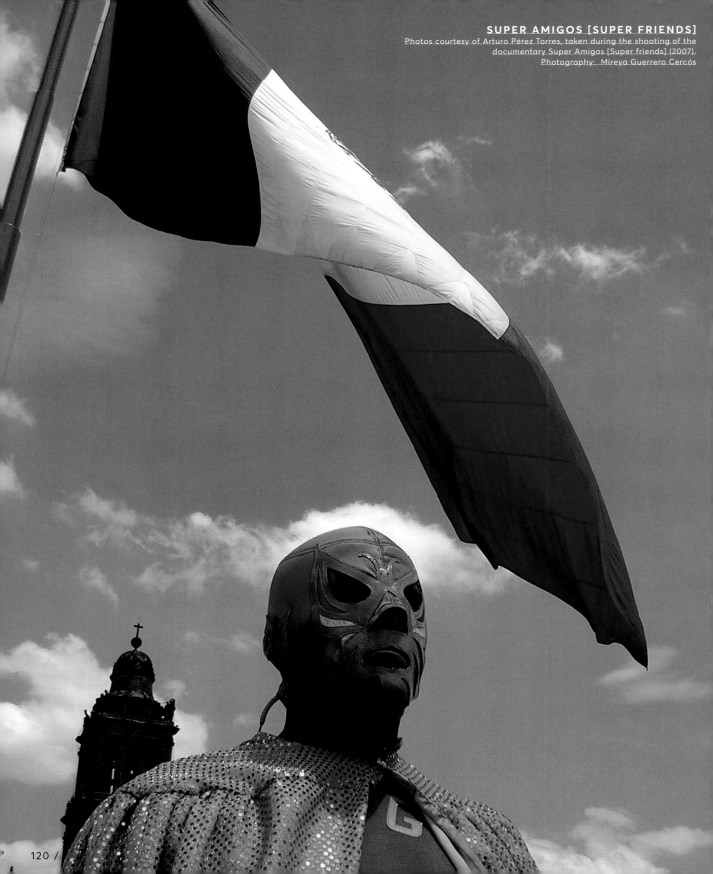

SUPER AMIGOS [SUPER FRIENDS]
Photos courtesy of Arturo Pérez Torres, taken during the shooting of the
documentary Super Amigos [Super friends] (2007).
Photography: Mireya Guerrero Cercós

120 /

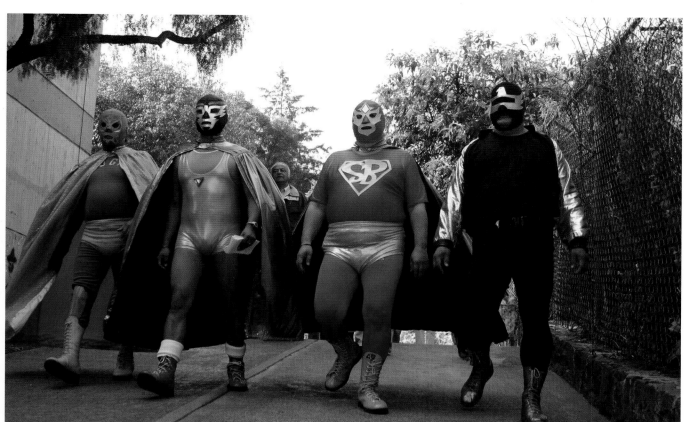

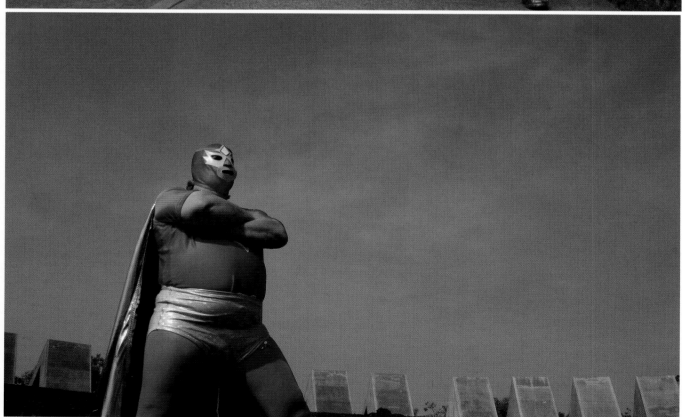

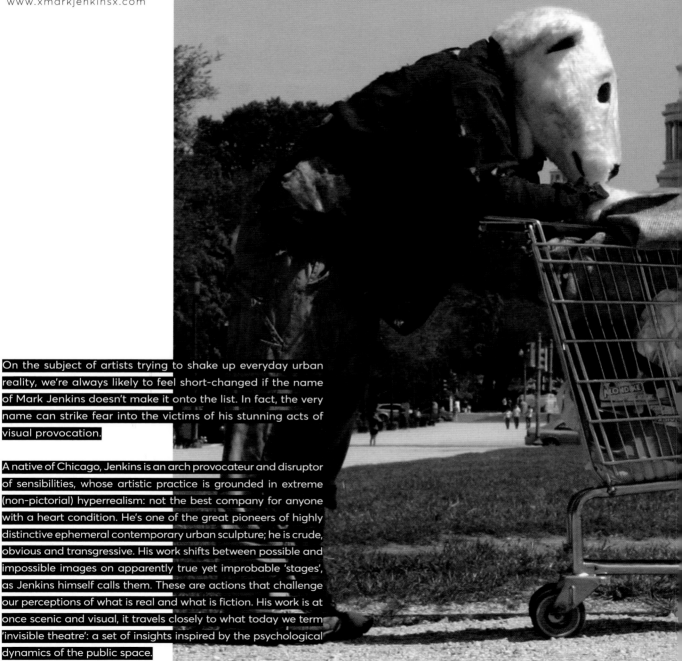

THE POLAR FEAR AND THE BOMB

MARK JENKINS

www.xmarkjenkinsx.com

On the subject of artists trying to shake up everyday urban reality, we're always likely to feel short-changed if the name of Mark Jenkins doesn't make it onto the list. In fact, the very name can strike fear into the victims of his stunning acts of visual provocation.

A native of Chicago, Jenkins is an arch provocateur and disruptor of sensibilities, whose artistic practice is grounded in extreme (non-pictorial) hyperrealism: not the best company for anyone with a heart condition. He's one of the great pioneers of highly distinctive ephemeral contemporary urban sculpture; he is crude, obvious and transgressive. His work shifts between possible and impossible images on apparently true yet improbable 'stages', as Jenkins himself calls them. These are actions that challenge our perceptions of what is real and what is fiction. His work is at once scenic and visual, it travels closely to what today we term 'invisible theatre': a set of insights inspired by the psychological dynamics of the public space.

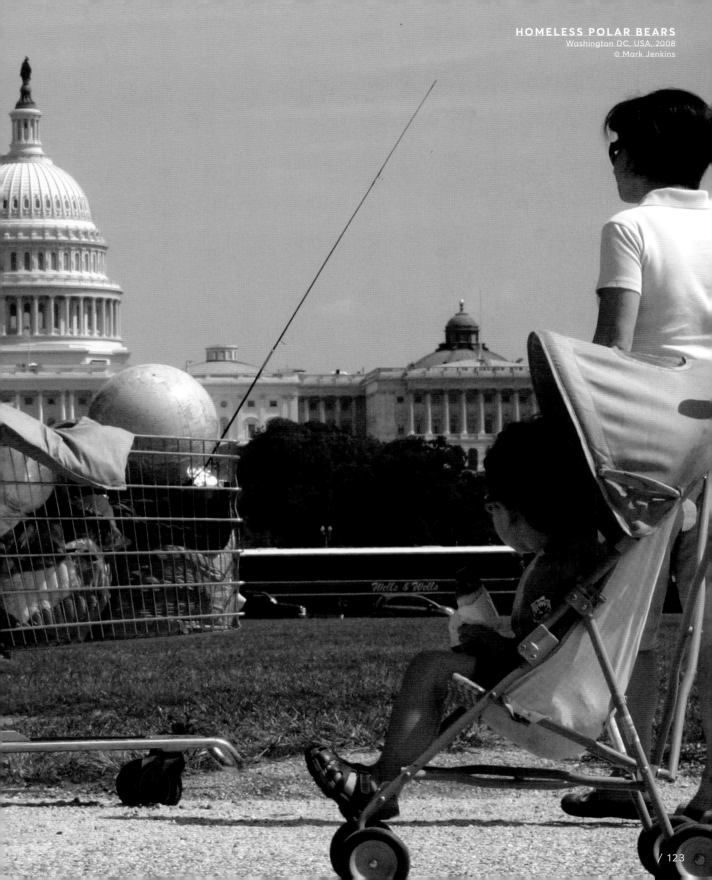

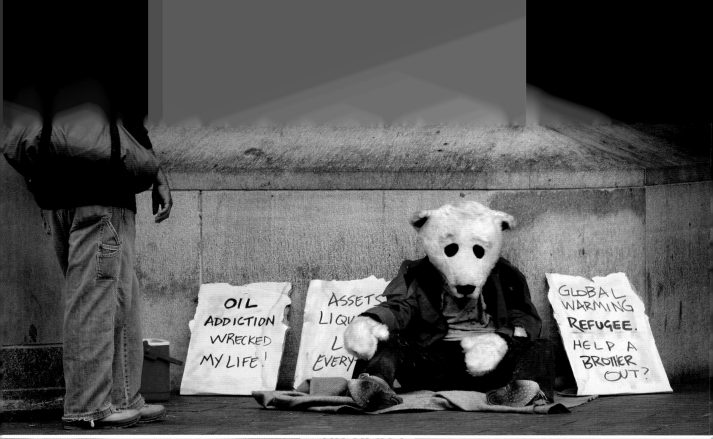

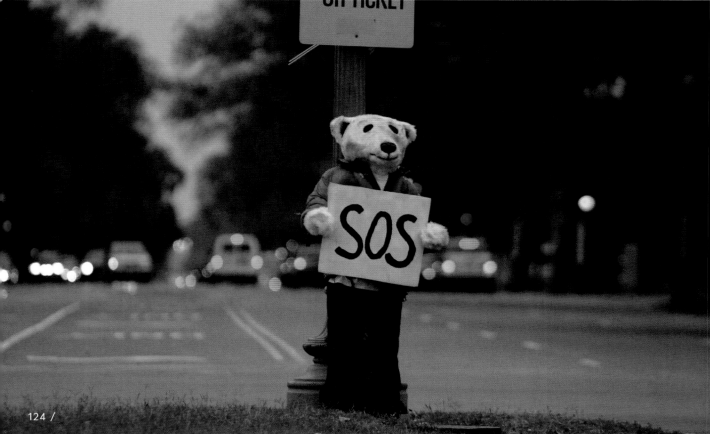

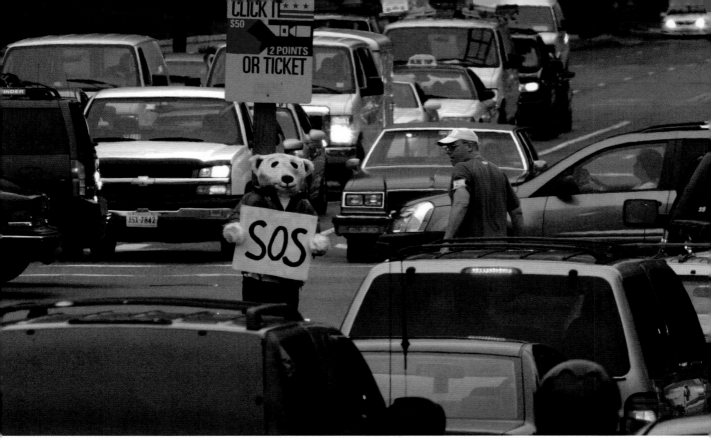

In 2008, on one of the Western world's favourite stages for protest, outside the Capitol Building in Washington DC, Jenkins carried out one of his best-known media projects, fusing the concepts of social and environmental activism. On the one hand, his non-human human figures could be considered the perfect activist, a figure capable of carrying banners for hours or even days on end before being removed by the authorities (exhaustion will never be grounds to abandon the cause in the field). On the other hand, as the artist himself points out, Greenpeace climate activists love dressing up as polar bears and brandishing banners that often bear rather simplistic, narcissistic messages, like 'I LOVE GREENPEACE' or 'MORE ICE, LESS OIL'. The piece basically involved combining these two tendencies of urban protest. The result: a group of homeless polar bear-human hybrids that created very different stages.

But the funniest thing about the action came from right out of left field: by law, any unattended package in the public space is treated as suspicious. So, five hours after the bear's installation a potential bomb-scare protocol was activated, prompting the appearance of the police bomb disposal team. They quickly cordoned off the whole area between the Washington Monument and the Capitol while some guy inspected the bear and hundreds of bewildered tourists looked on from a safe distance. Then something utterly unexpected happened: a squirrel fell out of a tree, stone dead, so everyone thought the suspicious package contained some kind of lethal gas and consequently panic spread.

After all this rumpus Mark thought it was time to shut the project down, but Greenpeace insisted on replacing the bear the following day. Mark was flying out to Amsterdam that day, so Greenpeace had to stage it themselves. Next day, on his way to the airport, he passed the same street. It was cut off again. They'd apparently closed all the shops and even the schools. Yet another bomb squad had arrived.

Greenpeace later reproduced the work around various different cities. However, they had to get someone to stand within 15 feet of the piece, because then the object can't be deemed unattended. 'And the moral of the story: if you're going to make a fake polar bear man, you should also make another fake real man next to him, less than 15 feet away. And to be safe make a fake police officer standing near watching them. Maybe holding a tape measure.'

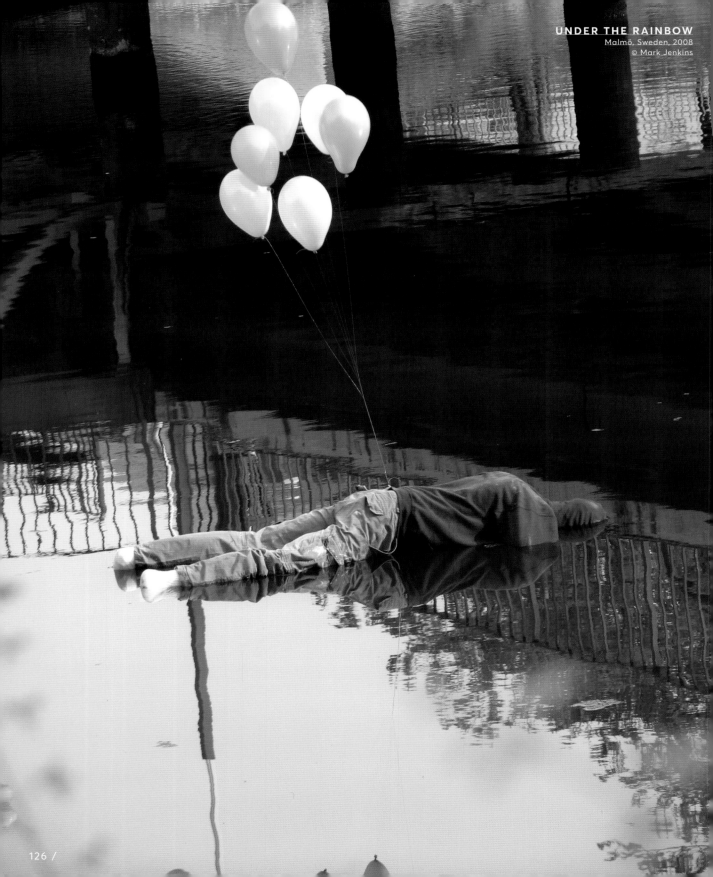

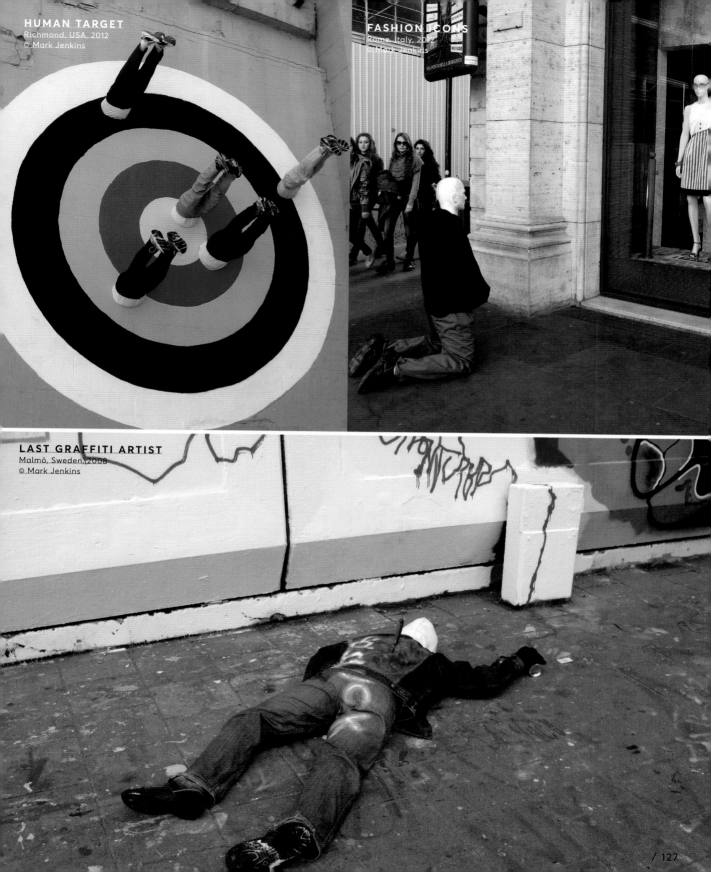

HUMAN TARGET
Richmond, USA, 2012
© Mark Jenkins

FASHION ICONS
Rome, Italy, 2012
© Mark Jenkins

LAST GRAFFITI ARTIST
Malmö, Sweden, 2008
© Mark Jenkins

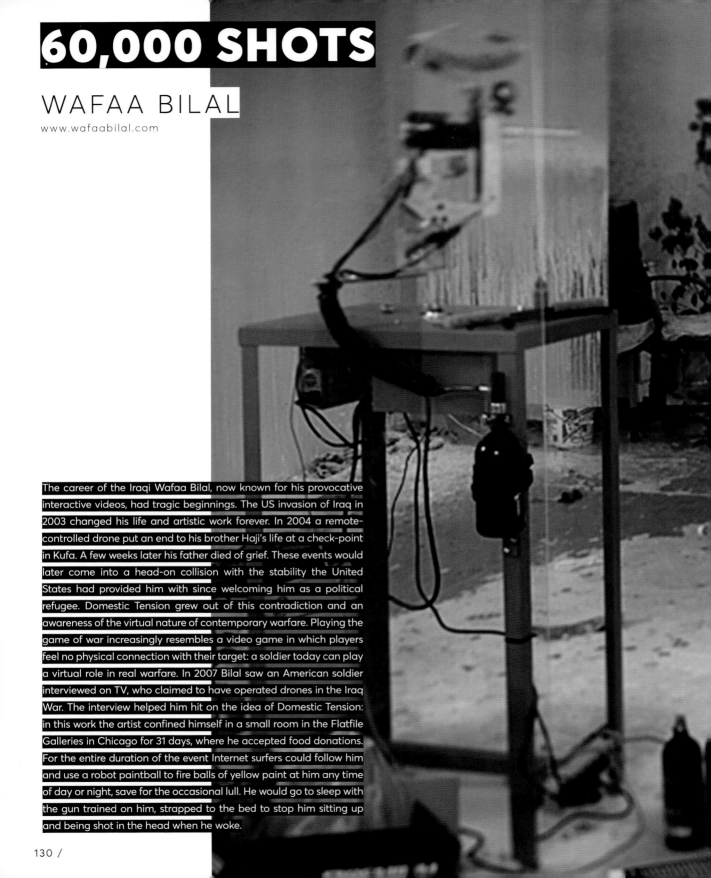

60,000 SHOTS

WAFAA BILAL
www.wafaabilal.com

The career of the Iraqi Wafaa Bilal, now known for his provocative interactive videos, had tragic beginnings. The US invasion of Iraq in 2003 changed his life and artistic work forever. In 2004 a remote-controlled drone put an end to his brother Haji's life at a check-point in Kufa. A few weeks later his father died of grief. These events would later come into a head-on collision with the stability the United States had provided him with since welcoming him as a political refugee. Domestic Tension grew out of this contradiction and an awareness of the virtual nature of contemporary warfare. Playing the game of war increasingly resembles a video game in which players feel no physical connection with their target: a soldier today can play a virtual role in real warfare. In 2007 Bilal saw an American soldier interviewed on TV, who claimed to have operated drones in the Iraq War. The interview helped him hit on the idea of Domestic Tension: in this work the artist confined himself in a small room in the Flatfile Galleries in Chicago for 31 days, where he accepted food donations. For the entire duration of the event Internet surfers could follow him and use a robot paintball to fire balls of yellow paint at him any time of day or night, save for the occasional lull. He would go to sleep with the gun trained on him, strapped to the bed to stop him sitting up and being shot in the head when he woke.

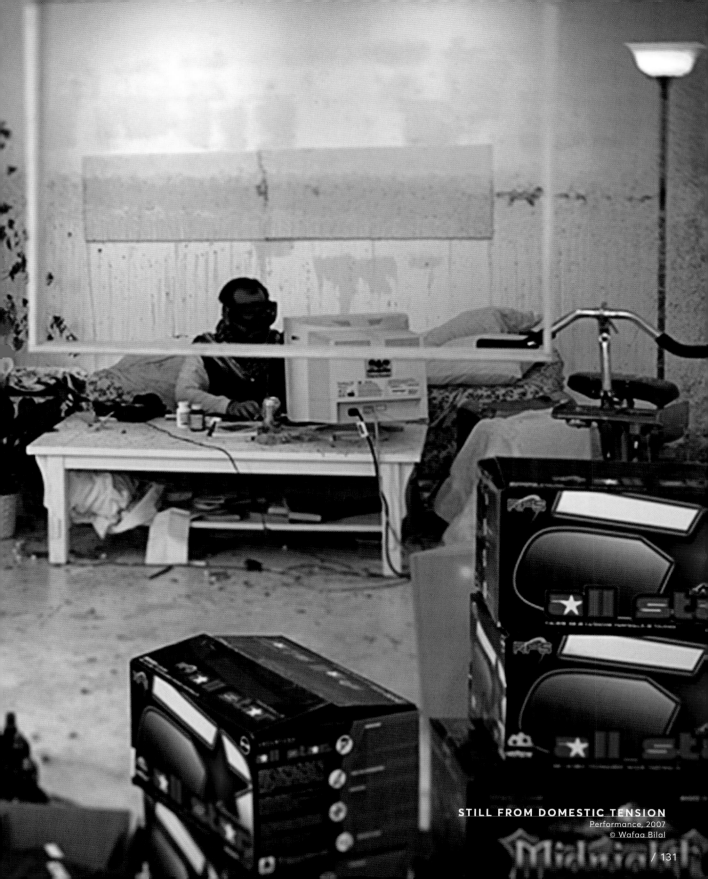

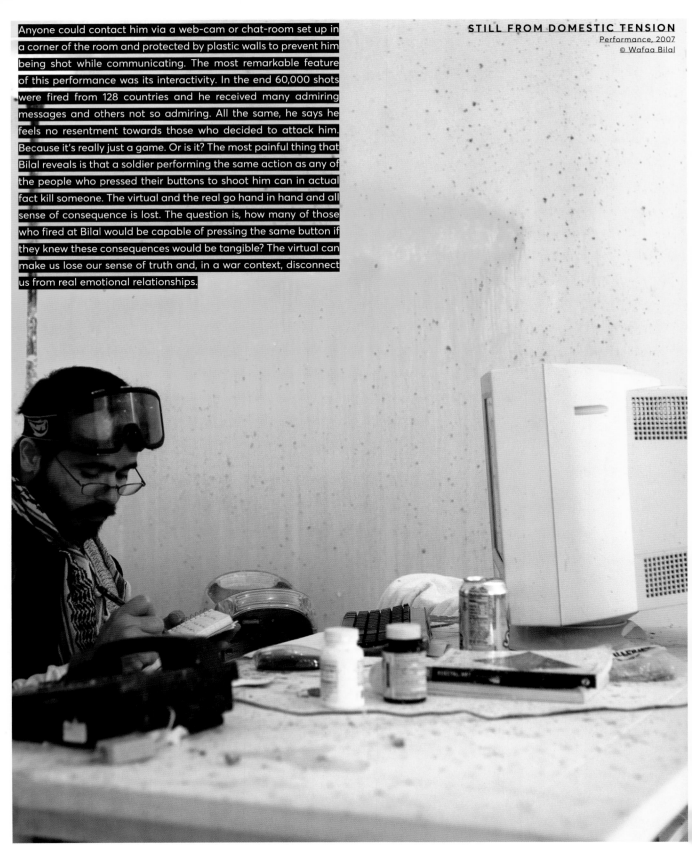

Anyone could contact him via a web-cam or chat-room set up in a corner of the room and protected by plastic walls to prevent him being shot while communicating. The most remarkable feature of this performance was its interactivity. In the end 60,000 shots were fired from 128 countries and he received many admiring messages and others not so admiring. All the same, he says he feels no resentment towards those who decided to attack him. Because it's really just a game. Or is it? The most painful thing that Bilal reveals is that a soldier performing the same action as any of the people who pressed their buttons to shoot him can in actual fact kill someone. The virtual and the real go hand in hand and all sense of consequence is lost. The question is, how many of those who fired at Bilal would be capable of pressing the same button if they knew these consequences would be tangible? The virtual can make us lose our sense of truth and, in a war context, disconnect us from real emotional relationships.

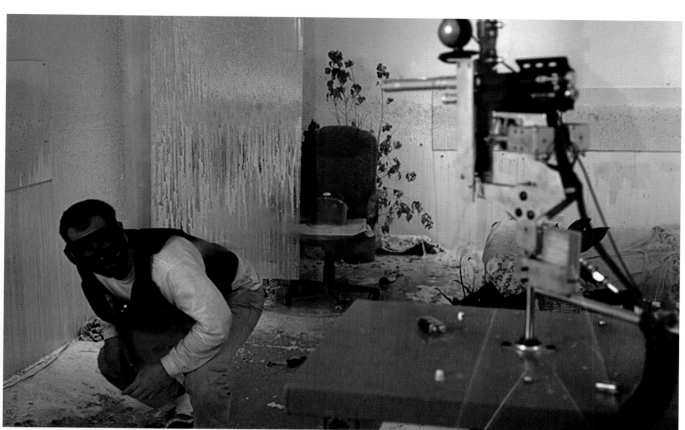

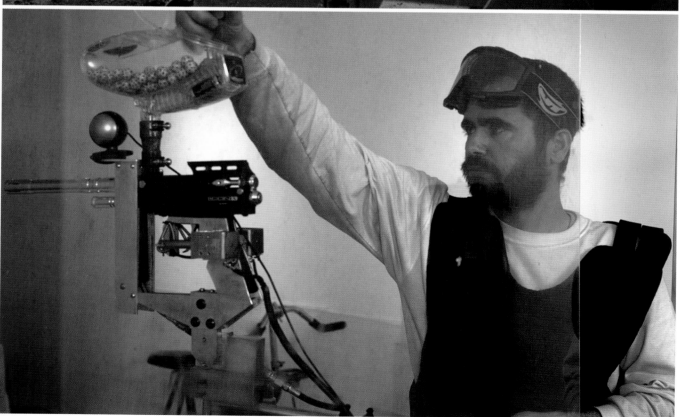

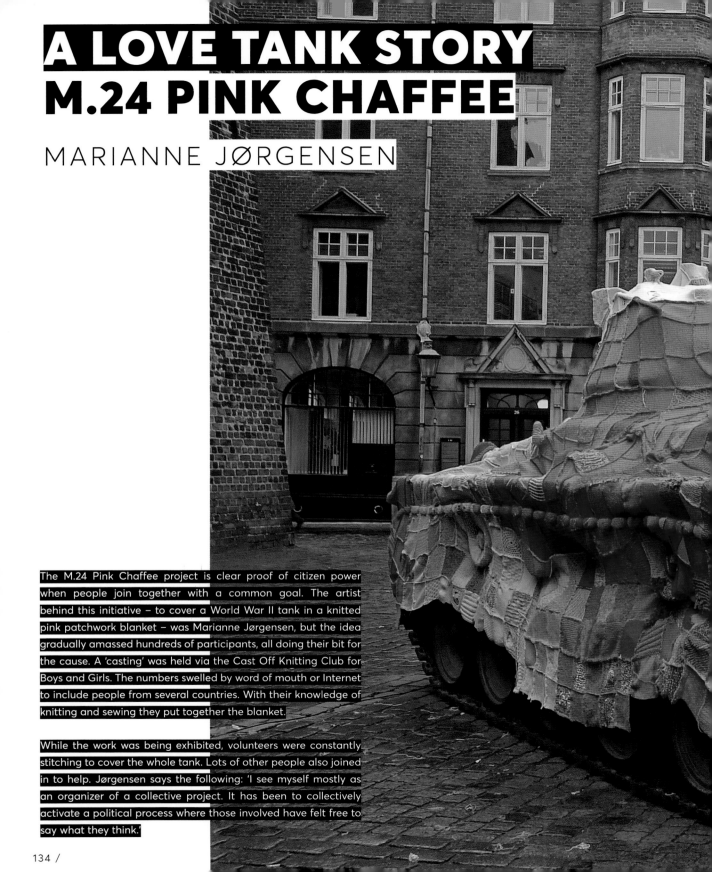

A LOVE TANK STORY
M.24 PINK CHAFFEE

MARIANNE JØRGENSEN

The M.24 Pink Chaffee project is clear proof of citizen power when people join together with a common goal. The artist behind this initiative – to cover a World War II tank in a knitted pink patchwork blanket – was Marianne Jørgensen, but the idea gradually amassed hundreds of participants, all doing their bit for the cause. A 'casting' was held via the Cast Off Knitting Club for Boys and Girls. The numbers swelled by word of mouth or Internet to include people from several countries. With their knowledge of knitting and sewing they put together the blanket.

While the work was being exhibited, volunteers were constantly stitching to cover the whole tank. Lots of other people also joined in to help. Jørgensen says the following: 'I see myself mostly as an organizer of a collective project. It has been to collectively activate a political process where those involved have felt free to say what they think.'

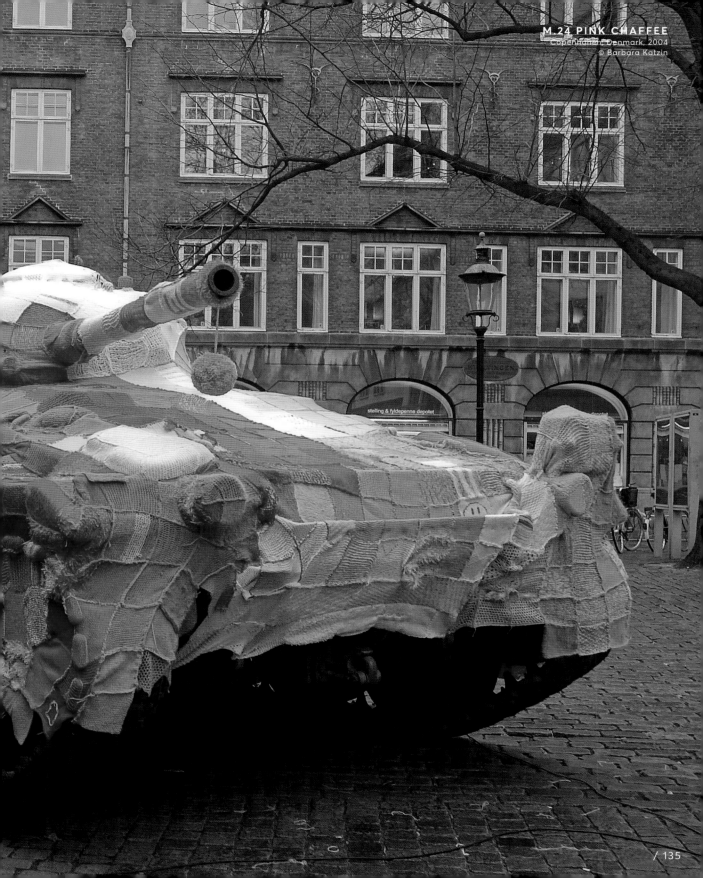

The brilliant thing about the initiative was all the conversations and discussions about war that people had while the blanket was being stitched together. In the run-up to the unveiling of the piece a group of knitters took shape, meeting frequently to get the project off the ground. As their meetings were held in the public space, the discussions were open even to outsiders.

Jørgensen fought long and hard to find a genuine World War II tank. The Royal Danish Army has plenty, and many can be seen dotted around Copenhagen. The artist hooked up with the army and other organizations interested in tanks and other historical weapons of war.

Six months had gone by before she got permission to use an M24 Chaffee. The tank had to belong to the army, which was one of the key points in the project. A lot of Danes had been against the country joining the war, so Jørgensen's thinking was that, if a tank can be used for war, it can also be used to speak out against it.

Jørgensen's patchwork brainchild stands for home, family, protection and time to reflect. And when you give a tank a pink coat, it falls to pieces and gives way to a travesty that erodes its authority. The contrast between the material, the colour and the vehicle is a poem in itself. This is dazzle camouflage taken to an extreme, colours that are very hard not to notice.

The installation was exhibited in a central square in Copenhagen in 2006 with the support of the Nikolaj Kunsthal. But since Denmark joined the Iraq War, Jørgensen has been producing a series of pink tanks and is determined to stick to her guns.

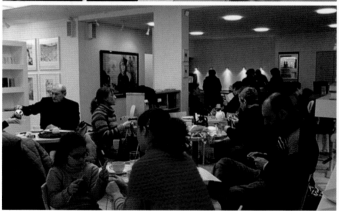

M.24 PINK CHAFFEE
Copenhahen, Denmark, 2004
© Barbara Katzin

136 /

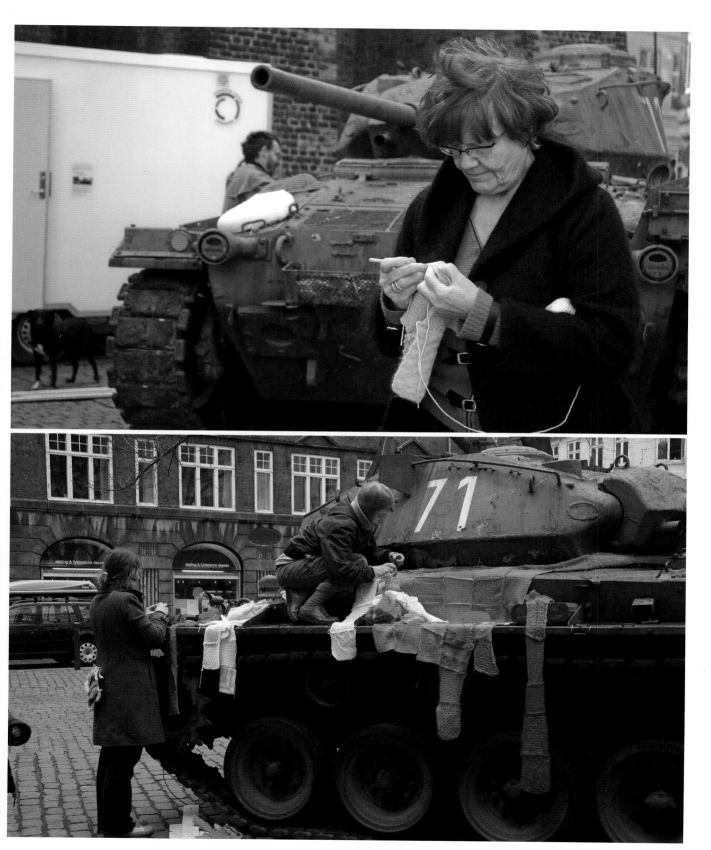

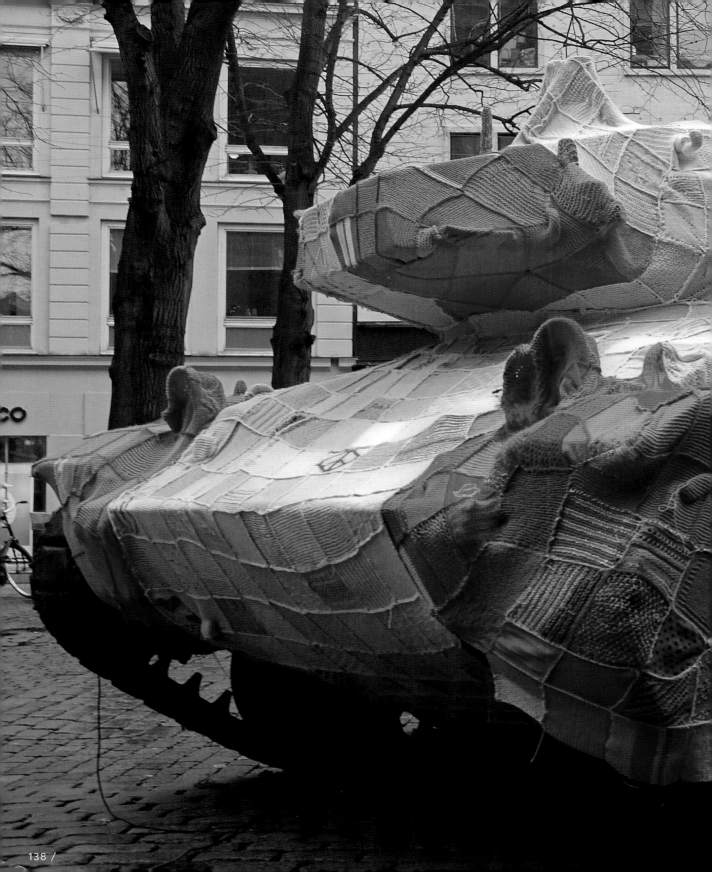

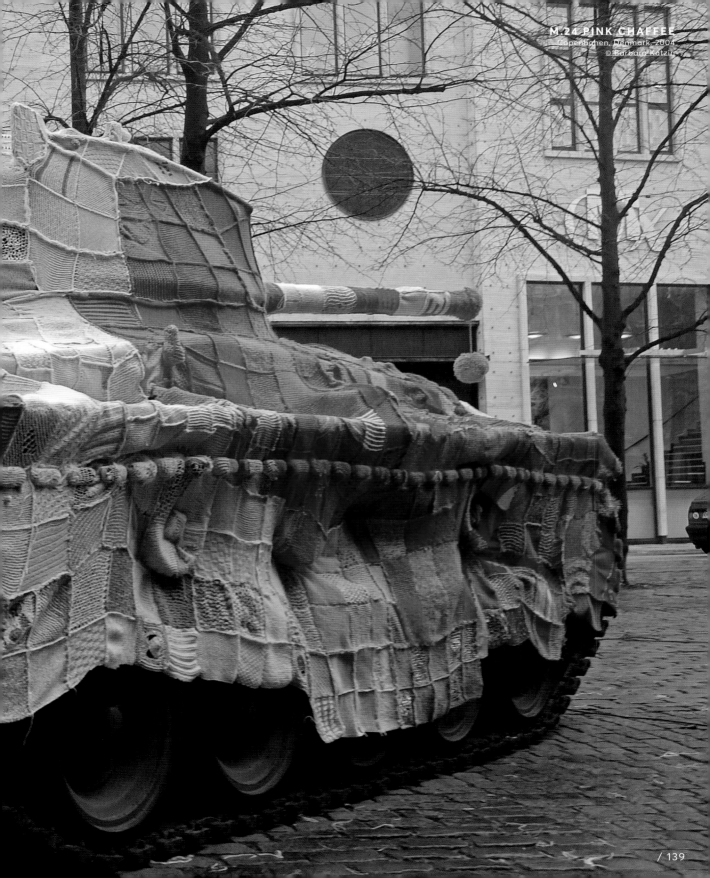

THE COLOURS OF WAR

RALPH ZIMAN

www.ralphziman.com

The image of Africa, a place of sprawling grasslands, baobab trees, megafauna and breathtaking sunsets has become an essential part of Western imagination. It overlays all the wars and the guns and all the rest. Granted, but let's not set too much store by it in case the myth collapses.

Africa as a continent has a fetishistic relationship with guns, especially the AK-47. The African that's never held one belongs to a threatened species. Of the 500 million small arms in circulation, 70 million are AK-47s. Lions devouring wildebeest, the sun setting over endless savannahs, thousands of people being wasted by small arms – better not to dwell on it too long. But let's not delude ourselves either: good journalism has brought to light heart-rending truths about the arms market in Africa, and images of the child soldier or village chief who have spontaneously let themselves be photographed in bad-boy poses clutching their weapons, sometimes even looking right into the camera, are nowadays all too familiar. It may sound perverse, but there's also something attractive, something seductive in those images. Let's be honest with ourselves: there's a beautiful perversity, an attractive sadism about them. Of course, most people feel like turning away from them yet their eyes are drawn to them for a few more seconds.

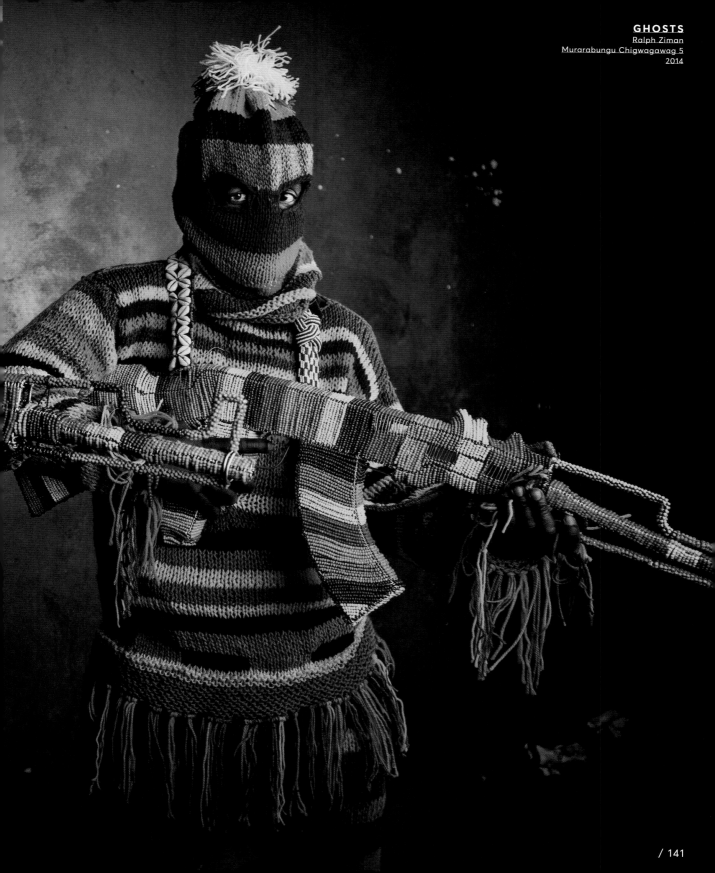

This is where Ralph Ziman and his Ghosts snap into action. As a project it has nothing invisible or phantasmagorical about it, which is precisely why it's in this book. And not just because it isn't invisible, but because it's beautifully and disturbingly visible. Raw and bright. Like all good artivist works the idea started life from a germ of madness. Carried along by his anger, and presumably by a sense of helplessness, he invited six Zimbabwean artists to craft thousands of replica bullets and hundreds of replica AK-47s out of wire and coloured beads. They worked non-stop for six months, then shipped all these non-lethal weapons to the USA in a container. That was part one of the action: a shipment of artist-crafted weapons to the great American continent. What Ziman and his fellow craftsmen made were rifles as art objects – the art of non-war. Once they'd finished manufacturing all those harmless weapons, Ziman invited all the artists for a photo session with their art-works. The results were eventually exhibited at the C.A.V.E. Gallery in California, along with the weapons themselves, as a symbol of their undying omnipresence. And, it goes without saying, to upset, unsettle and provoke. The money from the sales was ploughed back into the cause. Part two of the action was a documentary about the creative process, and a second photo session with real people in real situations.

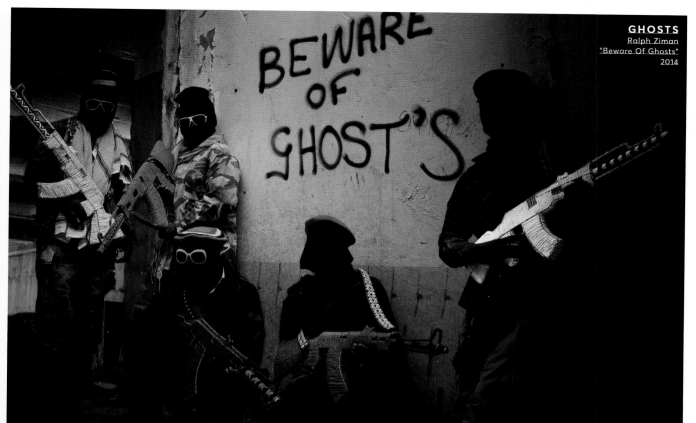

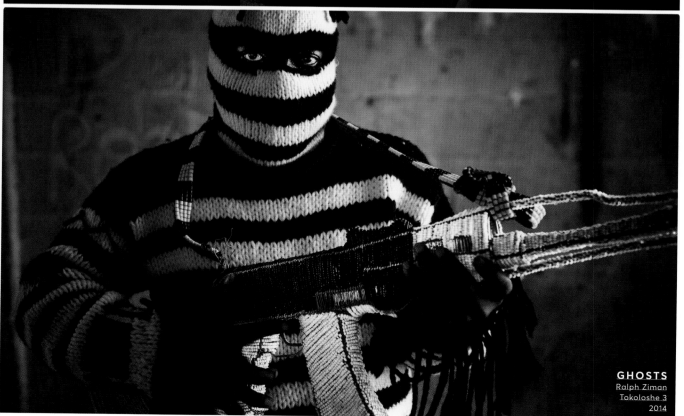

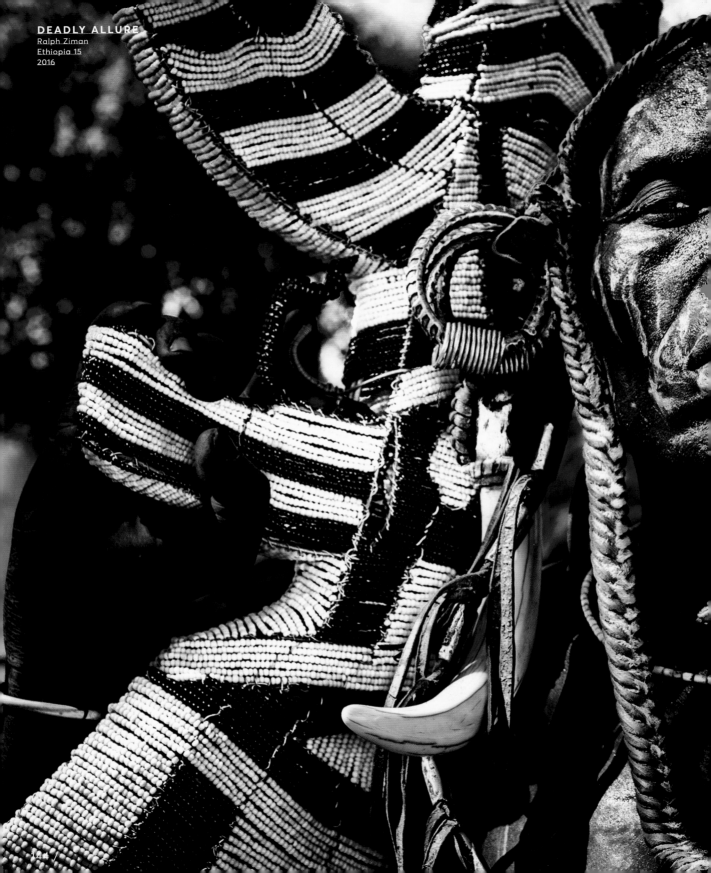

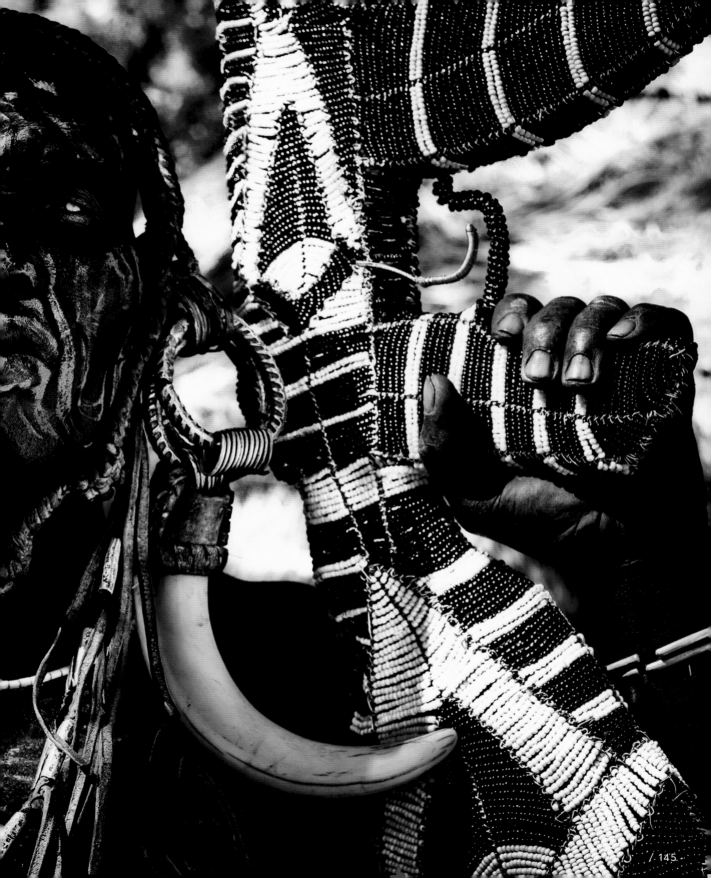

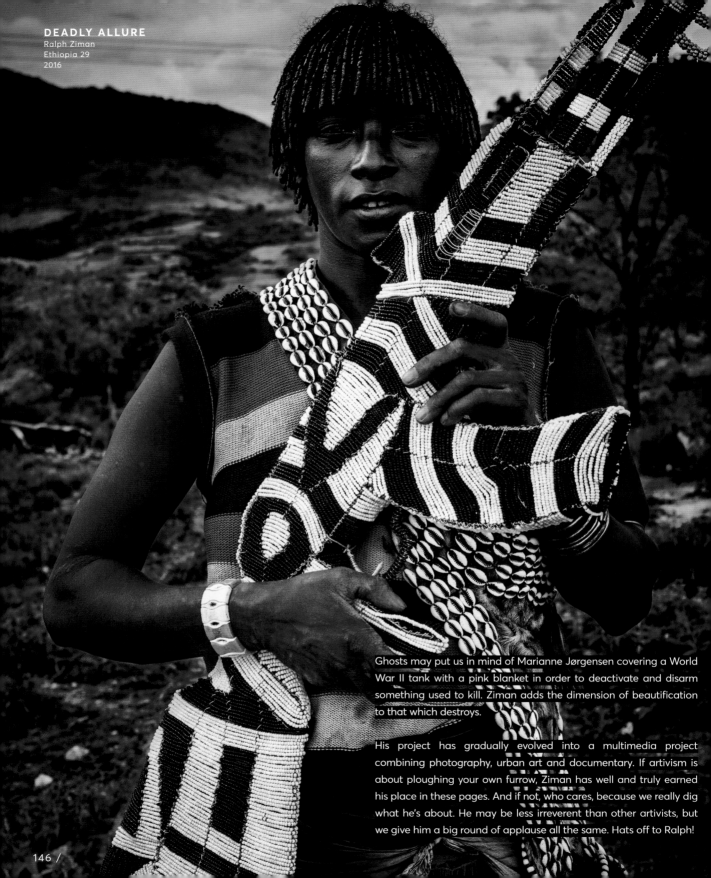

Ghosts may put us in mind of Marianne Jørgensen covering a World War II tank with a pink blanket in order to deactivate and disarm something used to kill. Ziman adds the dimension of beautification to that which destroys.

His project has gradually evolved into a multimedia project combining photography, urban art and documentary. If artivism is about ploughing your own furrow, Ziman has well and truly earned his place in these pages. And if not, who cares, because we really dig what he's about. He may be less irreverent than other artivists, but we give him a big round of applause all the same. Hats off to Ralph!

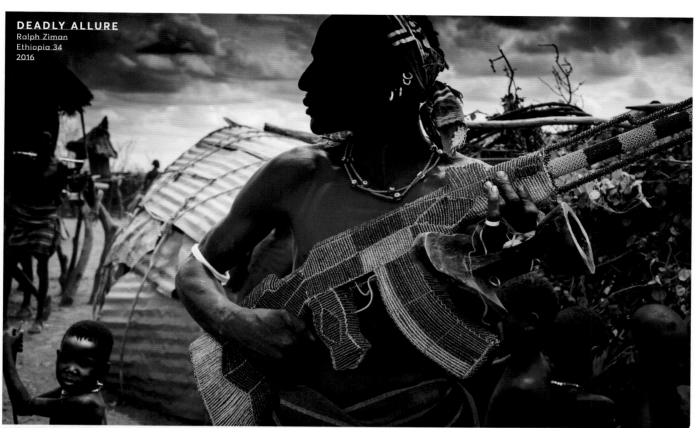

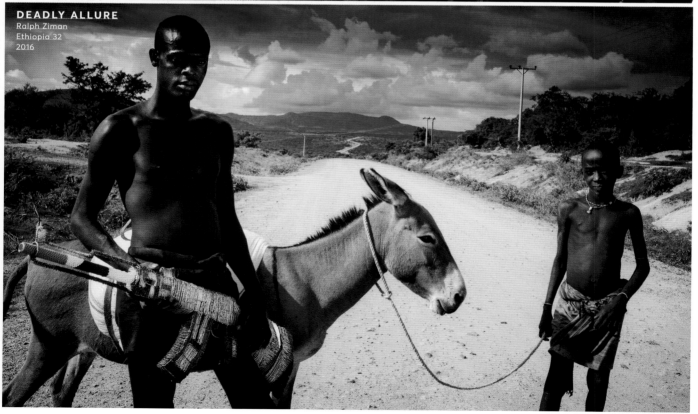

DEADLY ALLURE
Ralph Ziman
Ethiopia 32
2016

THE SOUND OF REVOLUTION

FILASTINE

www.filastine.com

Percussion was probably the first art form to come into existence, the primal form of free, creative human expression. Its inherent primitive power may be why this musician nicknamed Filastine (a 'Philistine' is someone unreceptive or hostile towards culture and the arts) born in Seattle in the 1970s (actually, nobody really knows where he was born) uses it as his main vehicle of social agitation. The concept of noise is what every artivist needs to draw the attention of society at large, but in his case it has become an integral part of his practice. His ability to compose distinctive sounds associated with a way of interacting with the world makes Filastine one of the sharpest, most unique artivists around.

He bases his game on the use of auditory codes which after just a few minutes' listening are capable of transporting us to that sensitive world of acoustic-æsthetic language, a post-Apocalyptic atmosphere that somehow pushes us to think critically, beyond the limits of its lyrical content. This may well be due to various components: on the one hand, the tough, raw, epic treatment of sound, sometimes aggressive, sometimes poetic; on the other, its evident background in some of the most underground corners on the planet. These are where Filastine gets his gloomiest sounds from, sounds he later uses in his compositions, sounds born of conflict, marginalization, darkness and the most absolute oblivion. His work can be seen not just as summing up but as forcefully restating the ultimate punk maxim 'No Future', without for a second losing any of his devastatingly contemporary artistic creativity.

But to understand his work we need to immerse ourselves in the themes of his enigmatic, energy-packed live events. Filastine's pieces are usually conceived around specific aspects of complex social issues. A case in point is his Abandon project that concentrates on the worst kind of worker exploitation, like the sulphur miners of the Kawah Ijen volcano on Java. Every day hundreds of men descend into the crater to collect heavy and smoking lumps of contaminating sulphur in baskets, which they then have to haul on their shoulders back up to the top of the volcano. They're then paid a pittance for their efforts before the material is carted off in lorries to end up as matches or fertiliser, or to bleach sugar.

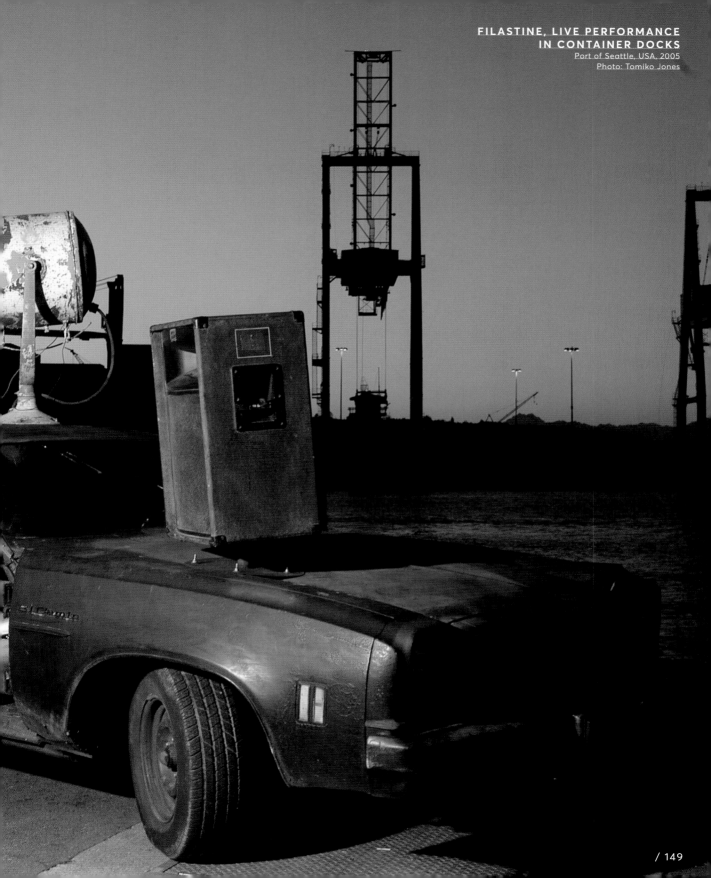

This is just one of the countless issues this artivist musician has tackled. Where you get a real sense of the themes behind his music is when you get up-close at one of his high-energy live shows: here the audio-visual dimension becomes essential, transcending the sound in an effort to capture the rawness and seriousness of the issue in question. Filastine's creations are always accompanied by a record of the conflict and audio-visuals endowed with an incalculable solemnity and power. It may be why this artivist, who combines the most primitive percussion with the most contemporary electronica, never leaves anyone unmoved: inescapable and irrevocable, his drums resonate deep, even in the most impenetrable of souls.

So Filastine raises fresh questions about what a true artivist is, isn't or may be. In the early days he put together a big 'marching band' more than 25 strong, which made a helluva noise at the major international socio-economic and environmental meetings like the G20 or G8. Nowadays he focuses primarily on the music. With the collaboration of his Indonesian partner and companion Nova, with whom he composes and who provides vocals and other sounds, he stages a new show every couple of years, which they take on tour wherever they're wanted.

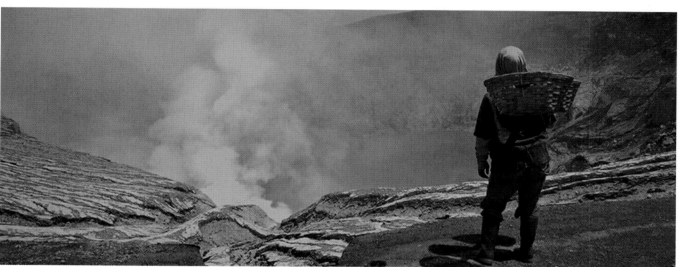

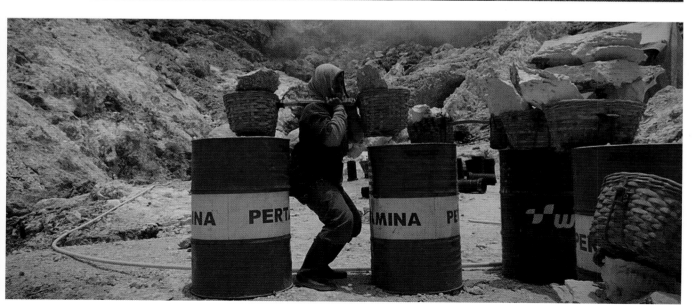

So, putting pure street action aside for a moment, can the artivist also get across the same ideas and thoughts in the format of a paid show? Can it be seen as a valid formula for extending and refining the message itself? Or should the authentic artivist only act outside any economic exchange or transaction for the gesture to be interpreted as truly pure, sincere and recognized? These days Filastine travels the world in search of the balance inherent in any artivist action, where form and beauty are as important as message or function. To achieve this balance, it requires many hours of creation and rehearsal. Filastine's work is a perfect example of transcending Situationism to spark criticism and form an anti-capitalist economic market. Another question arises in this analysis: whether this is a legitimate market or whether, adopting a consistent ethical position, we should ignore creators like Filastine the moment we're asked to pay for our tickets?

Rather than provide an exhaustive answer to these issues, it may be better to leave the whole question open and ask ourselves whether the theory of the lesser evil applies. Let's not forget that 'almost' all contemporary critical thinkers travel by plane, even Al Gore himself. So? What exactly is the real price of criticism?

INFERNAL NOISE BRIGADE, STREET PROTEST
Federal Building, Seattle, USA, 2003
Photo: Tomiko Jones

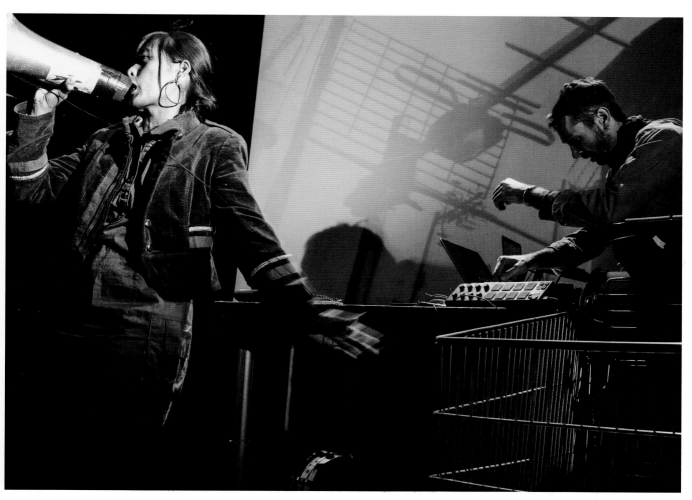

FILASTINE & NOVA, LIVE PERFORMANCE
Lisboa, Portugal, 2015
Photo: Ricardo Quaresma Vieira

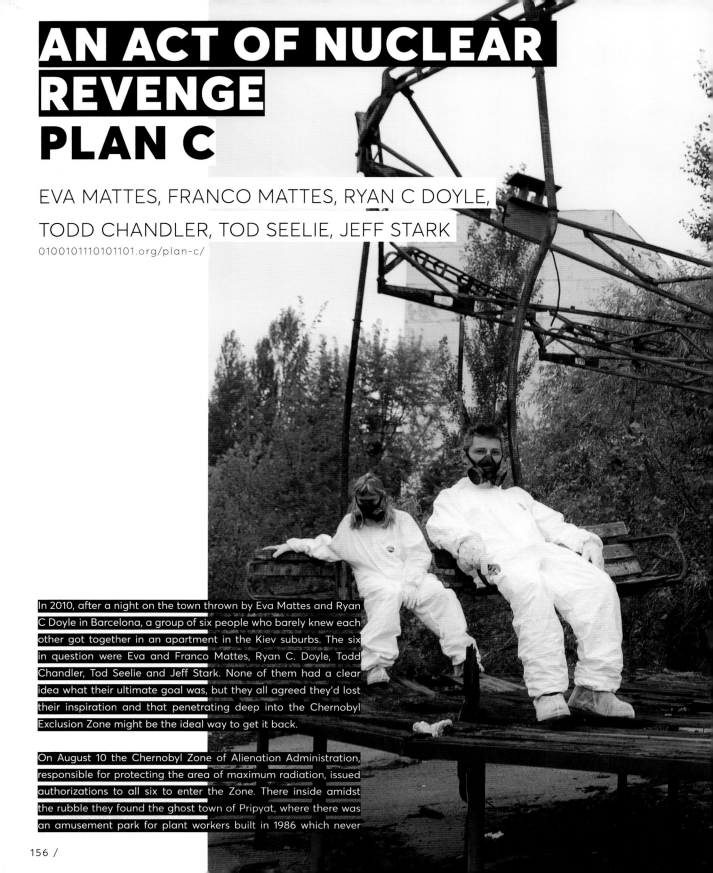

AN ACT OF NUCLEAR REVENGE
PLAN C

EVA MATTES, FRANCO MATTES, RYAN C DOYLE,
TODD CHANDLER, TOD SEELIE, JEFF STARK

010010111010101.org/plan-c/

In 2010, after a night on the town thrown by Eva Mattes and Ryan C Doyle in Barcelona, a group of six people who barely knew each other got together in an apartment in the Kiev suburbs. The six in question were Eva and Franco Mattes, Ryan C. Doyle, Todd Chandler, Tod Seelie and Jeff Stark. None of them had a clear idea what their ultimate goal was, but they all agreed they'd lost their inspiration and that penetrating deep into the Chernobyl Exclusion Zone might be the ideal way to get it back.

On August 10 the Chernobyl Zone of Alienation Administration, responsible for protecting the area of maximum radiation, issued authorizations to all six to enter the Zone. There inside amidst the rubble they found the ghost town of Pripyat, where there was an amusement park for plant workers built in 1986 which never

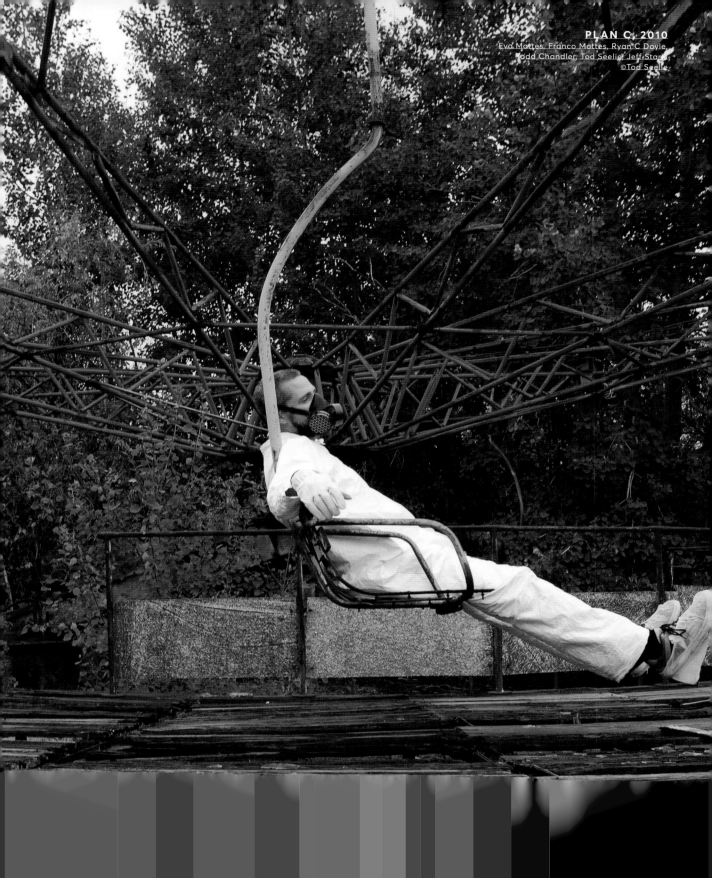

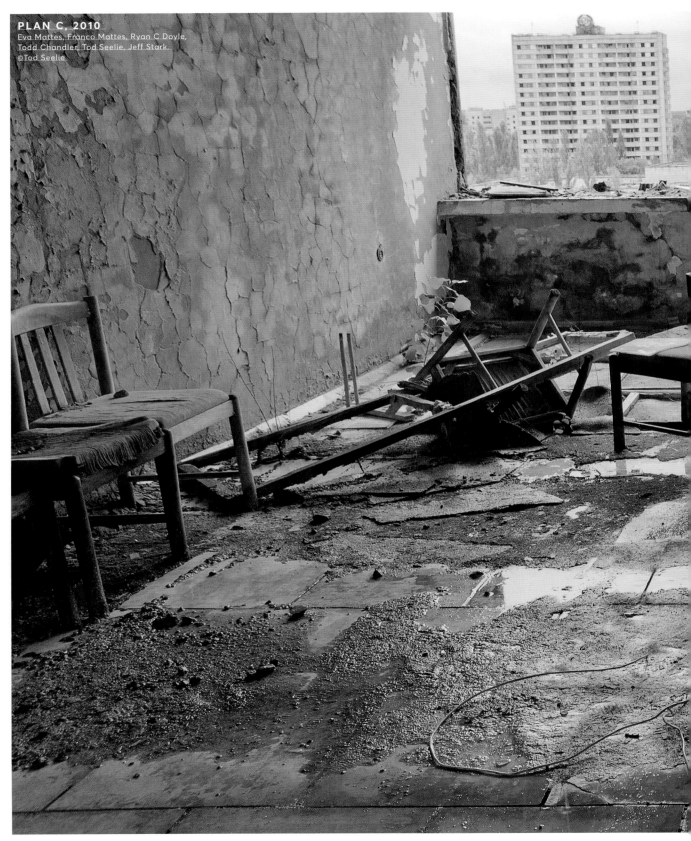

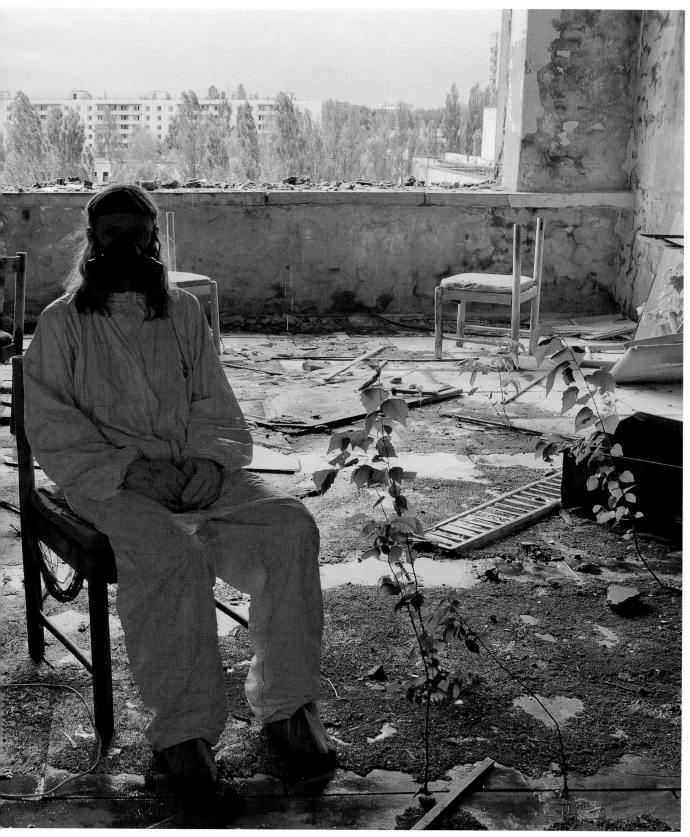

opened. What happened next was absolutely off the cuff. The initial idea was to meet up with James Acord, the world's first nuclear sculptor, but the adventure led them to the discovery of a Red Ferris Wheel. They had rediscovered their inspiration. They stripped it and collected the contaminated metal parts. How did they transport them? No idea. Where to? Manchester, UK.

A month later this vibrant, cosmopolitan city would be confronted overnight with a strange interactive mobile sculpture made out of contaminated metal, called The Liquidator, built in secret in an anonymous warehouse under the railroad. It ended up as a kind of clunky Ferris wheel and operated every day for a whole week in early October 2010, receiving thousands of visitors and disappearing as fast as it had appeared.

Franco Mattes said in an interview: 'Thousands of tons of radioactive scrap metal leave the Zone every day to be sold to the Russian and Chinese market and eventually come back to us in the form of spoons, pots and sinks.' So, just the way radioactivity left Chernobyl, it had returned to Manchester.

Radioactivity knows no limits. Nor does artivism.

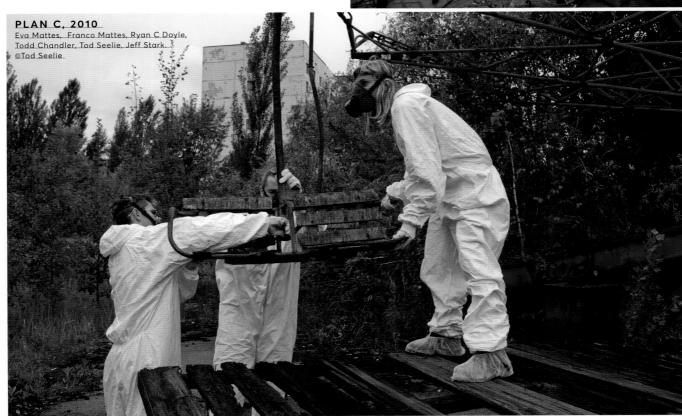

PLAN C, 2010
Eva Mattes, Franco Mattes, Ryan C Doyle, Todd Chandler, Tod Seelie, Jeff Stark.
©Tod Seelie

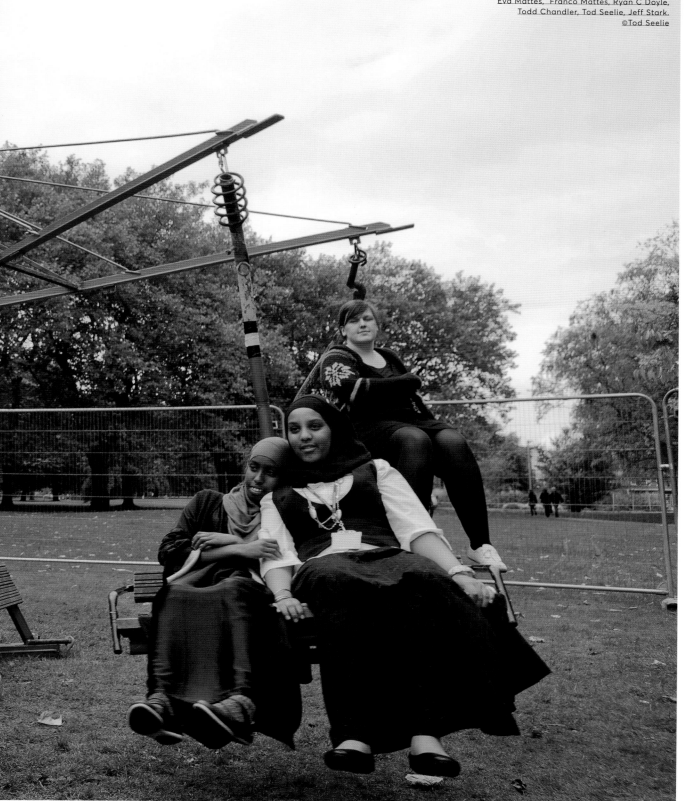

PLAN C, 2010
Eva Mattes, Franco Mattes, Ryan C Doyle,
Todd Chandler, Tod Seelie, Jeff Stark.
©Tod Seelie

THE ACADEMY OF ARTIVISM

JOHN JORDAN AND THE LABORATORY OF INSURRECTIONARY IMAGINATION

www.labofii.net

The Laboratory of Insurrectionary Imagination is a space for artists and activists to explore and create new forms of disobedience. It teaches disobedience of rules and the sharing of talents towards the qualitative improvement of new forms of possible protest. This laboratory of artivism, or what they call 'creative activism', already has broad support from other notorious artivists, like Reverend Billy and The Yes Men.

They want to change the world, tackle its problems head on, teach people how to beat the system and not to lose heart, to stir up debate and reflection, and share expertise and knowledge. The Laboratory of Insurrectionary Imagination is the glue of the social movement. Sometimes they organize actions, other times they're hired by cultural institutions.

With existing forms of protest now obsolete the idea is to unite the talents of artists and activists for effective disobedience: the artists provide a poetic and æsthetic approach; the activists look after the radical side of things. But they're always feeding back into one another, while calling the artist ego into question.

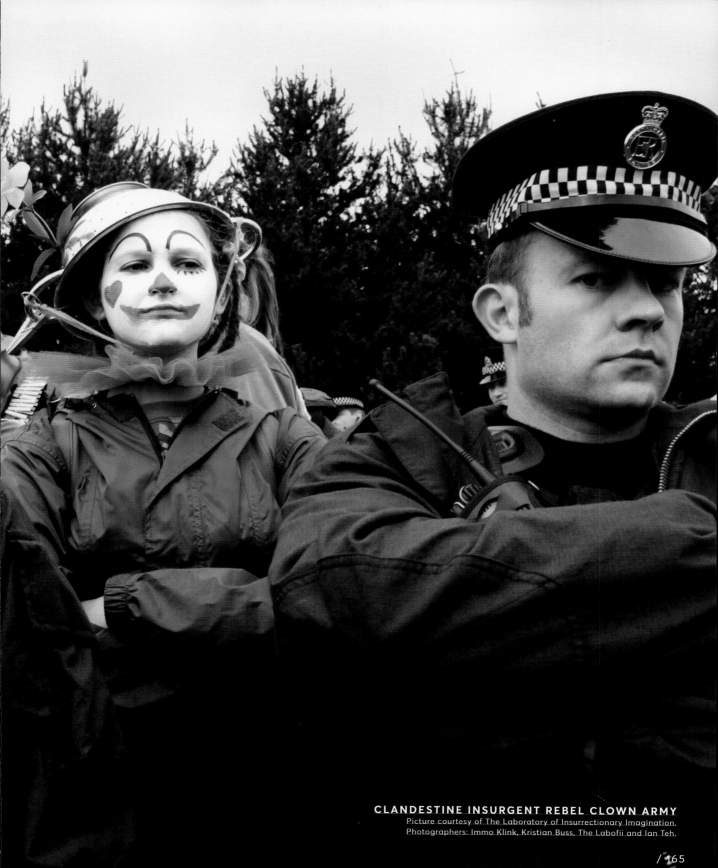

CLANDESTINE INSURGENT REBEL CLOWN ARMY
Picture courtesy of The Laboratory of Insurrectionary Imagination.
Photographers: Immo Klink, Kristian Buss, The Labofii and Ian Teh.

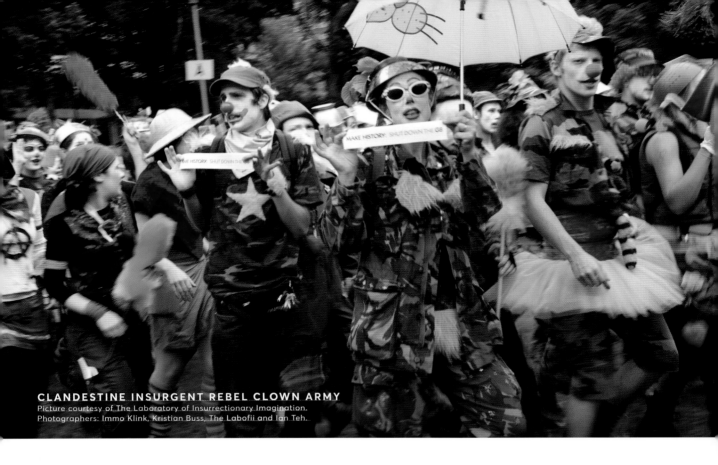

CLANDESTINE INSURGENT REBEL CLOWN ARMY
Picture courtesy of The Laboratory of Insurrectionary Imagination.
Photographers: Immo Klink, Kristian Buss, The Labofii and Ian Teh.

They once released ants in a bank. Attracted by the electronics, the ants wreaked havoc with the computers and even caused a short circuit. The Laboratory also spawned the Clandestine Insurgent Rebel Clown Army (CIRCA), a direct action group establishing a new methodology of rebellion. The methodology consists in using clowning techniques to discover the spontaneity and disobedience within us. It began in London, but over the years clown armies have sprung up all round the world. The police didn't really know how to react, accustomed as they were to confrontation but not to mockery and subversion of their authority. On a separate occasion CIRCA started a snowball fight against a banking corporation. It ended up in a veritable battlefield.

The essence of what the Laboratory does is 'radical friendship'. Through their activities they not only help to create actions or provide tools for ever more beautiful disobedience but promote the formation of politically active groups based on trust, friendship, love, horizontality and a collective spirit. If disobedience isn't truly carried out in a joint spirit, it easily falls apart. For effective disobedience strong groups need to be created whose members feel they're part of a gang.

They were once invited by Tate Modern to give a workshop on art and activism, entitled Disobedience Makes History. The Tate were delighted at the idea of having some 'real activists' in the gallery. They wanted the workshop to last two weekends and culminate in an action. Despite the gallery's excitement about inviting the Laboratory, they clearly weren't going to stick their necks out too far, so they sent them an e-mail stating the following: 'Ultimately, it is also important to be aware that we cannot host any activism directed against Tate and its sponsors, however we very much welcome and encourage a debate and reflection on the relationship between art and activism.' It so happens that Tate Modern is sponsored by BP and Shell, two of the world's largest oil companies and between them responsible for many of our planet's present evils. Their reasons for funding culture is a smokescreen, a whitewash to camouflage the wars and droughts caused by drilling for oil.

There was the rub. During the workshop the Laboratory projected the Tate's e-mail on the wall, and the participants had to decide what to do about it. There was intense debate, with some advocating disobedience and some opposed to it. Then the Tate told them there was no need to stage their closing action and stimulating reflection on

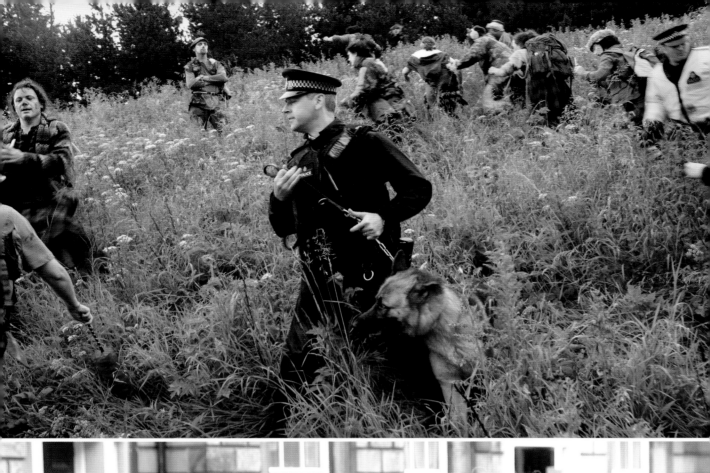

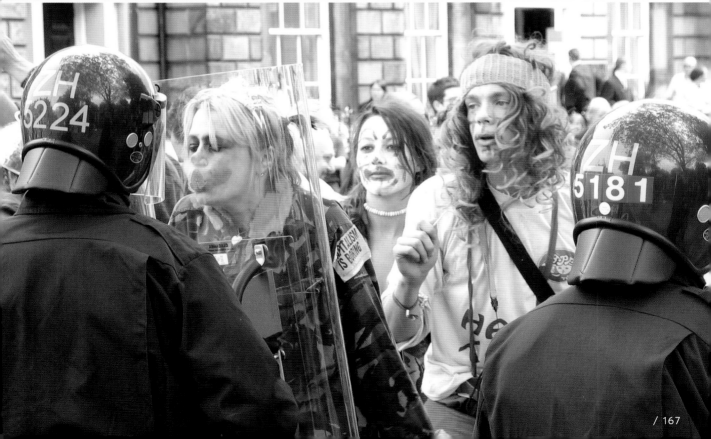

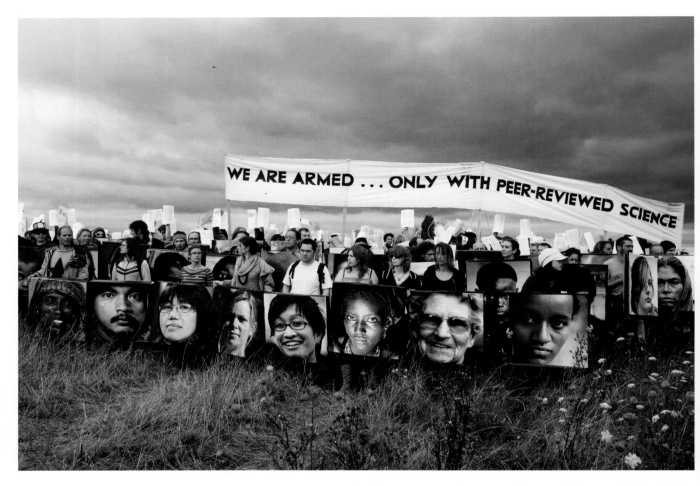

WE ARE ARMED ... ONLY WITH PEER-REVIEWED SCIENCE

Picture courtesy of The Laboratory of
Insurrectionary Imagination.
Photographers: Immo Klink, Kristian
Buss, The Labofii and Ian Teh.

the close bonds between art and activism had been enough. Still, the Laboratory did just what they felt like doing, fully aware they'd never be invited back. From this episode they drew their greatest lesson: to bring about societal sea change, you have to destroy your cultural capital. So they went ahead and staged the action. Then they staged others: seventeen over a period of six years. One of them was during Tate Modern's tenth birthday celebration, shortly after the sinking of the offshore oil-rig Deepwater Horizon, which devastated wildlife and communities. The Laboratory affiliated group, Liberate Tate, gate-crashed the birthday party and released black helium balloons, to which they'd tied oil-slicked dead fish. The stench was overpowering, and because the balloons floated straight up to the ceiling, there was nothing for it but to shoot them down.

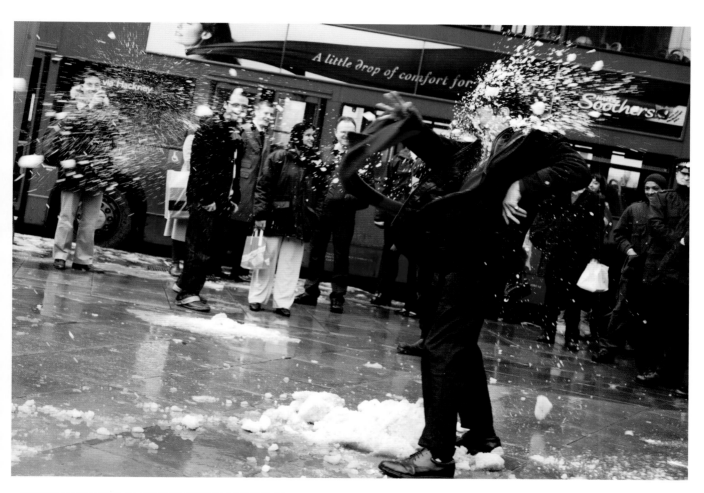

Such experiments have led the Laboratory to formulate fifteen basic principles for effectively creating beautiful problems, such as knowing your cultural terrain, applying æsthetic discipline always, shifting the spectrum of allies, putting your target in a decision dilemma, etc.

The lab now lives at the zone a défendre (zad), 4,000 acres of squatted wetlands, where they are fighting to avoid the construction of an airport. With 60 living collectives experimenting shared forms of life in a giant laboratory of commoning that the French government call 'the territory lost to the republic'. Their latest experiment is to build a full scale working defensive lighthouse, to welcome people to the zone and warn of the dangers to come.

THE PEOPLE VS THE BANKERS
Picture courtesy of The Laboratory of Insurrectionary Imagination.
Photographers: Immo Klink, Kristian Buss, The Labofii and Ian Teh.

THE HOTEL WITH THE WORST VIEW IN THE WORLD
THE WALLED OFF HOTEL

BANKSY

www.walledoffhotel.com

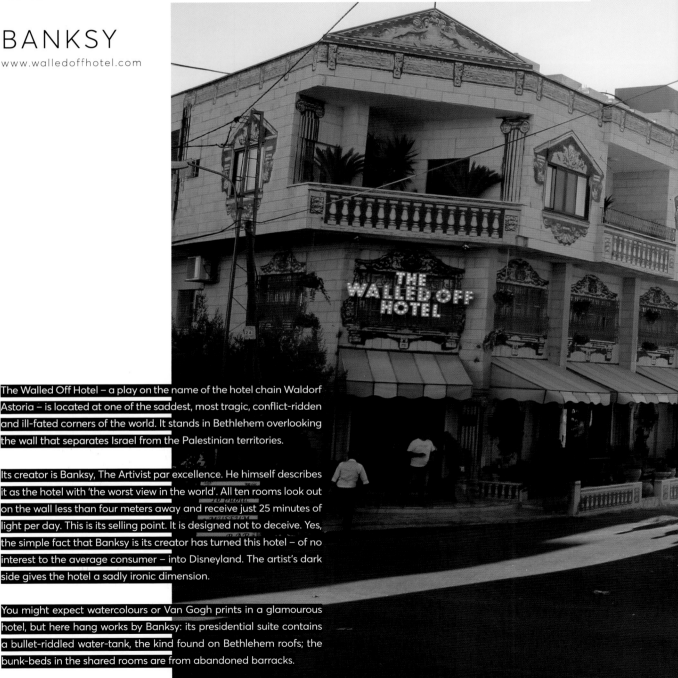

The Walled Off Hotel – a play on the name of the hotel chain Waldorf Astoria – is located at one of the saddest, most tragic, conflict-ridden and ill-fated corners of the world. It stands in Bethlehem overlooking the wall that separates Israel from the Palestinian territories.

Its creator is Banksy, The Artivist par excellence. He himself describes it as the hotel with 'the worst view in the world'. All ten rooms look out on the wall less than four meters away and receive just 25 minutes of light per day. This is its selling point. It is designed not to deceive. Yes, the simple fact that Banksy is its creator has turned this hotel – of no interest to the average consumer – into Disneyland. The artist's dark side gives the hotel a sadly ironic dimension.

You might expect watercolours or Van Gogh prints in a glamourous hotel, but here hang works by Banksy: its presidential suite contains a bullet-riddled water-tank, the kind found on Bethlehem roofs; the bunk-beds in the shared rooms are from abandoned barracks.

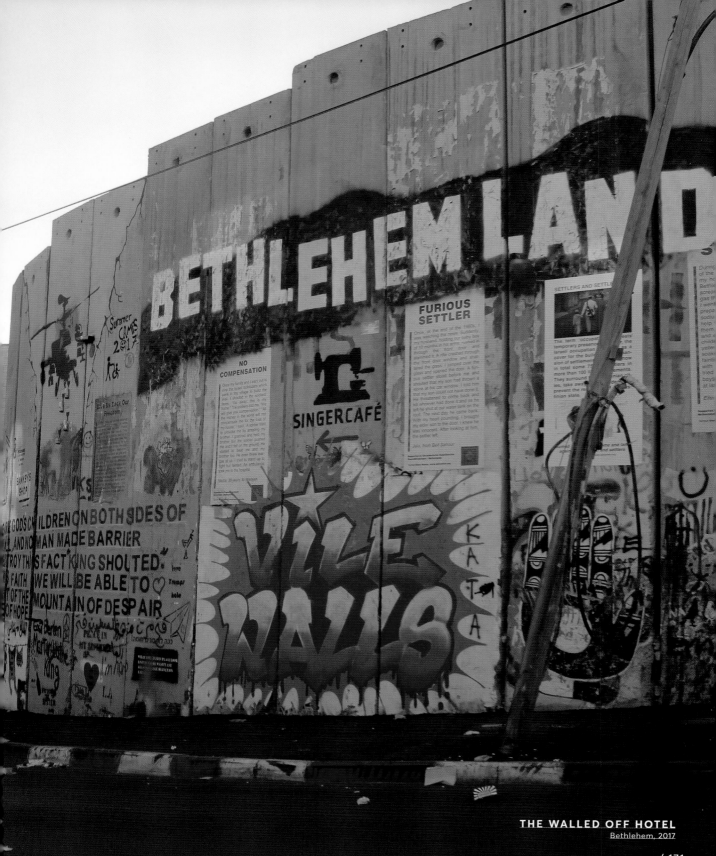

As an artist Banksy has always been highly sensitive to the Israeli-Palestinian conflict. He painted the wall as early as 2005 with iconic works such as 'Window on the West Bank' and 'Balloon Debate', returning in 2007 to create 'Armoured Dove of Peace' amongst others as part of the infamous Santa's Ghetto held in Bethlehem Square.

The Walled Off project has promoted employment, generated economic activity in the local population and opened up a valuable tourist market for the city. But let's tell it like it is: this is no hotel; it's a beautiful form of provocation, an invitation to dialogue, an opportunity for comradeship: "Our Palestinian management and staff offer an especially warm welcome to young Israelis who come with an open heart", says team Banksy.

THE WALLED OFF HOTEL
Bethlehem, 2017

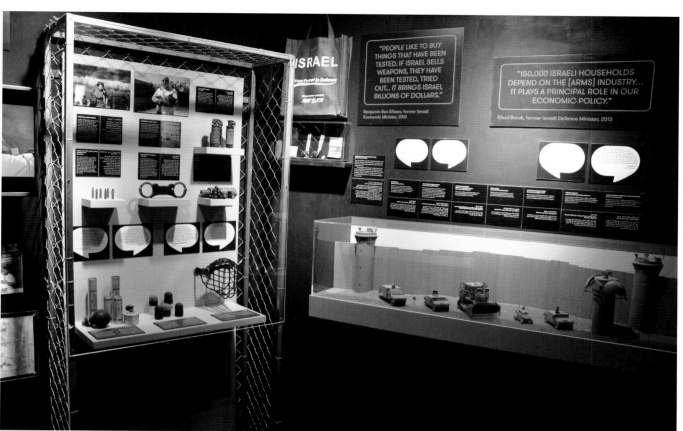

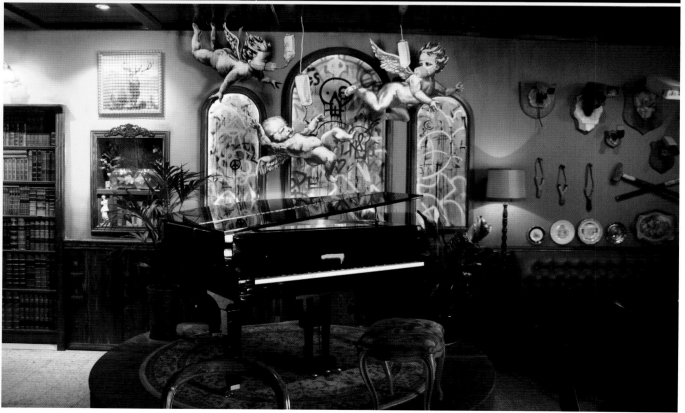

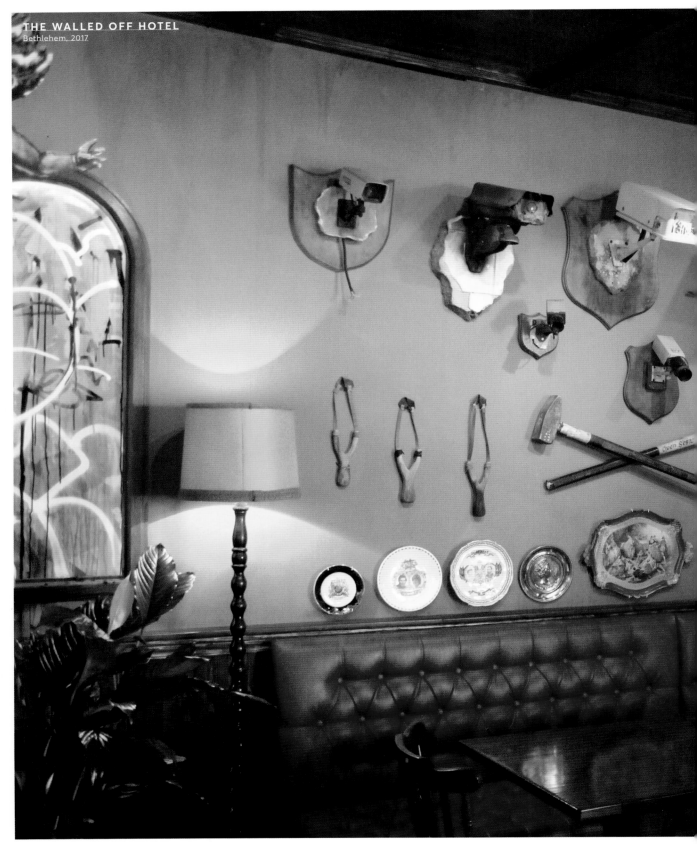

A WHOLE HEAP OF BEAUTY AND STORIES

PEJAC
www.pejac.es

Surrealism, urban art, social art: whenever Pejac's name comes up, these are the three concepts that define him. However, he isn't exactly what you'd call a fixture on a hypothetical list of artivists. This led us to question whether the few defining premises of 'artivism' need broadening, or if it's just tremendously difficult to classify anyone as such. Certain doubts occur where Pejac's concerned, and his actions open up many lines of inquiry. Which is why he deserves his space here. Whether he is or isn't an artivist is a subjective question. Some say he is, others say he isn't. We ourselves are divided on the issue: Arcadi proposed including him here, and I felt the chapter would serve to open up the debate. The first contradiction we encountered was that we came up against our own loathing of cataloguing art. Yet choosing who stays in and who's left out of a book on artivism is nothing if not an act of cataloguing. So, we're being inconsistent. That's what makes a journey like this interesting.

I'll take a leaf out of those 'Choose Your Own Adventure' books, where the plot twists and turns this way or that depending which path you choose. So here's the first adventure: let's say Pejac definitely is an artivist and defend him as one. Pejac is an artivist for two reasons: because every one of his works is completely defined by his social and ecological commitment; and because he willingly takes artistic responsibility for his own work. If we divide the portmanteau 'artivism' into its components, 'art' and 'activism', we can call Pejac an 'activist' because at no time does he ease up on his commitment, restlessness, melancholy or discontent, and an 'artist' because he has a powerful æsthetic drive. The beauty and thought-provoking nature of his street art stops the spectator dead in their tracks. On his own website and other sites that reference him there are many photos of his works with random observers: people taking time out to stop and look at his works. He himself often states in interviews that if he gets people thinking as they walk past, then it all makes sense. So, we conclude, Pejac himself does speak to people, to passers-by who happen unexpectedly upon his works. Surprise. An artivist action must always be a surprise.

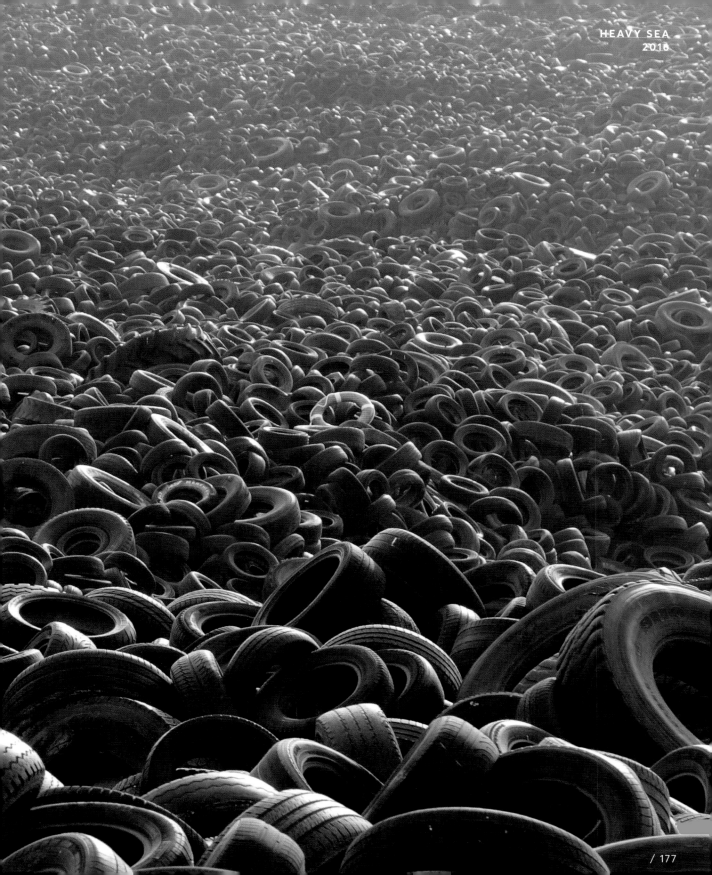

MIGRATION, AL-HUSSEIN
PALESTINIAN REFUGEE CAMP
Amman, Jordan, 2016

Then I stop to think about his canvases, the ones hanging on walls, which only see the street when they're moved about. Looking at Pejac's pictures, we see real scenes, painful situations and apocalyptic yet plausible imagery. Pejac's indoor works form a brutal continent of believable images that evoke scenes of desolation. There's an ethical and æsthetic coherence to his double life as an artist.

A powerfully beautiful story is attached to one of his canvases and one of his urban interventions. Two of his works are entitled Heavy Sea: one a watercolour from 2013; the other a physical intervention photographed and recorded in 2016. Both works have the same subject: an ocean of tyres with a red life-belt floating on the surface. The egg in this case clearly came before the chicken: the watercolour was a response to a landscape of his imagination, whereas the action was sparked by an unfortunate encounter with the very same landscape three years later, when to the sea of tyres he added the life-belt he'd drawn earlier. In a statement Pejac said: 'It was like reliving the watercolour I'd once painted, like walking through the paper into my own imagined world. It was as exciting as it was dramatic.' The anecdote serves to show just how packed with reality Pejac's imagination is and how connected his indoor and outdoor work are. When thinking about what artivism is, one question that's always cropping up is whether the street should be the only physical context where it takes place?

THE RE-THINKER
Hong Kong, China, 2015
© Pejac

178 /

Now let's follow in the steps of someone who took the other road in their adventure. Let's imagine we cannot categorically say that Pejac is an artivist, but that he has a chapter here either because he challenges the very definition of artivism or because he expands the boundaries of the concept. If Pejac didn't appear on our hypothetical list of artivists, it would be because the line between committed political and critical art and artistic activism were too thick. There's quite a margin for classification, so even if an artist does create socially and politically committed work, they're highly unlikely to fall into the category of artivism. Even today artivism is still seen as a recent movement with links to protests against globalization and the armed conflicts triggered by it. It's been claimed that artivism's main goal is to push political agendas and expose the wrongdoings of the ruling classes. To achieve such exposure, what's clearly needed is a short-to-medium-term tactic. Artivism is also associated with protest against advertising and the consumer society. It forms part of the history of critical art but goes one step further in its desire to make the world aware of mechanisms of domination and to transform the spectator into an actor aware of their own transformation. In other words, the context in which artivism took its first steps produced a highly specific and categorical definition that still prevails. If we were to stick strictly to this definition of artivism, then Pejac would get left out. We may add that the evolution of artivism has led to the incorporation of more avant-garde work which continues to puncture and tear reality so that any damage beyond repair and any solution must be immediate. Pejac moves to a place – Hong Kong, Jordan, Istanbul, wherever – incorporates its context and beautifies it in small actions with big insights: to think is to change the world.

One work of Pejac's sets up an interesting paradox: a small-scale watercolour intervention of Rodin's The Thinker on a window-pane. Here the interior connects with the outside world by means of an optical illusion. Entitled The Re-Thinker, this work was done in Hong Kong during the protests of October 2015 which questioned the immovability and impermeability of mainland China's political structures. Urban art and graffiti are both completely outlawed in China. One study conducted by an international group of art lawyers found that China is the most dangerous country in the world for urban artists. And Pejac woz there. According to him, he weighed up his options and decided to go ahead and do a painting on a hotel bathroom window. The fact that the system forbids the use of the public space for protest and that the system can grind you underfoot for expressing yourself reflects the street's power for self-expression. By this we mean that, just as artivism has by definition to tear up reality, reality is also capable of tearing up the artivist. When artivism tears up reality, it causes a major fracture in the system itself. It's like taking a screw out of the machine, which in turn affects the whole production line.

Whether to include Pejac or not depends on which adventure you choose.

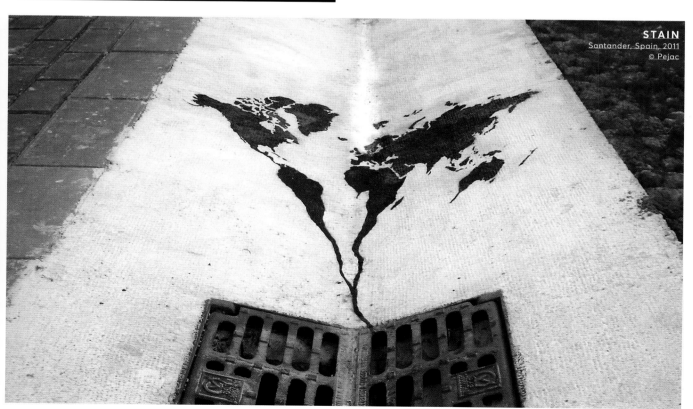

STAIN
Santander, Spain, 2011
© Pejac

SO FAR, SO GOOD

VINZ
www.vinzfeelfree.com/

Vinz's work is a highly stylized symbolic-æsthetic construct grounded in a critical view of consumer society.

After such an introduction you may be forgiven for thinking Vinz is just another classic case of glib, opportunistic artivism along all too familiar lines: that excessive consumerism is a very bad thing, blah blah blah, social automata, blah blah blah… But look again. Vinz is a special case whose qualities deserve special attention. His images are the result of meticulous, highly conscious work which goes beyond criticism for criticism's sake. The concern he shows for the consequences of the world being built by contemporary humanity is real and honest. Vinz's work contains certain singularities that tend not to be obvious at first sight: while the public is at once attracted and distracted by the beauty of a simple nude in the public space – a sight today as common as it's extraordinary – he uses the nude openly and brazenly to catch the eye and spark a thought in the observer. We could describe this as a case of urban suggestion or simply as a straightforward exercise in free-flowing open communication.

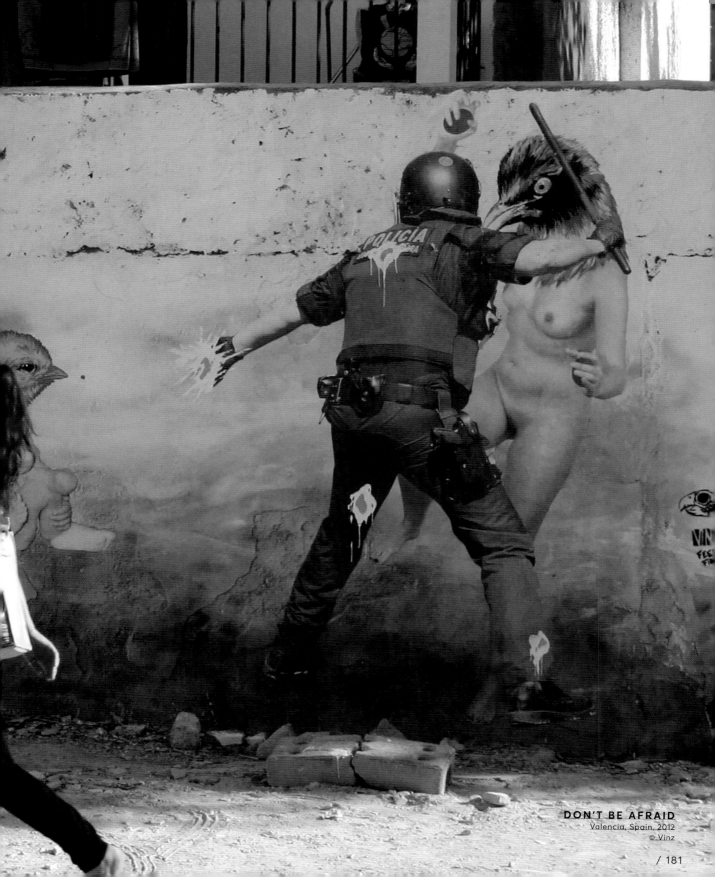

DON'T BE AFRAID
Valencia, Spain, 2012
© Vinz

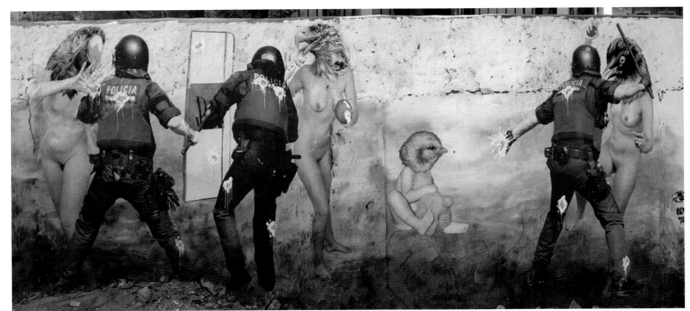

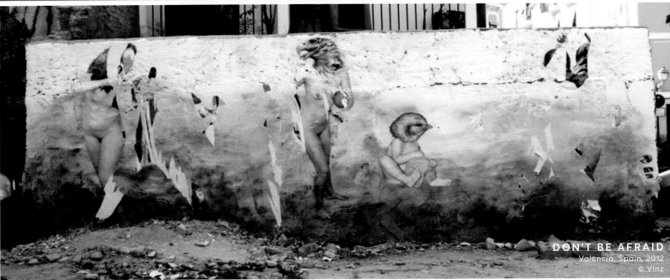

Deploying this complex, meticulously conceived æsthetic repertoire Vinz breaks with the canons of subversive thought. His singularity arises from the combination of his unique technique and composition playing with surfaces almost always illegally and almost always in the street. The passer-by stumbles across hybrid characters, half human, half animal, usually naked, which throw thoughts at us in a highly graphic way, sometimes accompanied by a text or protest in the form of street-signs, placards or banners. Among the array of characters three major groups stand out: reptiles dressed as riot police standing for authority, fish in swimsuits for consumerism and naked birds for freedom. These are the building blocks of his visual and gestural world. In this overt exercise in anti-system propaganda Vinz's figures interact and confront each other through the design of various scenes, or give us glimpses into the dark and hidden corners of their inner worlds.

In terms of technique Vinz's work is the diametrical opposite of the classical painter's: first he outlines the scene on paper, then finds a human model to represent the character and photographs them in the studio; lastly he posts the paste-up of the naked body on the wall and paints in the animal heads by hand. His works crop up in many cities around the world, but New York is one of his favourite backdrops, where he frequently collaborates with the Wooster Collective in its efforts to disseminate ephemeral culture.

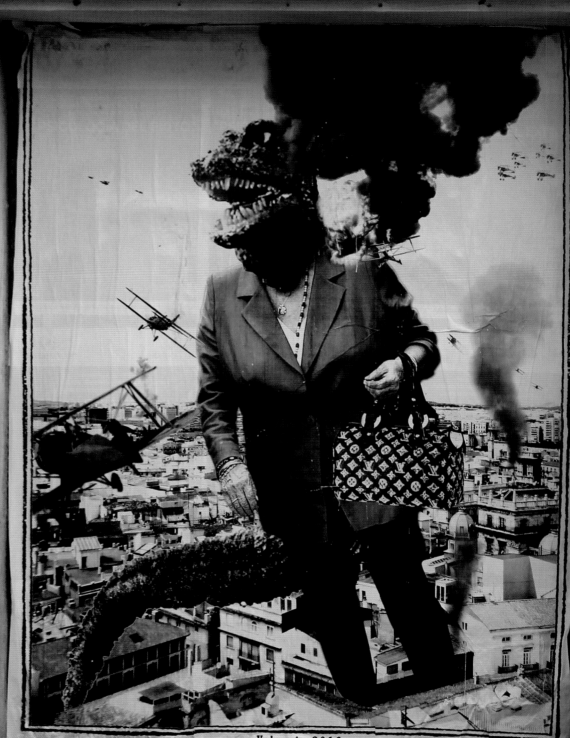

·Valencia 2016·

EL HUNDIMIENTO [SINKING]
Valencia, Spain, 2016
© Vinz

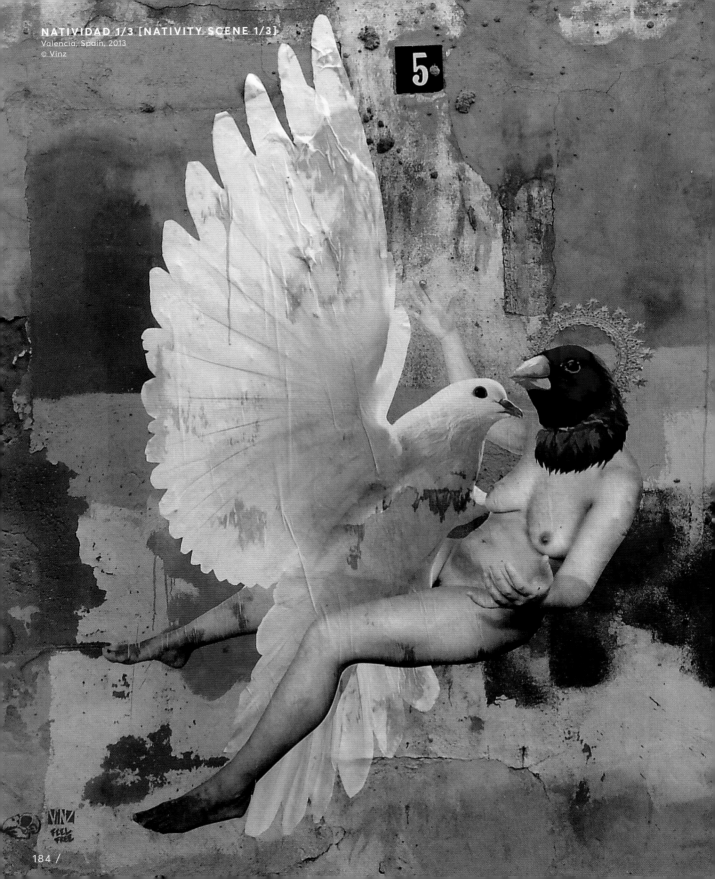

Many pieces are also to be found on the streets of his native Valencia in Spain, a highly conservative city where his works have been more heavily censored than elsewhere, the naked genitalia and breasts of his characters repeatedly being torn off the wall.

In what has become known as the Valencian Spring – a time of intense student rioting and social revolt against government policies intended to squeeze the middle and lower classes with massive cuts to education and other social services – Vinz was invited to take part in a local festival called 'Incubarte' [Incubart]. As an artist committed to the current political and social climate he put the spotlight on wives and daughters in several mining communities locked in a struggle against the government: the works depicted naked women with birds' heads confronting riot police. Within a few short hours the paste-ups of the policemen had been torn off the walls; it soon came to light that the police themselves were responsible, and Vinz went on to become an icon of the struggle. This is a case in point of just how histrionic and perverse the system can be, when those who should be protecting our freedom of expression are precisely the ones repressing and censoring it.

Vinz keeps his distance from the conventional international street art scene, a counterpoint that sets him in another dimension, often closer to the urban subvertising movement. His main purpose is to catalyse thought and renew the struggle in the collective imagination. His images are powerful, dark, disturbing and aggressive. They grab the man-in-the-street by the lapels. Yet amidst the relentless scream of advertising and suggestion the citizen can find a quiet oasis of sanity in Vinz's images, a plain-talking exposure of the social reality that politics makes every effort to disguise.

His tag says it all: when it came to choosing a moniker to escape prosecution by the authorities for his unremitting illegal actions, he decided to take the name 'Vinz' in honour of French actor Vincent Cassel (Vince) who plays 'Vinz' in Mathieu Kassovitz's film La Haine [Hate]. The central metaphor is of a society in free-fall repeating to itself the mantra 'Jusqu'ici tout va bien' – 'So far, so good' – as it plunges into the void.

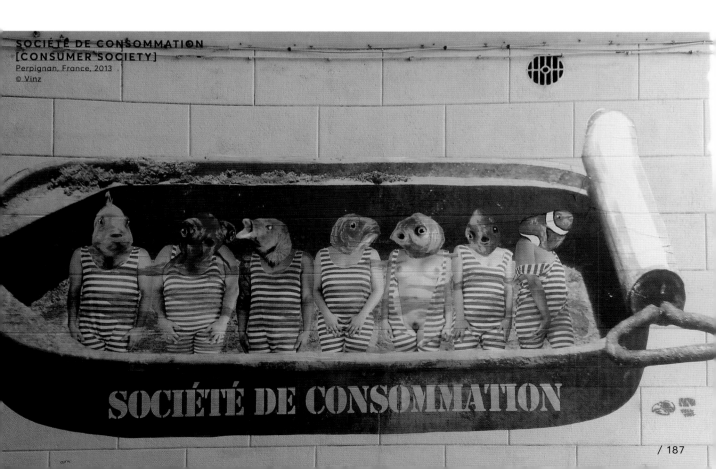

SOCIÉTÉ DE CONSOMMATION
[CONSUMER SOCIETY]
Perpignan, France, 2013
© Vinz

I COULD REALLY DO WITHOUT THE APOCALYPSE RIGHT NOW

ESCIF

WWW.STREETAGAINST.COM

'I don't believe art's about painting big walls or appearing in books or earning millions of dollars. Art isn't about history or the business world. Art's about investigating, expanding people's consciousnesses, experimenting with limits, about curiosity and constant search. Art's about the human need to understand the secrets of our existence. There are two possible pathways to take in this search: towards or away from reality. I've chosen to move towards it, because it's only by walking that pathway that I feel lighter.'

This is how the Valencian artist defines art: 'a way of looking imbued with great sensitivity and a critical spirit'. These are in evidence in all his projects, all quite different from each other. Today Escif is one of the most highly respected muralists and urban conceptual artists among critics and public alike. Banksy himself contacted him personally to invite him to take part in his Dismaland project, a pop-up post-Apocalyptic amusement park in the UK town of Weston-super-Mare.

Escif's visual language is simple and concise, shunning the kind of spectacle and grandiloquence the urban art scene has been feeding us in recent years. His work radiates honesty and simplicity, which he uses to establish an intimate relationship with the spectator through images and ideas that at first sight seem easy to grasp, yet carry an undeniable, inherent conceptual charge which sometimes depends on humour, other times on the most searing and caustic criticism.

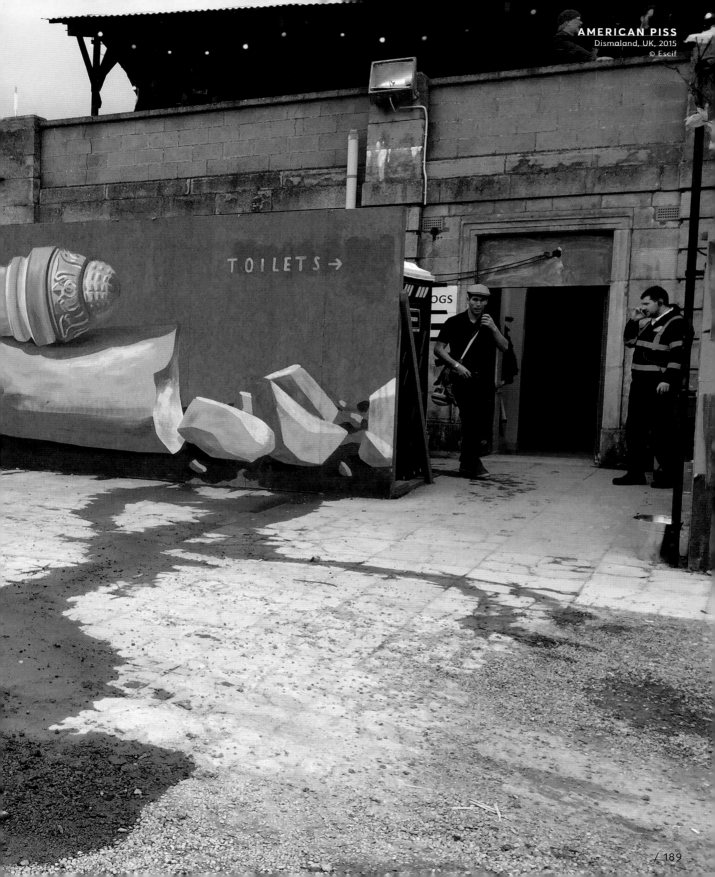

TOILETS →

APPLAUSE PLEASE
Grotaglie, Italy, 2012
© Escif

ECLIPSE
Valencia, Spain, 2014
© Escif

His radical situationist philosophy leads him to immerse himself deeply in the settings where he works and to devote more time to understanding than to responding. This way he makes sure that these responses avoid the levels of colonization present in those of many other artists: his respect for the people who live with his pieces couldn't be greater, nor could his commitment to ideas and reflection. However, this respect in no way makes his work indulgent. Just the opposite, its effect is often to provoke a reaction in the context itself and involve it in reflections about its own reality. It's his realitywards approach of his that ensures that each piece is perfectly contextualized.

Escif is the perfect example of an artist serving the community at large, rather than the other way round. This anti-colonizing spirit is graphically apparent in projects like those in Senegal or India, where he played with the concept known to some as the 'tyranny of the author', essentially removing the immense ego that often suffuses the artist and the work. To this end, he printed some posters, which he pasted up around the different villages he was working in, offering his services in exchange for whatever – a prayer, a plate of food, a haircut and so on.

EDUCACIÓN PARA LA CIUDADANÍA
[EDUCATION FOR CITIZENSHIP]
Valencia, Spain, 2012
© Escif

CHEIKH MAKHFOUSS
OULD CHEIKH TOURAD

LES PETITES ÉCHANGES [SMALL EXCHANGES]
Dakar, Senegal, 2014
© Escif

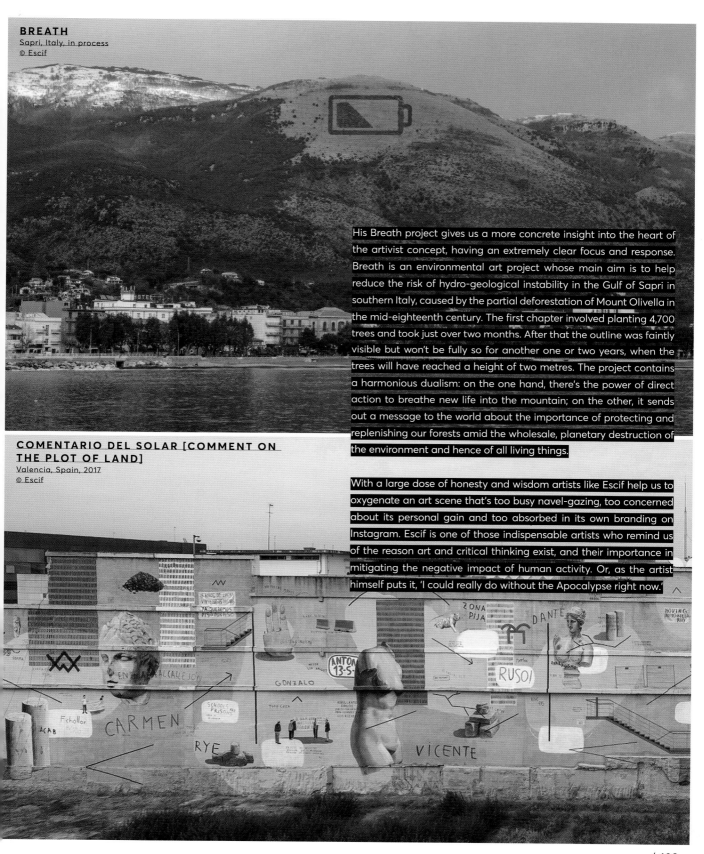

BREATH
Sapri, Italy, in process
© Escif

His Breath project gives us a more concrete insight into the heart of the artivist concept, having an extremely clear focus and response. Breath is an environmental art project whose main aim is to help reduce the risk of hydro-geological instability in the Gulf of Sapri in southern Italy, caused by the partial deforestation of Mount Olivella in the mid-eighteenth century. The first chapter involved planting 4,700 trees and took just over two months. After that the outline was faintly visible but won't be fully so for another one or two years, when the trees will have reached a height of two metres. The project contains a harmonious dualism: on the one hand, there's the power of direct action to breathe new life into the mountain; on the other, it sends out a message to the world about the importance of protecting and replenishing our forests amid the wholesale, planetary destruction of the environment and hence of all living things.

With a large dose of honesty and wisdom artists like Escif help us to oxygenate an art scene that's too busy navel-gazing, too concerned about its personal gain and too absorbed in its own branding on Instagram. Escif is one of those indispensable artists who remind us of the reason art and critical thinking exist, and their importance in mitigating the negative impact of human activity. Or, as the artist himself puts it, 'I could really do without the Apocalypse right now.'

COMENTARIO DEL SOLAR [COMMENT ON THE PLOT OF LAND]
Valencia, Spain, 2017
© Escif

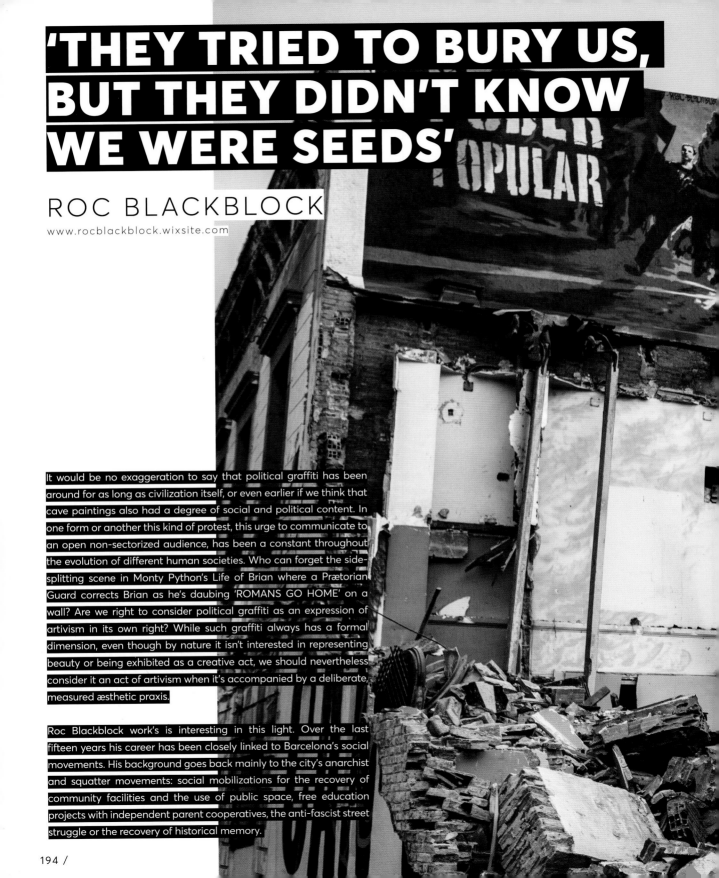

'THEY TRIED TO BURY US, BUT THEY DIDN'T KNOW WE WERE SEEDS'

ROC BLACKBLOCK
www.rocblackblock.wixsite.com

It would be no exaggeration to say that political graffiti has been around for as long as civilization itself, or even earlier if we think that cave paintings also had a degree of social and political content. In one form or another this kind of protest, this urge to communicate to an open non-sectorized audience, has been a constant throughout the evolution of different human societies. Who can forget the side-splitting scene in Monty Python's Life of Brian where a Prætorian Guard corrects Brian as he's daubing 'ROMANS GO HOME' on a wall? Are we right to consider political graffiti as an expression of artivism in its own right? While such graffiti always has a formal dimension, even though by nature it isn't interested in representing beauty or being exhibited as a creative act, we should nevertheless consider it an act of artivism when it's accompanied by a deliberate, measured æsthetic praxis.

Roc Blackblock work's is interesting in this light. Over the last fifteen years his career has been closely linked to Barcelona's social movements. His background goes back mainly to the city's anarchist and squatter movements: social mobilizations for the recovery of community facilities and the use of public space, free education projects with independent parent cooperatives, the anti-fascist street struggle or the recovery of historical memory.

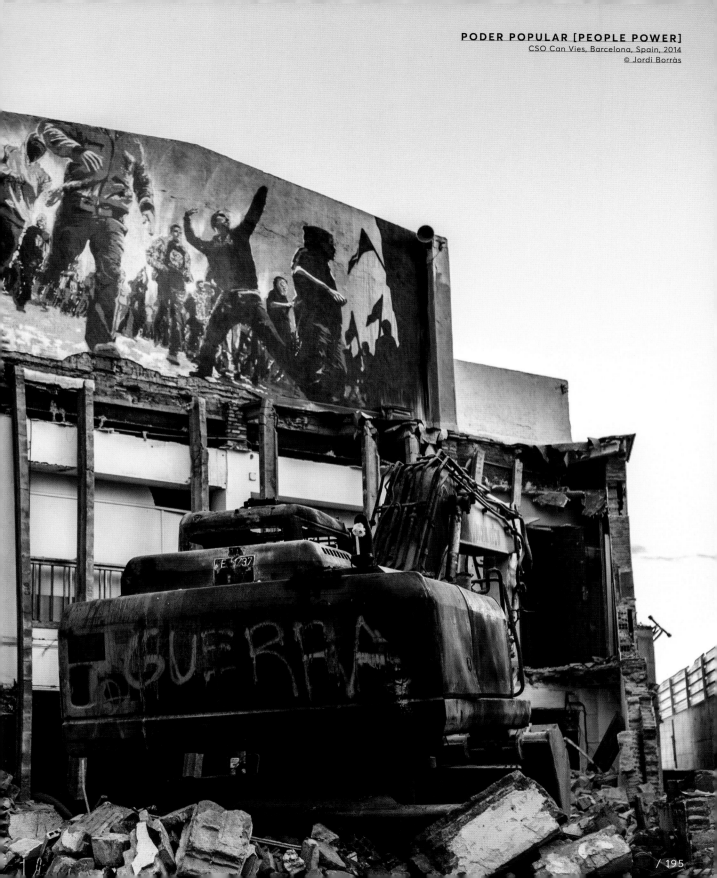

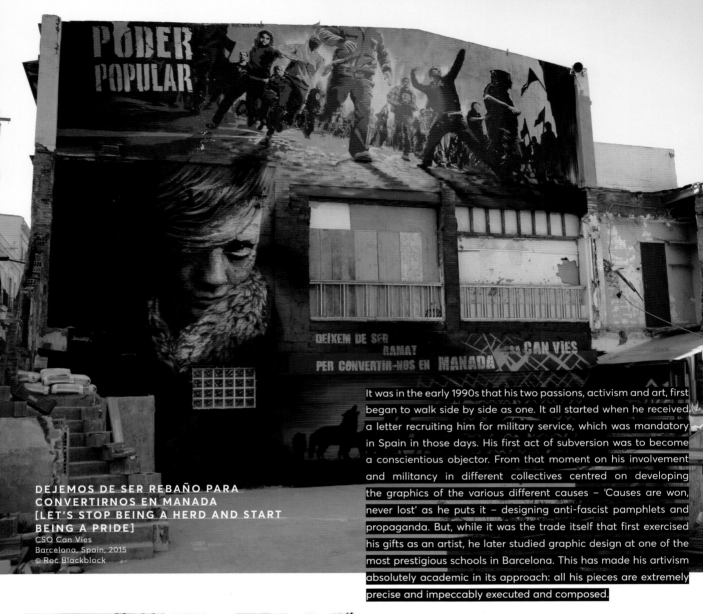

DEJEMOS DE SER REBAÑO PARA CONVERTIRNOS EN MANADA [LET'S STOP BEING A HERD AND START BEING A PRIDE]
CSO Can Vies
Barcelona, Spain, 2015
© Roc Blackblock

It was in the early 1990s that his two passions, activism and art, first began to walk side by side as one. It all started when he received a letter recruiting him for military service, which was mandatory in Spain in those days. His first act of subversion was to become a conscientious objector. From that moment on his involvement and militancy in different collectives centred on developing the graphics of the various different causes – 'Causes are won, never lost' as he puts it – designing anti-fascist pamphlets and propaganda. But, while it was the trade itself that first exercised his gifts as an artist, he later studied graphic design at one of the most prestigious schools in Barcelona. This has made his artivism absolutely academic in its approach: all his pieces are extremely precise and impeccably executed and composed.

Later, running parallel to his urban social action, he added another creative string to his bow in order to make money and keep the spirit of militancy burning by tattooing his comrades with his designs. In the course of that whole æsthetic and creative development he also drew on the boom of street art after the start of the new millennium, when he began to investigate other techniques like stencil, which allowed him to work from actual photographs rather than working free-hand. Roc Blackblock is today regarded as one of Barcelona's most highly evolved, refined and precise stencil artists. He combines these stencil techniques with landscape and other free-hand elements, using either brush or spray-can. He is unquestionably one of the most complete and engaged wall artists in southern Europe.

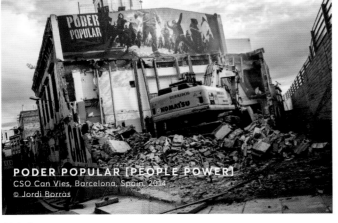

PODER POPULAR [PEOPLE POWER]
CSO Can Vies, Barcelona, Spain, 2014
© Jordi Borràs

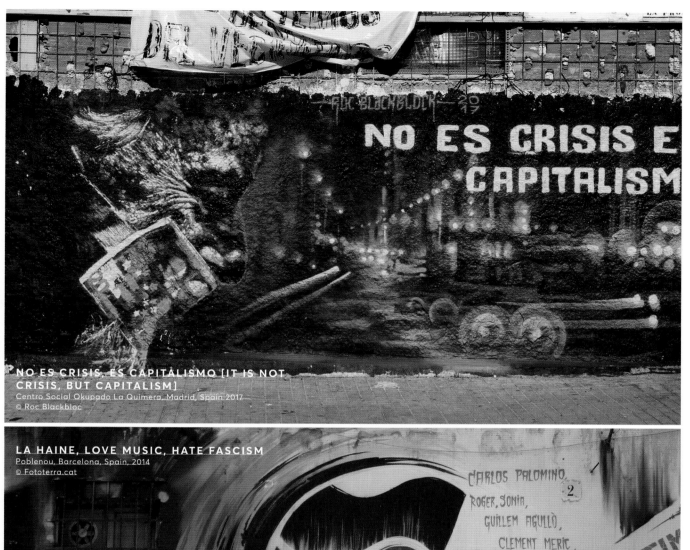

NO ES CRISIS, ES CAPITALISMO [IT IS NOT CRISIS, BUT CAPITALISM]
Centro Social Okupado La Quimera, Madrid, Spain 2017
© Roc Blackbloc

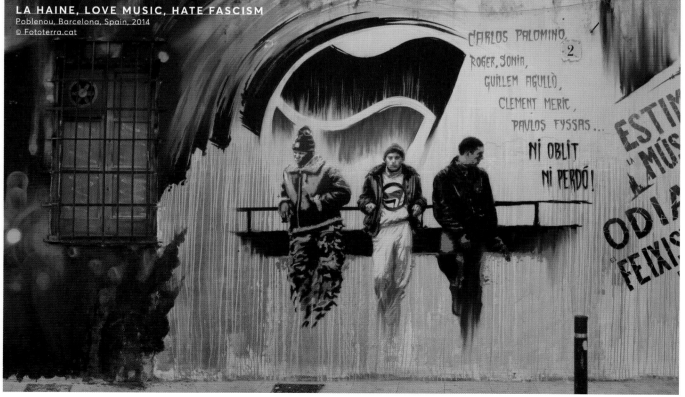

LA HAINE, LOVE MUSIC, HATE FASCISM
Poblenou, Barcelona, Spain, 2014
© Fototerra.cat

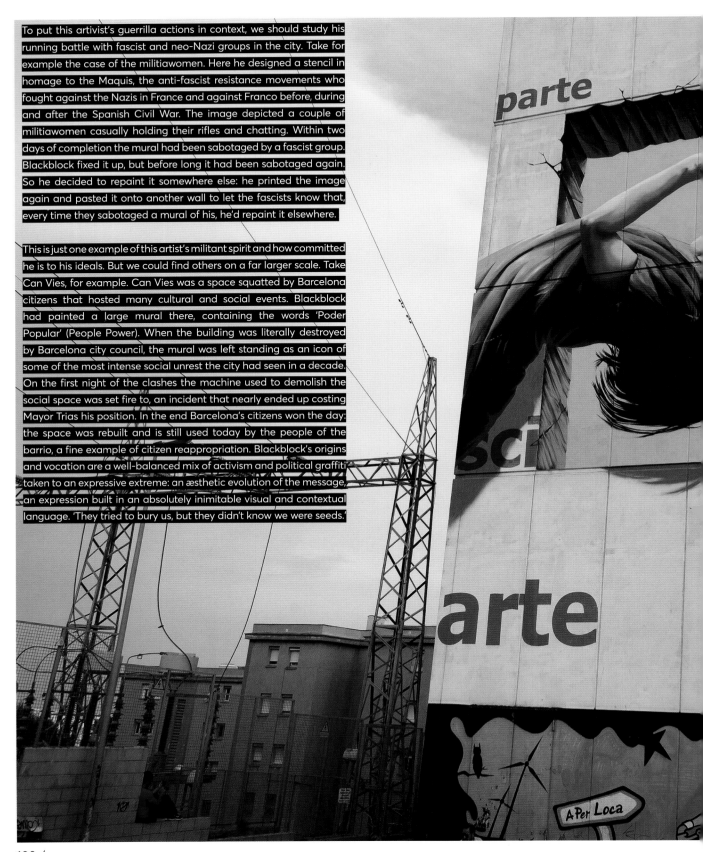

To put this artivist's guerrilla actions in context, we should study his running battle with fascist and neo-Nazi groups in the city. Take for example the case of the militiawomen. Here he designed a stencil in homage to the Maquis, the anti-fascist resistance movements who fought against the Nazis in France and against Franco before, during and after the Spanish Civil War. The image depicted a couple of militiawomen casually holding their rifles and chatting. Within two days of completion the mural had been sabotaged by a fascist group. Blackblock fixed it up, but before long it had been sabotaged again. So he decided to repaint it somewhere else: he printed the image again and pasted it onto another wall to let the fascists know that, every time they sabotaged a mural of his, he'd repaint it elsewhere.

This is just one example of this artist's militant spirit and how committed he is to his ideals. But we could find others on a far larger scale. Take Can Vies, for example. Can Vies was a space squatted by Barcelona citizens that hosted many cultural and social events. Blackblock had painted a large mural there, containing the words 'Poder Popular' (People Power). When the building was literally destroyed by Barcelona city council, the mural was left standing as an icon of some of the most intense social unrest the city had seen in a decade. On the first night of the clashes the machine used to demolish the social space was set fire to, an incident that nearly ended up costing Mayor Trias his position. In the end Barcelona's citizens won the day: the space was rebuilt and is still used today by the people of the barrio, a fine example of citizen reappropriation. Blackblock's origins and vocation are a well-balanced mix of activism and political graffiti taken to an expressive extreme: an æsthetic evolution of the message, an expression built in an absolutely inimitable visual and contextual language. 'They tried to bury us, but they didn't know we were seeds.'

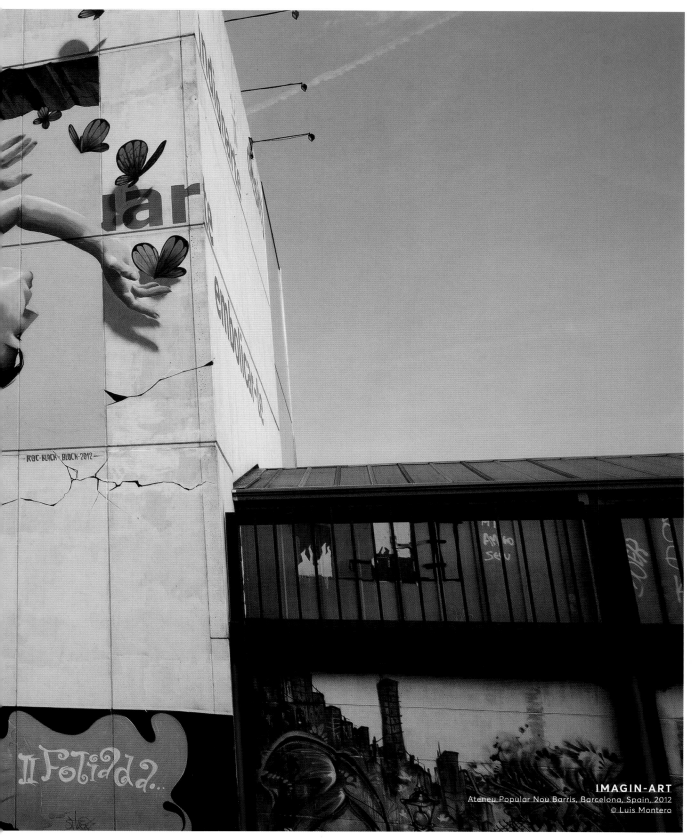

A LEG-PULL AND A MASS THRASHING

ČESKÝ SEN

Český sen is the Czech Republic's first 'reality show'. It's also a big leg-pull for the whole of Europe. The documentary's directors, Vít Klusák and Filip Remunda, created a whole story around the opening of a fictional new hypermarket in Prague: Český sen – The Czech Dream.

The first thing they did was to learn how to dress like hypermarket managers and behave like big businessmen. So they followed a course for managers and spoke to an endless string of image consultants, who advised one of them to wear a red tie to attract attention to the lips when speaking and the other one to wear a blue tie because it matched his eyes. It was also recommended that they wear the best Hugo Boss cologne for every occasion.

So, all groomed and perfumed, they set off to an advertising agency – one of the Czech Republic's largest, responsible for the Pepsi campaign – with the idea of running a fake hypermarket campaign. Convinced they'd get 90 minutes' free coverage on film, the agency felt the project would be extremely good publicity for them. Together they set up everything needed for a successful marketing campaign: television spots, web-sites, radio advertising, posters in bus shelters, ads in trams and Metro trains, and up to 200,000 fliers delivered to homes and dished out all over Prague. Everything reeked of low-price promises and dreams come true. They had to get it perfect down to the smallest detail: the charade had to be water-tight, completely believable, above all suspicion. The smallest false note could blow the whole project out of the water.

CESKY SEN–CZECH DREAM, (2004)
Ceska TV/Hypermarket Film
Kobal/REX/Shutterstock
Director: Vit & Remuneda Klusak

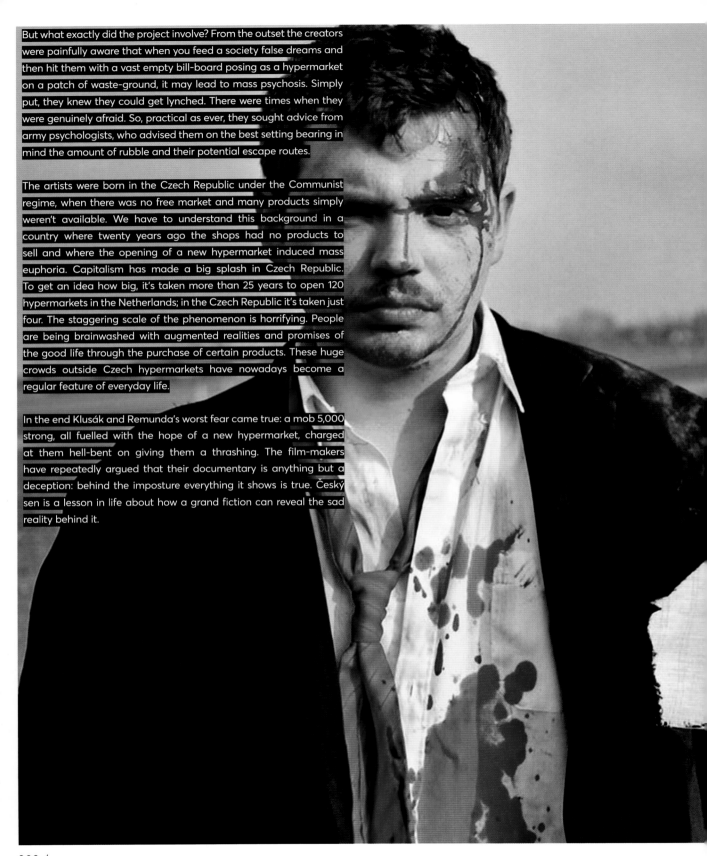

But what exactly did the project involve? From the outset the creators were painfully aware that when you feed a society false dreams and then hit them with a vast empty bill-board posing as a hypermarket on a patch of waste-ground, it may lead to mass psychosis. Simply put, they knew they could get lynched. There were times when they were genuinely afraid. So, practical as ever, they sought advice from army psychologists, who advised them on the best setting bearing in mind the amount of rubble and their potential escape routes.

The artists were born in the Czech Republic under the Communist regime, when there was no free market and many products simply weren't available. We have to understand this background in a country where twenty years ago the shops had no products to sell and where the opening of a new hypermarket induced mass euphoria. Capitalism has made a big splash in Czech Republic. To get an idea how big, it's taken more than 25 years to open 120 hypermarkets in the Netherlands; in the Czech Republic it's taken just four. The staggering scale of the phenomenon is horrifying. People are being brainwashed with augmented realities and promises of the good life through the purchase of certain products. These huge crowds outside Czech hypermarkets have nowadays become a regular feature of everyday life.

In the end Klusák and Remunda's worst fear came true: a mob 5,000 strong, all fuelled with the hope of a new hypermarket, charged at them hell-bent on giving them a thrashing. The film-makers have repeatedly argued that their documentary is anything but a deception: behind the imposture everything it shows is true. Český sen is a lesson in life about how a grand fiction can reveal the sad reality behind it.

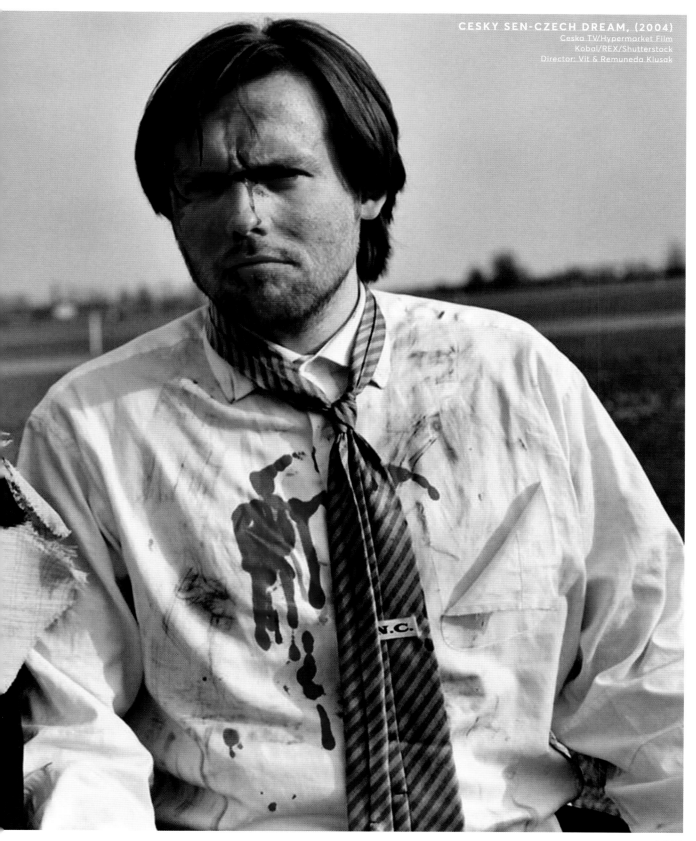

DANIELA POCH

is a stage-language explorer, theatre creator and dramatist specializing in street dramaturgy and urban creativity interventions. She is a co-founder of the Eléctrico 28 collective, whose work focuses on the public space and whose members question social and theatrical conventions, rethink the role of the audience and create site-specific projects. She is co-author of the books Creaticity and Urban Creativity Experience, a collection on creativity and the public space. She has a degree in Literary Theory and Comparative Literature, and her research centres on humour and the literary representation of traumatic experiences.

ARCADI POCH

is the founder and CEO of YTIC Labs. As a socio-cultural explorer he is devoted mainly to research and development. He also acts as a consultant for artistic and social projects in the public space. He is the co-founder of Kognitif, an international network of creators and professionals who use culture and the arts to stimulate the collective conscience both through socio-cultural projects in the public space, and audiovisual works and exhibitions. With Daniela Poch he has co-authored the books Creaticity (Lemo 2013) and Urban Creativity Experience (Lemo 2014). He is also co-author of Fotografía y contrapublicidad en el arte urbano [Market, counter-publicity and photography in urban art] (VINZ 2014).